Teacher's Edition
Kindergarten

Kindergarten Author Cathy Weisman Topal

PROGRAM AUTHORS MARILYN G. STEWART ELDON KATTER

CONTRIBUTING AUTHORS LAURA H. CHAPMAN NANCY WALKUP

Davis Publications, Inc. Worcester, Massachusetts

Kindergarten Author

Cathy Weisman Topal

Program Authors

Marilyn G. Stewart
Eldon Katter

Contributing Authors

Laura H. Chapman
Nancy Walkup

Educational Consultants

Bettyann Plishker
Art Educator
Fairfax County, Virginia,
Public Schools

Alexandra Coffee
Art Teacher
Claremont Math and Science
Academy
Chicago, Illinois

Project Staff

President and Publisher
Wyatt Wade

Managing Editor
David Coen

Editor
Reba Libby

Consulting Editor
Claire Mowbray Golding

Product Manager
Barbara Place

Design
WGBH Design:
Tong-Mei Chan
Julie DiAngelis
Tyler Kemp-Benedict
Chrissy Kurpeski
Vijay Mathews
Jonathan Rissmeyer
Douglass Scott

Production
Thompson Steele, Inc.
Matt Mayerchak

Editorial Assistants
Photo Acquisitions
Missy Nicholson
Annette Cinelli
Diane Carr

Illustrators
Janet Theurer
Network Graphics
Susan Christy-Pallo

Photography
Tom Fiorelli

Manufacturing
Georgiana Rock

Library of Congress Control Number: 2007929980
Printed in the United States of America
ISBN: 978-0-87192-774-3
1 2 3 4 5 6 7 8 9 WC 14 13 12 11 10 09 08 07

Teacher's Edition Contents

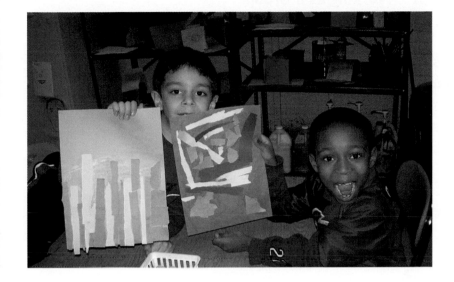

Unit 1
Thinking and Working as Artists

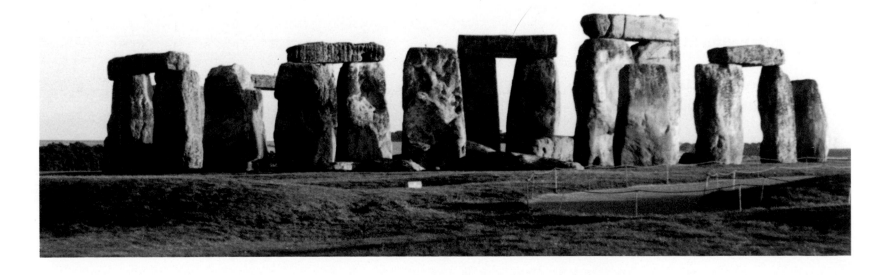

Unit 6
Design

Unit 7
Sewing

Unit 8
Animals

Unit 9
Color

Unit 10
Buildings and Cities

Reference

Authors

Kindergarten Author

Cathy Weisman Topal

Cathy Weisman Topal has been a visual arts educator at the pre-school, elementary, middle school, and college levels for over twenty-five years. She is currently a studio art teacher at the Center for Early Childhood Education and the Smith College Campus School at Smith College in Northampton, Massachusetts. She is also a lecturer in Visual Arts Education in the Department of Education and Child Study at Smith College. Cathy is the author of four books—*Children, Clay, and Sculpture, Children and Painting, Beautiful Stuff!* and *Thinking with a Line*—that have grown from her explorations and exchanges with children, classroom teachers and in-service and pre-service teachers.

Program Authors

Marilyn Stewart

Marilyn Stewart, author of grades 1–5, is Professor of Art Education, Kutztown University. She is author of *Thinking Through Aesthetics*, co-author of *Rethinking Curriculum in Art*, series editor of the *Art Education in Practice* series by Davis Publications, and co-author, with Eldon Katter, of Davis's three-text middle school art program, *Art: A Global Pursuit, Art: A Community Connection*, and *Art: A Personal Journey*. Named 1998 Eastern Region Higher Education Art Educator of the Year and 2006 Pennsylvania Art Educator of the Year, Dr. Stewart was the 1997–1998 Getty Education Institute for the Arts Visiting Scholar. She is a frequent speaker and consultant to numerous national projects and has conducted over 160 extended staff development institutes, seminars, or workshops in over 25 states.

Eldon Katter

Eldon Katter, author of grades 1–5, is an emeritus professor of art education at Kutztown University in Pennsylvania. He is a former editor of *SchoolArts* and a former president of the National Art Education Association. He taught art in the elementary schools in Park Ridge, Illinois and Needham, Massachusetts. As a Peace Corps volunteer in the 1960s, Eldon taught art at a teacher training school in Harar, Ethiopia. He also worked for the Teacher Education in East Africa project in Kampala, Uganda.

Contributing Authors

Laura H. Chapman

Laura H. Chapman has taught art at all levels of education and in many venues, including schools, community and museum programs, and teacher education at Indiana University, Ohio State University, University of Illinois, and University of Cincinnati. She has exhibited paintings in museums and galleries in the South and Midwest, written numerous articles and books, and served as a consultant for national and international programs. She is a Distinguished Fellow of the National Art Education Association, among many other awards. Laura is the author of *Discover Art, Adventures in Art.*

Nancy Walkup

Nancy Walkup is the editor of *SchoolArts* Magazine and an art specialist at W.S. Ryan Elementary in Denton, Texas. She was Project Coordinator for ten years at the North Texas Institute for Educators on the Visual Arts at the University of North Texas. She was named Texas Art Education Association Texas Art Educator of the year in 2001, Texas Higher Education Art Educator of the Year in 1997, and Louisiana Art Educator of the Year in 1991. She has taught art to every grade from kindergarten to university.

How to Use This Program

You'll love teaching Kindergarten with this **child-centered**, carefully structured program. Experience, along with your students, the delight of discovering materials, developing skills, and inventing new ways to create. **Field tested, effective classroom management techniques** are included in each lesson.

The Big Book

Contains 39 lessons in 10 engaging units.

Each lesson includes:

- Carefully chosen works of fine art and photographs of the world around us to help spark children's interest and enthusiasm.

- Simple text to introduce basic concepts.

- Step-by-step, clearly illustrated Studio Explorations to help children discover their own creativity.

- Sidebars to reinforce techniques, offer background, or remind children of expectations.

Kindergarten

Explorations in ART

Cathy Weisman Topal

DAVIS

The following ancillaries are available with the Kindergarten Big Book.

e-Book
The Kindergarten Big Book and Teacher's Edition are available as an e-Book.

Music CD
Choose from a variety of genres, time periods, and themes to inspire students during studio time.

Instructional Posters
A set of 10 Instructional Posters in **English and Spanish**. Use these to introduce or review the **elements and principles**, **art criticism**, **techniques**, **safety tips**, and more. Each of the 10 posters has been designed so that you can easily display the Spanish and English versions side by side.

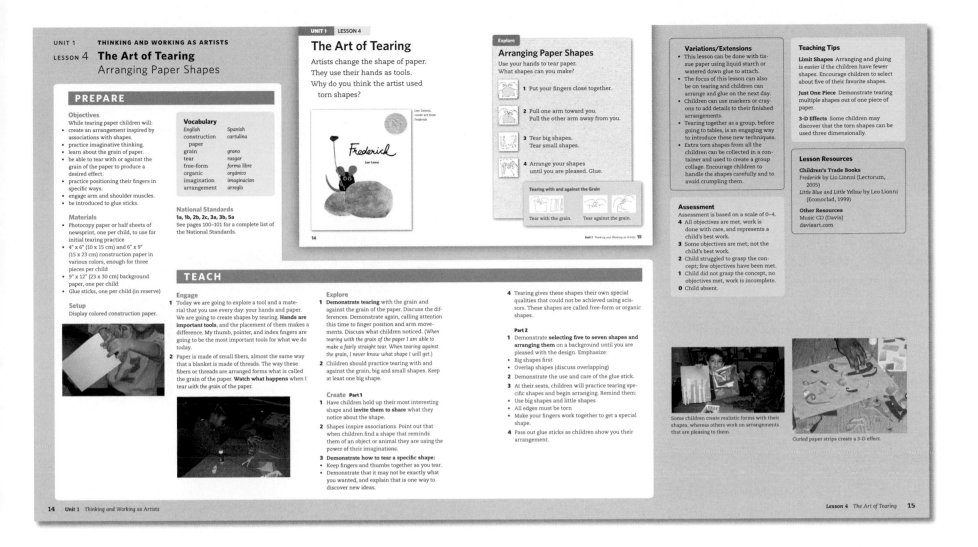

The Teacher's Edition

- Contains an introduction to each unit.

- Outlines tested approaches to early encounters with materials and processes.

- Gets you ready to teach with materials lists, vocabulary, age-appropriate objectives, and set-up suggestions.

- Takes you step by step through each part of the lesson: engaging students at the start, suggesting questions and comments to promote idea-sharing, pointing out potential challenges, and more.

- Offers ongoing assessment suggestions as well as scoring rubrics.

- Provides tips for making each lesson more successful, manageable, and enjoyable.

- Suggests variations and extensions to lengthen or deepen instruction.

- Includes illustrations and photographs of classroom situations and children's artwork.

- Includes correlations to the National Visual Arts Standards.

Prepare
Everything you need
to get ready.

Teach
Careful description
of lesson process.

Student Art
See examples of authentic
Kindergarten artwork.

Standards Correlations
Standards identified
in every lesson.

Assessment Rubrics
Rubrics for each lesson.

Unit 1 Opener

Thinking and Working as Artists

This unit introduces children to the habits of mind and approaches to learning offered by the visual arts. The curriculum takes an exploratory approach to tools, materials and concepts. As teachers guide these explorations, they also step into uncharted territory. They open themselves to the new ways of thinking, describing, categorizing and arranging discovered by the children. In this way teachers and children become collaborators in the great adventure of learning.

Learning to use, respect, and care for tools and materials; experimenting with multiple ways to approach a new task; engaging muscles and developing physically; practicing and refining new skills, striving for just the right words to describe work and ideas—these are all important parts of what it means to discover the artist within. At the same time, learning takes place in a group setting as children become part of a community of researchers, thinkers and learners.

This curriculum makes connections with every aspect of a child's development. While exploring the potential of a variety of artists' tools and materials, children construct the understandings and approaches to learning that they need to succeed—and not just in art.

Lessons in this unit:

Introductory Lesson
Lesson 1 **Discovering Materials: Arranging Stones**
Lesson 2 **Introducing Crayons: Crayon Techniques**
Lesson 3 **Seeing Lines: Inventing Lines with Markers**
Lesson 4 **The Art of Tearing: Arranging Paper Shapes**
Lesson 5 **The Art of Cutting: Making Many Shapes**
Lesson 6 **Meet the Paintbrush: A Brushstroke Composition**
Lesson 7 **Creating Shapes: Paint with Blobs and Outlines**
Lesson 8 **Serendipity: Experiments with Watercolor**

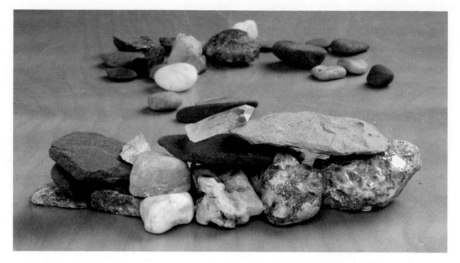

Children are quick to see the variety of lines, shapes, textures, colors and organizational possibilities in even the most common materials.

Watercolorist Richard Yarde introduces the program by recalling his early memories of drawing and painting at the kitchen table. He shares his technique for beginning a painting.

Materials surround us in the natural world. Thinking and working as an artist means seeing possible materials in your own surroundings – and children are natural material detectives!

Lesson three challenges children to discover different kinds of lines. These lines become a common language and a reference for the rest of the year.

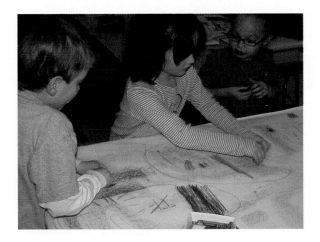

Exploring tools and materials in a group enables children to share discoveries and excitement and to get to know one another's ways of working. It is a natural way to build a classroom community.

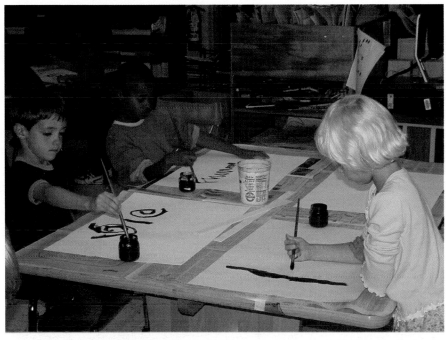

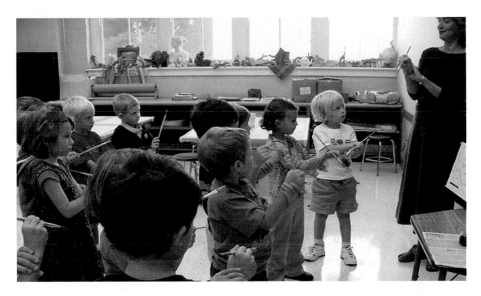

Practicing hand holds and brush movements in the air before working with paint allows children to experience different brushstrokes, without the concern of thinking about how the brushstrokes will look.

Line possibilities become a reference as children explore the many ways to hold and move a brush. They discover that any single brushstroke can be painted in many different sizes.

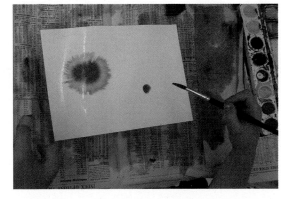

Coordinating hand, arm and body movements works slightly differently for each tool and material. Practice and small challenges help children to gain control and confidence.

Watercolor explorations capitalize on the serendipitous nature of this medium. Watercolors come in especially handy as a way to add color to drawings made with indelible markers.

Introductory Lesson

How Do Artists Think and Work?

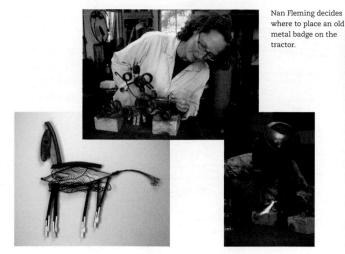

Nan Fleming decides where to place an old metal badge on the tractor.

Nan Fleming, *C Horse*, 2007. Found objects.

Nan welds two parts of the tractor together.

Nan Fleming says, "I play with things, move them around in different ways. I usually start with two things that I put together—and that is the beginning of something!"

PREPARE

Objectives

When a teacher introduces the work of an artist and engages children in thinking about what it means to think and work as an artist, children begin to understand that:

- seeing with an artist's eye is a way of being in the world.
- artists work with many different kinds of materials—studio art materials as well as found materials.
- artists are always looking at the world with eyes that see interesting shapes, colors, textures, lines, and spaces.
- each artist works in a very different way.
- it is interesting to hear what artists have to say about their work and their ideas.

Setup

Be sure that children can see the images from where they are sitting. Consider having them sit near to you to begin. Read through the quotes and information about the artists beforehand to become familiar with and enthusiastic about their work. Kindergarten children are very perceptive and quickly pick up on a teacher's interests and excitement.

Vocabulary

English	Spanish
artist	*artista*
experiment	*experimento*
explore	*exlporar*
sculpture	*escultura*
painting	*cuadro*
style	*estilo*

National Standards

1a, 2a, 2b, 4b, 5a, 5b

See pages 100–101 for a complete list of the National Standards.

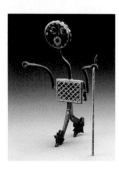

Nan Fleming, *Senior,* 2003. Welded recycled metal, acrylic paint, marbles. Photo by John Polak. From the Fraidstern Collection.

TEACH

Engage

Introduce Nan Fleming and Richard Yarde by using the images, quotes, and captions on the Big Book pages to give the children a little background about each of the artists.

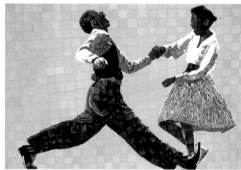

Richard Yarde, *Savoy: Heel and Toe,* 1999. Watercolor, 29" × 42" (74 × 107 cm). Courtesy of the artist.

Explore

1 Explain that Nan Fleming is an artist who especially enjoys creating sculptures by welding discarded metal parts together. She finds the parts for her sculptures everywhere—tag sales and junk yards, for example—and many friends also bring her interesting metal pieces that they have found. She says, "Some people would walk into my barn and see a lot of junk. But I walk in and I see forms and shapes that remind me of a horse head, a body part, a person's shape."

2 After being out of school for many years, Nan went back to finish her college degree. "I took a welding class on a whim … I remember so clearly the first time I heated metal and could bend it—it was like a miracle."

3 Richard Yarde's mother gave him his first set of watercolor paints when he was young. He remembers working as a child on the dining room table. He remembers that his big brother used to draw really great pictures, and that he liked to draw and paint over old maps. He "drew a lot of volcanoes." Now he is well

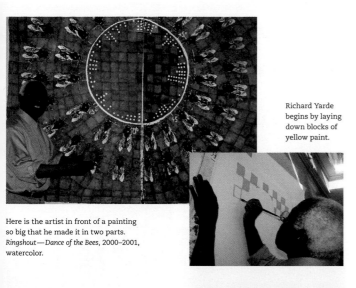

Richard Yarde begins by laying down blocks of yellow paint.

Here is the artist in front of a painting so big that he made it in two parts. *Ringshout—Dance of the Bees*, 2000–2001, watercolor.

Richard Yarde almost always begins his paintings by laying down blocks of color.

He thinks these blocks of color come from the blocks he used to play with as a young boy.

Here a little girl performs at her jazz dance recital, even though she is scared. Notice the blocks in the background. Richard Yarde, *Mindy 1 and Mindy 2*, 2005, watercolor.

7

known for his very large watercolor paintings that glow with color and show lots of movement. He says that painting puts him into a space for thinking and that most of his work comes from some kind of personal experience. "You have paint, paper, and color and you are reacting to it," he says.

4 Notice the white areas in Richard Yarde's paintings. The artist deliberately painted around these areas, leaving them the color of the paper. Why do you think he left these areas white?

5 Invite children to share what they think it means for Nan Fleming and Richard Yarde to think and work as artists. Let them know that together we will spend the year exploring many different art materials and tools and discovering and sharing ways to use them with our classmates, just as these artists have shared their ways of working with us. Then proceed to the first lesson, or to one of the lessons in the first unit.

Teaching Tips

Establish Guidelines You might wish to begin by establishing guidelines for the art studio. It is helpful if the suggestions come from the children. "Can you think of rules that would help us to work well together this year?" Children will probably suggest some of the following:

- Keep your hands to yourself.
- Stay in your own space.
- Share.
- Walk.
- Treat materials and each other with respect.
- Raise your hand before speaking.

Keep the Lesson Moving Children will not be able to sit too long. Engage them right away by pointing to the image of Nan welding. Ask: "What do you think she is doing?" Move through the information about Nan. Then ask the same thing about Richard Yarde. Avoid posing too many questions; kindergarteners love to talk and share, but at the same time you will need to move along to keep all the children engaged. Share the information about Richard Yarde and then pose the final question: "What do you think it means to think and work as an artist?" Accept all answers.

Record Comments If another adult is in the room, ask him or her to record the children's comments and answers during the discussions. Then turn to one of the first lessons, because children will be anxious to touch materials and get to work.

Variations/Extensions

- Ask children what they are hoping to do during their studio time this year.
- Note that artwork and lessons using other works by Nan Fleming can be found on pages 30 and 36.

Lesson Resources

Children's Trade Books
I Am an Artist by Pat Lowery Collins. (Millbrook, 1994)
Stompin' at the Savoy by Bebe Moore Campbell, illustrated by Richard Yarde. (Philomel, 2006)

Other Resources
Music CD (Davis)
davisart.com

Discovering Materials
Arranging Stones

PREPARE

Objectives

While exploring, sorting, and arranging stones children will:

- notice and describe their characteristics: color, shape, texture, size.
- tap their natural sense of design.
- realize that these are artistic behaviors.
- use the art elements, principles of design, and their own words to describe their discoveries.
- experience the beginning stages of working collaboratively within a respectful community of artists, where all ideas are valued.
- be introduced to the artistic process.

Materials

- Stones or other natural materials (at least ten per child)
- White paper and pencils (in reserve)

Setup

Stones in the middle of the table. Baskets make excellent containers.

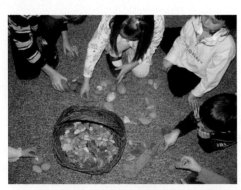

"See if this is heavy. Try these."
"This one has rings."
"I like this one because of the swirls."
"This one looks like it's from the mountains."
"This one is perfectly round."

Vocabulary

English	Spanish
stones	piedras
arrangement	arreglo
line	línea
shape	forma
color	color
texture	textura
value	valor
form	forma
space	espacio

National Standards

1a, 1b, 2a, 3a, 4a, 4b, 5a, 5c, 6b
See pages 100–101 for a complete list of the National Standards.

Discovering Materials

Materials are all around us.
People arranged these stones.
What did they do?

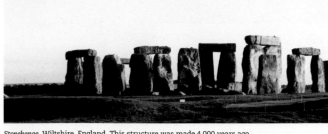

Stonehenge, Wiltshire, England. This structure was made 4,000 years ago.

Mary Bauermeister, *Eighteen Rows*, 1962–68. Pebbles and epoxy on linen covered board.

8

TEACH

Engage

1 Explain to children: There are materials all around us. It is the artistry we bring to these materials that allows us to create something beautiful. To find the beauty in the materials themselves, we need to take time to look and explore with our senses.

2 Mary Bauermeister is an artist who looked closely at stones and discovered that they could also be studio art materials. How would you describe the way she has organized her collection of stones?

3 **Focus on Stonehenge**. These enormous stones are one of the earliest examples that remain of post and beam construction. Do any of you know about these stones? Archeologists think that Stonehenge was built about 4,000 years ago, but how and why Stonehenge was built is still a mystery. What are your ideas about the purpose of this arrangement of giant stones?

Explore

1 **Introduce the natural material**, in this case stones. Notice the qualities of different stones.

2 Let the children know where you found these materials. Try to evoke a sense of wonder: Each stone was chosen because someone discovered something special about it (shape, size, texture, color, interesting line design, glimmers).

3 Ask: How could you sort these materials? Speculate and model some of the children's ideas for possible ways to sort (by color, shape, size, texture).

4 When children go to their seats ask them to spend some time looking at and touching the stones. Ask them to think about all the ways the stones can be sorted.

Create Part 1

1 Allow each table to share some characteristics they noticed and how they chose to sort the stones.

Arranging Natural Materials

Discover the unique qualities of stones.

1 Look, touch, smell.

2 Sort. Group similar stones together.

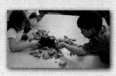

3 Arrange.

4 Share with others.

2 Ask children to **think of a beautiful way to display their stones**. How can they show off their stones' unique qualities? They can do this as a group, with a neighbor, or by themselves.

3 Have children think of a title or a way to describe their arrangement. Record titles.

4 Once arrangements are complete, encourage children to think of the space as a museum exhibit. Have children visit other displays, paying attention to details they find interesting.

Part 2

1 **End the lesson by** sharing the following ideas with children so that they recognize what they have achieved through this exploration.

- Materials for expression are all around us.
- The unique qualities of a material are revealed when we take the time to look.
- Each of us has an ability to create order and beauty.
- By sharing ideas, working together, and respecting one another we have taken the first steps toward building a community of artists.

2 Have children carefully put materials away so that they will be available for other children and for future explorations.

Variations/Extensions

- Materials made available by the season and the weather will offer new possibilities. Explorations can take place on the playground and the classroom.

- If you prefer that children work in a designated space, a piece of cardboard, brown paper, or a lunch tray can be used to define children's work areas.
- Offer paper and pencil for children to make a drawing of their arrangement, as a way for them to save a trace of the experience. You might also take a few photographs to save a memory of this first experience.

- In the weeks to come, a container of stones and a tray can be set aside for children who finish assignments early.

Assessment

Assessment is based on a scale of 0–4.

4 All objectives are met, work is done with care, and represents a child's best work.

3 Some objectives are met; not the child's best work.

2 Child struggled to grasp the concept; few objectives have been met.

1 Child did not grasp the concept, no objectives met, work is incomplete.

0 Child absent.

Note: "A child's best work" depends on each child's individual ability. It helps to establish a list of all children's names and record the number assessment for each lesson as soon as possible after the lesson.

Teaching Tips

Record Art Vocabulary When children take the time to explore natural materials, they automatically begin to use a descriptive art vocabulary. Describing characteristics necessitates the use of the art elements. In order to describe an arrangement they unconsciously use and refer to design principles: balance, contrast, proportion, pattern, rhythm, emphasis, unity, variety, movement, and harmony. As children share their ideas, make a list of art words to use as a reference throughout the year.

Artistic Process This lesson is a good introduction to the artistic process. It allows all children, regardless of ability, to experience the artistic process in a non-threatening and rewarding way.

Record Associations Natural materials carry stories and associations of wind and weather. Listen and record connections made by children; such as the connection this child made: "This is a celebration rock — it has green, orange and purple — remember the celebration rock in *Tillie and the Wall?*"

Lesson Resources

Children's Trade Books
If You Find A Rock by Peggy Christian (Harcourt, 2000)
Everybody Needs a Rock by Byrd Baylor and Peter Parnall (Aladdin Books, 1974)
On My Beach There Are Many Pebbles by Leo Lionni (HarperTrophy, 1995)
Georgia's Bones by Jen Bryant (Eerdman, 2005)

Other Resources
Stone by Andy Goldsworthy (Abrams, 1994)
Wood by Andy Goldsworthy (Abrams, 1996)
Rivers and Tides (New Video Group, 2004)
Music CD (Davis)
davisart.com

Introducing Crayons
Crayon Techniques

UNIT 1 LESSON 2

Introducing Crayons

Artists use crayons to create drawings.
What do you see in this drawing?

Beverly Buchanan, *Monroe County House with Yellow Datura*, 1994. Oil pastel on paper.

10

PREPARE

Objectives
While exploring crayon techniques children will:
- discover ways to use crayons to express ideas.
- use specific parts of the crayon to produce a desired effect.
- identify and name the parts of a crayon.
- feel and understand that how they hold the crayon affects the kind of mark they make.
- feel and understand that the pressure they apply affects the intensity of a color.
- learn how to blend crayon colors.

Vocabulary

English	Spanish
crayon	*crayón*
tip	*punta*
side	*lado*
pressure	*presión*
blending	*mezclar*
pale	*pálido*
vibrant	*vibrante*

National Standards
1a, 1b, 1c, 2a, 3b
See pages 100–101 for a complete list of the National Standards.

Materials
- Container of old (broken and unwrapped) and new (with sharp tips) crayons that can be shared
- White paper to cover tables

Setup
- Cover tables with white paper and tape sides down.
- Write children's names on their section of paper.
- Have chart paper available for demonstrating techniques.

TEACH

Engage
1 As beginning artists we need to discover the potential in the materials we use. Today we are going to learn about crayons, which you may have used before.

2 **Focus on the artwork.** Ask children to look closely and say how they thought the artist used crayons. Ask: What is unusual about the way the artist drew sky, grass, and trees? (lots of strokes of different colors, all going the same direction)

3 Just over a hundred years ago the first box of crayons was invented, with only eight colors. Ask: What would you have used to draw if you lived a hundred years ago? Hold up the crayon and **invite children's observations** about the parts of the crayon and how they think each part might be used. Ask: "This is the tip of the crayon. How would you use it?" Note that some of the children's crayons are new and some are broken. As beginning artists our first job is to explore and discover the potential of crayons.

Explore
1 **Demonstrate holding the crayon** in different places. Each time, ask what type of mark would be made. Using the chart paper, demonstrate:
- a writing hand hold
- gradually changing the pressure on the crayon from light to firm
- holding the crayon on its side
- one hand steadying the paper, while the other rubs the crayon
- gradually changing the pressure on the side-held crayon, from light to firm
- covering a large area by rubbing
- blending colors by rubbing

Crayon Techniques

Discover the power of crayons by experimenting.

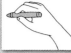

1 Practice holding the crayon in different ways.

Press lightly. Press harder.

2 Use the tip.

3 Use the side.

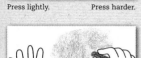 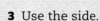

4 Blend colors.

Create **Part 1**

1 Point out that the tables are covered with paper. Explain that this is a special way for us to explore the potential of crayons as a group. Allow children to begin their explorations.

Part 2

1 Gather the children together to share crayon discoveries. With the children notice that:
- the direction of coloring makes a difference
- crayons can be used to create many different kinds of lines
- when lines are repeated next to each other, they make textures
- it's easy to create different kinds of shapes and put them together using crayons
- either the tip or the side may be used to mix colors

2 Children may be inspired to create drawings, which they can incorporate into their explorations.

Variations/Extensions

- After you introduce techniques, children could use them to color in a drawing they have already done.
- This lesson can be done with objects, where children can "mix to match" a color or texture they see.
- Children discover that colors generate and reflect emotions. Have papers that say "Today I feel . . ." and allow children to create a drawing. As you circulate you can fill in the emotion.

- This lesson format can be used to explore any drawing material: a soft drawing pencil, colored pencils, oil pastels, or chalk.

Assessment

Assessment is based on a scale of 0–4.
4 All objectives are met, work is done with care, and represents a child's best work.
3 Some objectives are met; not the child's best work.
2 Child struggled to grasp the concept; few objectives have been met.
1 Child did not grasp the concept, no objectives met, work is incomplete.
0 Child absent.

Teaching Tips

Blending is Dramatic The power of this lesson really comes out when children begin blending colors. When demonstrating, choose colors that will drastically change. For example, start with yellow and add blue. Then open it up to the children: what do they want you to add next? Working in this way sets the tone for the art room; it creates a respect for materials and a respect for other children and their space.

Lesson Resources

Children's Trade Books
How Is a Crayon Made? by Charles Oz (Simon & Schuster, 1988)
The Hello, Goodbye Window by Norton Juster and Christopher Raschka (Hyperion, 2005)
Harold and the Purple Crayon by Crockett Johnson (Bloomsbury, 1996)
Ish, by Peter Reynolds (Candlewick, 2004)
My Crayons Talk by Patricia Hubbard and Brian Karas (Henry Holt, 1996)

Other Resources
Music CD (Davis)
davisart.com

LESSON 3 Seeing Lines
Inventing Lines with Markers

PREPARE

Objectives
As children draw rows of lines they will:
- learn that lines can help us understand the structure of objects in the built and natural environments.
- learn that lines are tools for drawing our own ideas.
- explore the art form of drawing.
- practice drawing different types of lines.
- learn proper care of markers.

Materials
- Felt-tipped markers
- 9" x 12" (23 x 30 cm) white paper, one per child (extra in reserve)

Setup
- One piece of paper set out for each child
- Markers available to share

Vocabulary

English	Spanish
lines	líneas
straight	dereche
curved	curvado
zigzag	zigzag
spiral	espiral
dotted	punteado
broken	roto
wavy	ondulado
crossed	cruzado
diagonal	diagonal
horizontal	horizontal
vertical	vertical

National Standards
1a, 1b, 1d, 2c, 6b
See pages 100–101 for a complete list of the National Standards.

Kinds of Lines

straight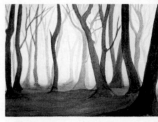

curved

wavy

thick

thin

horizontal

vertical

TEACH

Engage
1 Explain: **Lines give us information**, just like words do, and it is easy to read their language. Line is the most basic of all the art elements and is a key to thinking and seeing as an artist does. Lines are tools for drawing our own ideas.

2 Using the images, have children **find and describe the lines** that they see. In the photograph of the harbor, notice the vertical lines of the masts and their reflections, the diagonals of the docks, and the free flowing lines of the hills in the distance. In the weaving, point out some of the different lines. What shapes are made from lines and the spaces between them? In the gates: How many different kinds of spirals do you see?

Explore
1 With the children, **develop a chart of lines** to use as a reference. Include straight, curved, zigzag, wavy, dotted, broken, a line of x's, a line of +'s, loopy lines, a line of spirals, hearts, letters, and so on.

2 Introduce magic markers as a recently invented drawing tool. Discuss the difference between markers and other drawing tools.

UNIT 1 LESSON 3

Seeing Lines

Lines are all around us.
Describe the lines you see in these pictures.

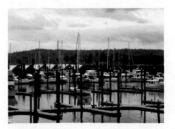

Boats in a harbor

A painting of trees. Marcia Wolff, *Winter Silhouettes*, 2005. Watercolor.

A blanket

A gate

12

Inventing Lines with Markers

Use markers to make many kinds of lines.

1 Start at the top of your paper.

2 Draw one kind of line all the way across.

3 Change colors. Draw another kind of line under the first line.

Draw at least 10 rows of lines.
What other kinds of lines can you invent?

Create

1 When children go to their seats they will:
- start at the top left of the paper and draw a line all of the way across to the other side
- draw at least ten rows of different kinds of lines
- change colors every line

2 If children finish early they can make a design or picture using lines. They can draw on the back or on a new piece of paper.

Children take this in different directions; that's OK.

Variations/Extensions

- Have children look between the lines and find small places to color in.
- Instead of lines, children can try rows of letters, numbers, and shapes.
- This lesson can also be done with crayons.
- End the lesson with children choosing one line to share with the class.
- Using index cards, create a set of line cards with different types of lines drawn on them. Pass them out in the classroom or outside, and go on a line hunt.

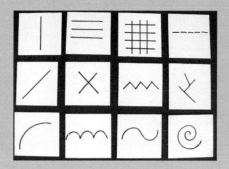

About the Artist

"I tend to paint from things that inspire me, trees for instance. To create this composition, I looked at both trees in nature and in photographs."
—Marcia Wolff

Assessment

Assessment is based on a scale of 0–4.
4 All objectives are met, work is done with care, and represents a child's best work.
3 Some objectives are met; not the child's best work.
2 Child struggled to grasp the concept; few objectives have been met.
1 Child did not grasp the concept, no objectives met, work is incomplete.
0 Child absent.

Teaching Tips

Early Finishers If a child finishes early, he or she can use both sides of the paper.

Marker Procedures Explain desired marker procedures; such as replacing caps when not in use, and drawing only on paper.

Using Music Rows of lines can be drawn to music—especially music with a strong beat. These rows of lines were drawn with black markers on brown construction paper, then painted with tempera paint using one color with one brush, and passing the paint when the music stopped.

Lesson Resources

Children's Trade Books
A Picture for Harold's Room by Crockett Johnson (HarperTrophy, 1985)
The Squiggle by Carole Lexa Schaefer and Pierre Morgan (Crown, 1996)
The Line Up Book by Marisabina Russo (Greenwillow, 1986)
Lines by Philip Yenawine (Museum of Modern Art, 1991)
Spirals, Curves, Fanshapes & Lines by Tana Hoban (Greenwillow, 1992)
Going for a Walk with a Line by Douglas and Elizabeth MacAgy (Doubleday, 1959)

Other Resources
Music CD (Davis)
davisart.com

The Art of Tearing
Arranging Paper Shapes

The Art of Tearing

Artists change the shape of paper.
They use their hands as tools.
Why do you think the artist used
torn shapes?

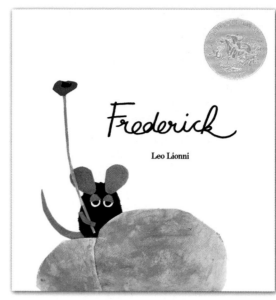

Leo Lionni,
cover art from
Frederick.

14

PREPARE

Objectives
While tearing paper children will:
- create an arrangement inspired by associations with shapes.
- practice imaginative thinking.
- learn about the grain of paper.
- be able to tear with or against the grain of the paper to produce a desired effect.
- practice positioning their fingers in specific ways.
- engage arm and shoulder muscles.
- be introduced to glue sticks.

Materials
- Photocopy paper or half sheets of newsprint, one per child, to use for initial tearing practice
- 4" x 6" (10 x 15 cm) and 6" x 9" (15 x 23 cm) construction paper in various colors, enough for three pieces per child
- 9" x 12" (23 x 30 cm) background paper, one per child
- Glue sticks, one per child (in reserve)

Setup
Display colored construction paper.

Vocabulary

English	Spanish
construction paper	cartulina
grain	grano
tear	rasgar
free-form	forma libre
organic	orgánico
imagination	imaginacíon
arrangement	arreglo

National Standards
1a, 1b, 2b, 2c, 3a, 3b, 5a
See pages 100–101 for a complete list of the National Standards.

TEACH

Engage

1 Today we are going to explore a tool and a material that you use every day: your hands and paper. We are going to create shapes by tearing. **Hands are important tools**, and the placement of them makes a difference. My thumb, pointer, and index fingers are going to be the most important tools for what we do today.

2 Paper is made of small fibers, almost the same way that a blanket is made of threads. The way these fibers or threads are arranged forms what is called the grain of the paper. **Watch what happens** when I tear *with the grain* of the paper.

Explore

1 **Demonstrate tearing** with the grain and against the grain of the paper. Discuss the differences. Demonstrate again, calling attention this time to finger position and arm movements. Discuss what children noticed. (*When tearing with the grain of the paper I am able to make a fairly straight tear. When tearing against the grain, I never know what shape I will get.*)

2 Children should practice tearing with and against the grain, big and small shapes. Keep at least one big shape.

Create Part 1

1 Have children hold up their most interesting shape and **invite them to share** what they notice about the shape.

2 Shapes inspire associations. Point out that when children find a shape that reminds them of an object or animal they are using the power of their imaginations.

3 **Demonstrate how to tear a specific shape:**
- Keep fingers and thumbs together as you tear.
- Demonstrate that it may not be exactly what you wanted, and explain that is one way to discover new ideas.

Arranging Paper Shapes

Use your hands to tear paper.
What shapes can you make?

 1 Put your fingers close together.

 2 Pull one arm toward you.
Pull the other arm away from you.

 3 Tear big shapes.
Tear small shapes.

 4 Arrange your shapes
until you are pleased. Glue.

Tearing with and against the Grain

Tear with the grain. Tear against the grain.

4 Tearing gives these shapes their own special qualities that could not be achieved using scissors. These shapes are called free-form or organic shapes.

Part 2

1 Demonstrate **selecting five to seven shapes and arranging them** on a background until you are pleased with the design. Emphasize:
- Big shapes first
- Overlap shapes (discuss overlapping)

2 Demonstrate the use and care of the glue stick.

3 At their seats, children will practice tearing specific shapes and begin arranging. Remind them:
- Use big shapes and little shapes.
- All edges must be torn.
- Make your fingers work together to get a special shape.

4 Pass out glue sticks as children show you their arrangement.

Variations/Extensions
- This lesson can be done with tissue paper using liquid starch or watered down glue to attach.
- The focus of this lesson can also be on tearing and children can arrange and glue on the next day.
- Children can use markers or crayons to add details to their finished arrangements.
- Tearing together as a group, before going to tables, is an engaging way to introduce these new techniques.
- Extra torn shapes from all the children can be collected in a container and used to create a group collage. Encourage children to handle the shapes carefully and to avoid crumpling them.

Assessment
Assessment is based on a scale of 0–4.
4 All objectives are met, work is done with care, and represents a child's best work.
3 Some objectives are met; not the child's best work.
2 Child struggled to grasp the concept; few objectives have been met.
1 Child did not grasp the concept, no objectives met, work is incomplete.
0 Child absent.

Teaching Tips

Limit Shapes Arranging and gluing is easier if the children have fewer shapes. Encourage children to select about five of their favorite shapes.

Just One Piece Demonstrate tearing multiple shapes out of one piece of paper.

3-D Effects Some children may discover that the torn shapes can be used three dimensionally.

Lesson Resources

Children's Trade Books
Frederick by Leo Lionni (Lectorum, 2005)
Little Blue and Little Yellow by Leo Lionni (Econoclad, 1999)

Other Resources
Music CD (Davis)
davisart.com

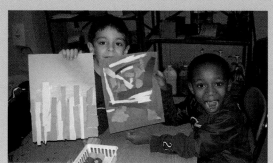

Some children create realistic forms with their shapes, whereas others work on arrangements that are pleasing to them.

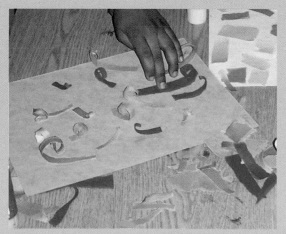

Curled paper strips create a 3-D effect.

UNIT 1 THINKING AND WORKING AS ARTISTS
LESSON 5 The Art of Cutting
Making Many Shapes

PREPARE

Objectives
While learning to use scissors children will:

- understand that the act of cutting is a complex task that requires the strength of the whole body, not just fingers.
- understand that both hands must be coordinated in order to cut.
- practice positioning body, shoulders, arms and hands. It's important to sit up straight.
- experience a proper grip.
- develop respect for scissors.
- articulate guidelines for using scissors.

Materials
- scissors
- 8" x 1 ½" (22 x 4 cm) oak tag, foam, colored index cards, or thick construction paper, cut into strips (3 or 4 strips per child)
- 5" x 7" (13 x 18 cm) oak tag, foam, colored index cards, or thick construction paper
- 9" x 12" (23 x 30 cm) paper for background, 1 per child (in reserve)
- glue stick, 1 per child (in reserve)

Setup
- For demonstration: have one pair of scissors and one strip of paper per child.
- Cover tables with newspaper.
- Strips of paper on tables, two or three per child.
- Glue sticks and background color in reserve.

Vocabulary

English	Spanish
scissors	tijeras
cutting hand	mano de corte
holding hand	mano que sostiene
muscles	músculos
thumb	pulgar

National Standards
1a, 1c, 1d, 3a, 3b, 4a, 4b, 4c, 5c
See pages 100–101 for a complete list of the National Standards.

UNIT 1 LESSON 5

The Art of Cutting

Scissors change the shape of paper. What shapes do you see in this artwork? Notice where shapes touch.

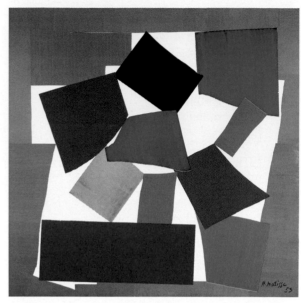

Henri Matisse, *The Snail (L'Escargot)*, 1953. Gouache on paper.

16

TEACH

Engage
1 **Focus on the artwork.** Explain that Henri Matisse made many artworks from pieces of paper that he cut with scissors. Ask children to point out and describe shapes they see. Each shape touches another shape. Notice where they touch.

2 Scissors are an important artist's tool. Using scissors is a complex task. Many muscle groups and hand skills are necessary to becoming a skilled cutter.

Explore
1 **Go over the poem demonstrating each step.** Tell children that this is an easy way to remember how to pick up and hold the scissors. Discuss the importance of having a firm material to use when practicing cutting. Demonstrate where to hold the foam and the scissors while cutting.

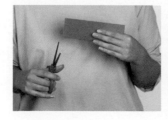 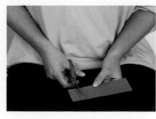

2 **Demonstrate:**
- cutting a square from one end of the foam strip.
- cutting a rectangular piece. Ask children to tell you how a rectangle is different from a square.
- cutting a triangle using the corner for the two sides of the triangle and cutting on the diagonal.
- cutting a triangle by cutting two diagonal lines that cross. It is important to demonstrate that there is more than one strategy for cutting a shape.
- cutting many lines (snips) on one edge of the piece, then changing direction and cutting across the snips, creating many tiny pieces.
- cutting a thin strip from one edge.

3 **Hand out scissors.** Go over the poem again together, each child following the line of the poem and repeating after you. Practice opening and closing the scissors in the air—always pointing to the center of the room or away from others!

Making Many Shapes

Scissors are an important tool for cutting.

1 Practice cutting squares, rectangles, and triangles.

2 Cut many tiny shapes.

3 Arrange your shapes until you are pleased.

Using Scissors

First children make a handshake. Say "Hello. Hello. Hello."

Then thumb goes in the little hole. We know, we know, we know.

Next, fingers in the big hole. Two or three is what we said.

Now elbow goes straight to your side. You're pointing straight ahead.

Then your fingers open wide. It's almost time to snip.

Remember we're just practicing. We're trying not to rip.

Unit 1 Thinking and Working as Artists **17**

Create **Part 1**

1 Hand out a strip of material to each child. Ask: Can you cut a square, rectangle, a triangle? Can you cut tiny shapes? How many pieces did you cut? Count your pieces.

2 Collect paper pieces into one container. Demonstrate and discuss the proper way to walk with scissors. At their seats children will find more strips of paper to cut.

Part 2

1 Discuss arranging cut pieces by referring to the Matisse collage. Matisse shows the movement of a snail. Ask: What will you think about while you arrange your shapes?

In your arrangement have at least one piece that:
- touches an edge of the background paper
- touches another shape
- overlaps another shape
- Try multiple arrangements before gluing.

2 Introduce glue sticks and proper procedure for using this artist's tool. Demonstrate techniques for gluing a piece or two onto a background color. Collect scissors as you pass out glue sticks.

Variations/Extensions

This lesson can be done using warm colors for cutting and cool colors for the background or contrasting colors.

Scissors History

Scissors were invented about 1500 B.C.E. in Egypt. These were probably shears with the joint at the far end. Modern scissors are made from two cross blades that pivot around a fulcrum. These were invented in ancient Rome about 100AD. Many people say that Leonardo Da Vinci, painter of the Mona Lisa, invented scissors. The scissors we have today are made from stronger, lighter and more refined materials. They cut very well and they are sharp, even if they are not pointed!

Scissors Power

"Learning to use scissors is one of the important ego-building achievements of early childhood. Children discover that scissors give them instant power to make changes in paper and other materials."
—Clare Cherry, *Creative Art for the Developing Child*

Assessment

Assessment is based on a scale of 0–4.
4 All objectives are met, work is done with care, and represents a child's best work.
3 Some objectives are met; not the child's best work.
2 Child struggled to grasp the concept; few objectives have been met.
1 Child did not grasp the concept, no objectives met, work is incomplete.
0 Child absent.

"Triangles. Triangles are my favorite shape."
—Jesse

Teaching Tips

Handing Out Scissors Place them in front of each child's right hand, unless you know a child is left-handed.

Scissor Safety Ask children: What rules do we need to keep everyone safe?

Practice! Challenging children with the question, "How many pieces can you cut from this one piece?" gives children many chances to practice cutting, avoiding the tendency to make one cut and then reach for a new piece of paper.

Emphasize Exploration Cultivate the attitude that we are all artists and explorers, discovering ways to use an artist's tool.

Many Strategies Remember to demonstrate that there is more than one strategy for cutting a shape.

Fair Warning Give children a warning a few minutes before you plan to collect the scissors and introduce gluing.

Different Outcomes Some children will create designs; others will create realistic forms.

Record Comments Some children will name their work. If possible, record children's comments about their work.

Include Classroom Teachers They appreciate knowing about and attending this lesson. It allows them to observe children's handedness, cutting skills, and allows them to reinforce cutting procedure and rules in the classroom.

Lesson Resources

Children's Trade Books
I See a Song by Eric Carle (Scholastic, 1996)
Peter's Chair by Ezra Jack Keats (Viking, 1998)

Other Resources
Music CD (Davis)
davisart.com

LESSON 6 Meet the Paintbrush
A Brushstroke Composition

Meet the Paintbrush

Every painting starts with a brushstroke. What kinds of brushstrokes do you see? Some of the lines are the same, but how are they different?

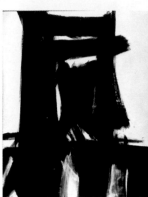

Wassily Kandinsky, *Untitled* (Drawing for "Diagram 17"), 1925. Black ink on ivory paper.

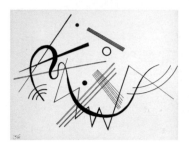

Franz Kline, *Meryon*, 1960–61. Oil on canvas.

18

PREPARE

Objectives
While children explore the paintbrush and painting they will:
- feel and understand that where they hold the brush and which joint they use affects the kind of line or mark they are able to create.
- use a variety of movements to create different types of brushstrokes: straight and curved, zigzag, broken.
- develop an appreciation for the paintbrush as an artist's tool and understand how to care for it.
- try out different paintbrushes.
- develop a descriptive line vocabulary.

Materials
- ⅜" (1 cm) easel brush, 1 per child
- Small jars or cups with less than 1" (2.5 cm) of black or dark colored tempera paint, 1 per child
- 18" x 24" (46 x 61 cm) paper, trimmed to 17" x 23" (43 x 58 cm) (See Setup)
- Smaller brushes, 1 per child (in reserve)
- CD player or tape player

Setup
- Cover tables with newspaper and tape the paper down to keep it in place.
- Trim paper beforehand if mounting finished work. Save trimmed strips for recording titles and children's comments.
- One piece of paper per child at table.
- Prepare cups of dark-colored paint beforehand, to hand out when children are at seats practicing.
- When preparing black or dark paint, add a *small* amount of water so the paint will glide smoothly onto the paper. Test the paint. When it is a good consistency, pour a small amount into each cup.
- Extra paper in reserve.
- Use music as a motivator, to inspire arm movements. Later in the lesson, music becomes a signal to begin painting.

Vocabulary

English	Spanish
paintbrush	*pincel*
bristle	*cerda*
handle	*mango*
ferrule	*casquillo*
arm	*brazo*
shoulder	*hombro*
elbow	*codo*
wrist	*muñeca*
finger joint	*articulacíon del dedo*

National Standards
1a, 1b, 1c, 1d, 2c, 3a, 3b, 4b, 6a
See pages 100–101 for a complete list of the National Standards.

TEACH

Engage
1 The goal for today is to **develop a friendship with the paintbrush** and learn strategies for controlling the kind of marks you can make using this new tool. Focus on the artworks: How are the lines different in each? Can you see some lines that are alike in both works of art?

Explore
1 Every painting begins with a single brushstroke or mark. Before we begin to paint, let us **take a close look at the parts of this easel brush**. List parts of the paintbrush: bristle, handle, ferrule.

2 Most of the time painters hold the paintbrush in the middle. Discuss how your control of the brush changes when you hold the ferrule, middle of the handle, and the end.

3 **Identify the arm joints:** shoulder, elbow, wrist, and finger. Ask the children to pretend they are holding brushes, and have them try the exercises in the air along with you.

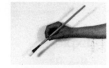
Normal control

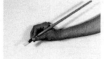
Greater control

Looser control

4 Demonstrate holding each of your joints with your free arm as you practice brushstrokes in the air. Emphasize the connection between the joint you activate and the length of the brushstroke. Try moving each joint so that you can understand with your body how it feels.

Create Part 1
1 Hand out paintbrushes, try the same exercises. **Experiment with different types of lines.** To introduce children to brush care, demonstrate painting a stroke and wiping the brush so that it won't drip.

2 Once children are at their seats, turn on the music to help inspire them to move their arms freely. Have children go to workspaces and practice making lines *without* paint while you hand out the containers of paint.

3 Encourage children to keep brushstrokes separate so that we can "read" the marks. Also encourage them to paint in the white places rather than painting on top of other strokes.

A Brushstroke Composition

The way you hold your paintbrush, and the way you move your arm, affects your brushstrokes.

 1 Practice your strokes in the air.

 2 Dip and wipe your brush.

 3 Paint a brushstroke.

 4 Leave a space between brushstrokes.

 5 Try a smaller brush.

Try different brushstrokes.

Unit 1 Thinking and Working as Artists **19**

Part 2

1 When you notice a few students have almost filled their papers with lines, turn off the music. Introduce the idea that music is a cue to stop, look, and listen. Tell students that you will now be passing out smaller brushes so that they can experiment with a smaller brush and smaller, thinner strokes.

2 Encourage children to look for spaces between lines and to paint inside and between them.

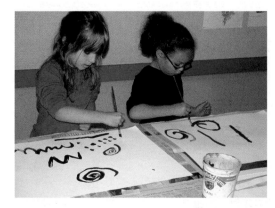

Variations/Extensions

- Other materials; such as markers, watercolor paints, or crayons, can be used for this lesson.
- Children can revisit these paintings by looking between the lines for spaces to fill in with primary colored paint, craypas, or other color media.

Assessment

Assessment is based on a scale of 0–4.

4 All objectives are met, work is done with care, and represents a child's best work.

3 Some objectives are met; not the child's best work.

2 Child struggled to grasp the concept; few objectives have been met.

1 Child did not grasp the concept, no objectives met, work is incomplete.

0 Child absent.

Lesson Resources

Children's Trade Books

No One Saw by Bob Raczka (Millbrook, 2001)

Ma Lien and the Magic Brush by Hisako Kimishima (Macmillan, 2000)

Other Resources

Music CD (Davis)
davisart.com

Teaching Tips

Bigger is Better 12" x 18" (30 x 46 cm) paper will also work for this lesson, but bigger works better if you have space.

Study the Paintbrush Defining the parts of the brush and types of brushes, and analyzing the kinds of marks one can make by activating particular joints, gives children real information that they can use. This takes the mystery out of being an artist, and opens up the possibility of artistic expression to everyone.

Practice! Feeling confident about holding and using the brush is one key to enjoying, understanding, and beginning the painting process.

Offer Information As you hand out paintbrushes, comment on the kind of brush; flat or round, and the size. Children enjoy learning about the identifying details of specific tools.

Note Similarities Point out that children work differently, but often "catch ideas" from one another and from visuals studied in class.

Use One Color Painting with only one color encourages children to experiment with the different kinds of marks they can create with a brush, and to think about how they hold the brush. It is a way to introduce painting without a lot of mess.

Stand Up Standing up while trying the beginning exercises allows the arm to move more freely. However, the exercises will also work if students are seated.

A Place for Brushes Have a few easily-accessible containers for collecting brushes as children finish.

Loosen Tight Grips Help students with very tight grips loosen up by gently moving their painting arms in the air until they relax a little. Help students with very little control to try tightening their grips and sliding their hands closer to the front of the brushes.

Have children hold a joint while moving a paintbrush.

Creating Shapes
Paint with Blobs and Outlines

Creating Shapes

When a paintbrush meets the paper and moves around, a shape is born. How did this artist move his brush?

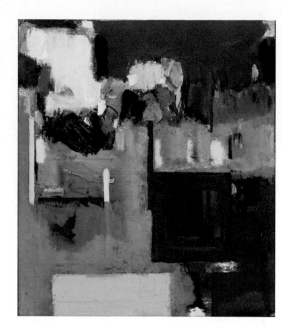

Hans Hofmann, *Image of Cape Cod: The Pond Country, Wellfleet*, 1961. Oil on canvas.

20

PREPARE

Objectives
While painting shapes children will:
- practice making shapes using both the blob and outline approach.
- discover that they can paint shapes in different sizes.
- learn to recognize geometric and free-form shapes.
- be able to create geometric and free-form shapes.
- use an artist's eye to find the open spaces to paint in.
- learn a procedure: When the music stops, everyone stops, looks and listens for the next instruction. In this lesson, stopping the music is a signal to stop work, place brush in paint container, and pass brush and paint to a neighbor.

Materials
- 22" x 16" (56 x 41 cm) white paper
- Medium size ⅜" (6 mm) easel brush, 1 per child
- Jars of red, blue, and yellow paints, one each per group of three children
- Jars of black paint (in reserve)
- Small brushes for adding details with the black paint, one per jar (in reserve)
- Music: Keep the music meditative to help children concentrate and focus. Avoid lyrics.
- CD or tape player

Setup
- Cover tables with newspaper. Tape the paper down to avoid sliding.
- One piece of white paper, one brush, and one jar of paint, about half full, per child should be ready at tables.
- Each table should have the primaries. Add secondary colors if you have more than three children at a table.

Vocabulary

English	Spanish
circle	círculo
square	cuadrado
rectangle	rectángulo
triangle	triángulo
geometric shapes	forma geometrica
free-form shapes	figuras de forma libre

National Standards
1c, 1d, 2a, 2c, 3a, 3b, 4c, 6b
See pages 100–101 for a complete list of the National Standards.

TEACH

Engage
1 **Hold and display a paintbrush** for the children as you review:
- parts of the paintbrush—handle, ferrule, bristle.
- shoulder, elbow, wrist, and finger joints and the sizes of lines they can create.
- placing your hand closer to the bristle when you want to paint precise details.

2 To paint is to create shapes. When a brush filled with paint meets a surface and moves around, a shape is formed! Ask children to identify the shapes they see in the visuals.

3 How do you think the artist moved his arm to create these shapes? Point to some geometric shapes and to some free-form shapes. Accept all answers.

Explore
1 Today we will be working with the three primary colors; yellow, red, and blue. **There are many ways to create a shape.** Here are two techniques to demonstrate and practice:

Blob Method
- Dip your brush into one of the colors.
- Wipe the brush so that it doesn't drip.
- Move the paint up and down (or back and forth) until you have a shape that resembles a free-form square.

Outline Method
- Paint two vertical lines.
- Cross them with two horizontal lines so that you have a square.
- Fill in the square with paint.
- Demonstrate both methods of painting another shape, such as a circle or triangle.

2 Remind children that they listened to music last week to help them create different brush-strokes. Today we will use music to help us concentrate and focus. We will also use it as a signal for switching colors. Remind children:
- to paint on the white spaces, and to leave the painted shapes so that we can see them.
- to paint a shape that touches another shape.

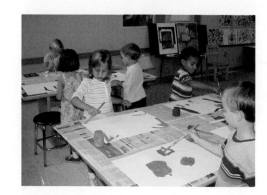

Paint with Blobs and Outlines

Learn two ways to create a square.

Blob Method	Outline Method

 1 Dip and wipe.

 2 Move your brush up and down or back and forth to make a square.

 1 Dip and wipe.

2 Paint two vertical lines.

3 Paint two horizontal lines.

 4 Are there other ways?

Can you paint a circle? a triangle? a free-form shape?

Create Part 1

1 **Demonstrate blending:** Pick up some of the other color and mix it into your shape. Once all children have painted a few shapes, stop the music. Remind children to place brushes in the jars and to pass the jar to a neighbor. Follow this procedure until the children have had a chance to paint with all of the colors at their table.

Part 2

1 Stop the children. Ask them to stand up and **look again at the shapes in their paintings** before they finish, as artists do. They might like to rotate their paintings, looking for new shapes they may not have noticed or intended. Encourage them to think about where they might like to add a detail or make a connection.

2 Offer the black paint and small brushes for adding details, lines and connections. Remind them to work slowly and carefully. It is difficult to add black paint to a very wet painting. Remove other colors and brushes from tables.

Variations/Extensions

- Use the same basic shape-making strategies with colored markers. Each child gets one color to begin and tries out the blob and outline methods. Children should keep creating shapes until the paper is full. Use the music to help children change colors. Emphasize changing sizes. Optional: Use black fine-line markers to add important details.
- This is also a great lesson to introduce oil pastels, but remove black oil pastels beforehand to put the focus on making shapes and blending colors. For oil pastels, reduce the size of the paper to no larger than 9" x 12" (23 x 30 cm). Working on a newspaper pad makes applying oil pastels much easier. Working on construction paper also works well. Another option is to work on white paper and add watercolors to the spaces between the shapes another day.
- If you prefer not to use black paint, offer small brushes for adding details with primary colors.

Assessment

Assessment is based on a scale of 0–4.

4 All objectives are met, work is done with care, and represents a child's best work.

3 Some objectives are met; not the child's best work.

2 Child struggled to grasp the concept; few objectives have been met.

1 Child did not grasp the concept, no objectives met, work is incomplete.

0 Child absent.

Teaching Tips

Newspaper Have extra newspaper handy for placing over any spills.

Enjoy! Allow time for the children to enjoy the paint, the shapes they are creating, and the colors that they are discovering. What is really important is that each child has a positive experience and builds confidence in his or her ability as a painter.

Free-form is Fine Some children find it difficult to paint precise shapes. Delight in their free-form shapes.

Listen and Record Record comments on paper strips or index cards as you walk around the room. Record names on the papers. Display these comments with the children's work.

Lesson Resources

Children's Trade Books
Shapes by Philip Yenawine (Museum of Modern Art, 2006)

Other Resources
Music CD (Davis)
davisart.com

LESSON 8 **Serendipity**
Experiments with Watercolor

PREPARE

Objectives
As children prepare and paint with watercolors, they will:
- follow procedures for wetting paper and paint, and washing the brush between colors.
- study the effects of working on wet paper.
- practice positioning the hand to access the tip of the brush.
- understand the unique qualities of watercolor paint, and how they differ from tempera paint qualities.
- understand how to make a color darker or lighter with water.
- understand how to use and care for watercolor sets.
- understand how to use and care for a watercolor brush.

Materials
- Medium size watercolor brushes, number 6 or 7, one per child
- Watercolor paper 4" x 6" (10 x 15 cm), 1 per child
- Sponges cut in half or thirds, 1 per child, for wetting paper
- Watercolor paints (place a piece of masking tape over the black pigment at first), one set per child
- Water dishes, half full (See Teaching Tips)
- Paper towels, 1 per child

Setup
- Cover tables with newspaper and tape the paper down to prevent sliding.
- Supply each child with a watercolor brush, paper towel, 4" x 6" white paper, set of watercolors, and a water dish to share.

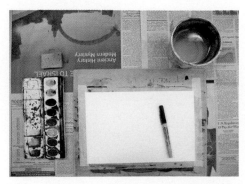

Vocabulary

English	Spanish
light	claro
dark	oscuro
wet	mojado
value	valor
dots	puntos
dabs	toques
lines	líneas
pigment	pigmento
transparent	transparente
serendipity	serendipia

National Standards
1a, 1b, 1c, 1d, 2b, 4a, 4c
See pages 100–101 for a complete list of the National Standards.

TEACH

Engage
1 **Focus attention on the painting** by Raoul Dufy. Ask: What do you notice about the colors and brush-strokes in this painting? Can you find light blues and dark blues?

2 The colors that are generated by watercolor paints are transparent. Unlike tempera paint, the colors in watercolor paintings remain clear, glowing, and vibrant even when paintings have dried. Sets of watercolors can be taken along almost anywhere. How many of you have sets of watercolor paints at home?

Explore
1 Traditionally artists used watercolor to add details to pencil drawings so that they could remember the colors when they went to the studio to paint in oil paint. In the past two hundred years artists have discovered that watercolors have a power of their own. There is one special ingredient that gives watercolors their power—what do you think it is? Water!

2 **Cover your paper with water.** It should look shiny. Water expands and stretches the fibers of the paper, sometimes causing the paper to form an arch. If this happens, demonstrate turning the paper over and adding water to the other side.

3 **Demonstrate "waking up" the pigment** using the magic ingredient of water. Show children how to "tickle" one color with the brush, working water into the pigment. (The word "tickle" helps children realize how little pressure is necessary.)

4 Demonstrate how to hold the brush if you want to use just the tip.

Create **Part 1**
1 Use the tip of the brush to **paint at least ten dots** of one color on the paper. Point out the difference between a dot and a dab: a dot uses just the tip of the brush; to make a dab, gently press the length of the bristles against the paper, and lift. How can you change the size of the dot? (let the brush rest against the paper longer) How can you change the lightness or darkness of the dot? (the more pigment used, the darker the dot)

2 Demonstrate the procedure of rinsing the brush by touching the bottom of the water dish gently, so you don't splash. Demonstrate wiping the brush to see if it is clean. Also demonstrate how to keep the bristles straight.

Serendipity

This is a watercolor painting.
What do you notice about the colors and the brushstrokes?

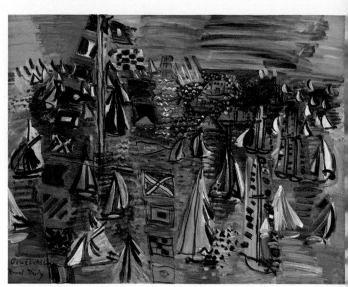

Raoul Dufy, *Regatta at Cowes*, 1934.

22

Experiments with Watercolor

Watercolor paints are full of surprises.

 1 Wet your paper.

 2 "Tickle" the paint.

 3 Paint dots. Use just the tip

 4 Paint dabs. Press gently.

 5 Paint dots inside dots.

Using Your Brush Properly

Brush with the bristles all going in the same direction.

Don't do this!

Unit 1 Thinking and Working as Artists **23**

3 Repeat the process with another color. Continue adding dots to the white part of the paper.

4 When your paper is getting full, see what happens if you place a dot inside another dot.

Part 2

1 Serendipity is making a valuable and agreeable discovery by accident. Unexpected or serendipitous things often happen with watercolors. **Invite children to share their discoveries.**

2 With a second paper, see what happens when you paint lines. Refer to the line chart and brushstroke work from Unit 1, Lesson 6.

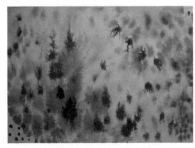

"The longer you use a color, the lighter it gets."—Ella
"Whichever way the brush goes, the paint follows it."—Duncan

Variations/Extensions

- Have children try more than one experiment on wet paper. The first painting can be just tiny dots, the second can be an experiment with dabs, and the third can be an experiment with lines.
- As a follow up, children can experiment with wash techniques.
- Watercolor paints are especially effective when used to add color to any drawing created with black permanent markers.
- Watercolor paints can be very colorful when children identify and paint in the negative spaces in shape drawings created with oil pastels or crayons. (See Unit 1 Lesson 7 Extensions)

Assessment

Assessment is based on a scale of 0–4.
4 All objectives are met, work is done with care, and represents a child's best work.
3 Some objectives are met; not the child's best work.
2 Child struggled to grasp the concept; few objectives have been met.
1 Child did not grasp the concept, no objectives met, work is incomplete.
0 Child absent.

Teaching Tips

Use One Color Practicing brushstroke techniques with one color places the beginning emphasis on the stroke rather than on the color options.

Dotting The act of dotting encourages children to use the strength of their upper body and to practice additional hand-holds.

Papers Watercolor paper is preferable, but the lesson can be done with heavy-weight drawing paper.

Watercolor Paper Watercolor paper is heavier and has "tooth," which means it is slightly textured and holds and grips the paint in unique ways. Working on watercolor paper extends children's understanding of the properties and potential of paper.

Small Sponge This allows children to wet the paper more efficiently.

Water Dish One for each child can eliminate distractions, and give each child control over supplies.

Lesson Resources

Music CD (Davis)
davisart.com

Lesson 8 *Serendipity* **23**

Unit 2 Opener

One Subject, Many Media

All kindergarten children and teachers have had encounters with insects. Insects are varied, but all have the same basic structure, providing an engaging subject for study and expression. When children work with one concept but change the materials, they have the opportunity to deepen their understanding and to practice a variety of fine motor, spatial, construction, and cognitive skills.

Lessons in this unit:

Lesson 1 **Inventing Insects: Painting One Shape at a Time**
Lesson 2 **Looking Carefully: Drawing Insects**
Lesson 3 **Arranging Shapes: Constructing with Cut Paper**

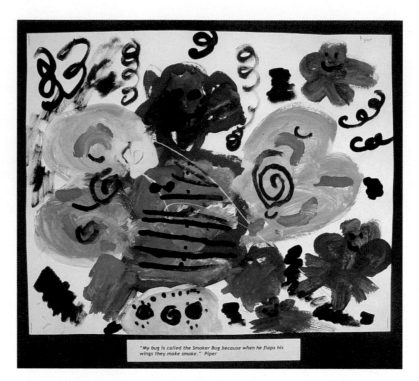

"My bug is called the Smoker Bug because when he flaps his wings they make smoke." Piper

Delightful paintings grow from this lesson. Keeping one brush to a jar and passing the paint helps keep the colors vibrant. Children often invent stories to go along with their creations. Displaying the children's words along with their work is a window into the way they create.

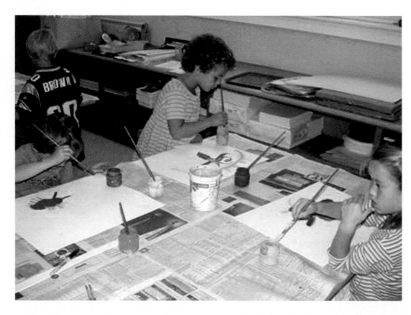

Using shape-making and brushstroke skills, students learn to work within the structure of an insect. Here they begin with one color, and invent the head, thorax and abdomen of a new kind of insect one shape at a time.

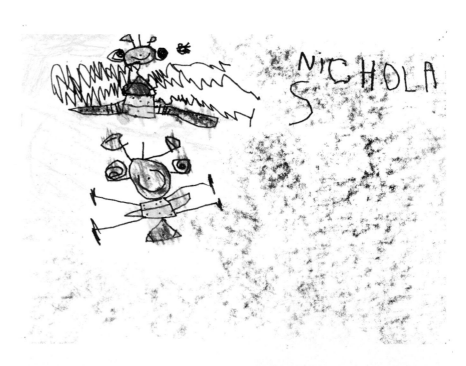

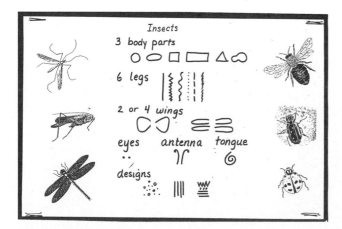

This chart lists insects' key features. At the conclusion of a drawing lesson, consider sending this chart home with the children so that they can continue exploring with their families.

Choosing lines and shapes to represent three body parts, six legs and other insect features helps even the most reluctant drawer make the leap into representational drawing. Children hone their crayon skills as they add color

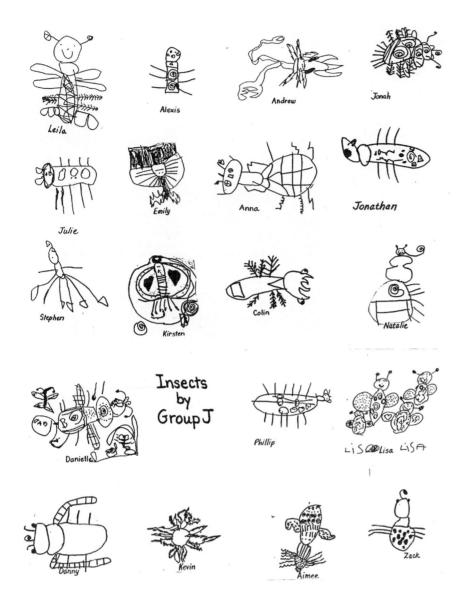

Gluing techniques are formally introduced in this unit

Drawings created with a fine-line black marker are easy to photocopy. They can be enlarged or reduced in size and used to enliven mailings and cards.

It was eating with its mouth.

A classroom teacher, inspired by the gift of a live cricket and the children's invented insects, encouraged her class to make observational drawings.

Any scraps of paper or found materials can be used to construct insects. Just follow the insect structure.

Inventing Insects
Painting One Shape at a Time

PREPARE

Objectives
When inventing insects with paint children will:
- invent a new species of insect based on insect characteristics: 3 body parts, 6 legs, 2 or 4 wings, antennae, proboscis, etc.
- review and apply strategies for using a paintbrush
- practice painting shapes using the blob and outline methods

Materials
- 3/8" (1 cm) paintbrush
- 18" x 24" (46 x 61 cm) white paper, trimmed to 17" x 23" (43 x 58 cm)
- Jars of primary colors of tempera paint, plus a few new colors; especially tints such as light blue, pink
- Jars of black paint (in reserve)
- Detail paintbrushes (in reserve)

Setup
- Cover tables with newspaper. Tape the paper down with masking tape if possible. Have extra newspaper handy for placing over any spills.
- One piece of white paper, one paintbrush, and one jar of paint, about half full, per child.

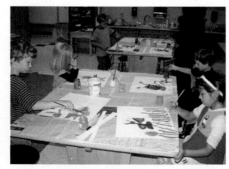

"I made the brain. This is the brain part. All insects need brains." "I made the tongue and the antennae." "Mine's symmetrical."

Vocabulary

English	Spanish
Insect parts:	parte del insecto:
head	cabeza
thorax	tórax
abdomen	abdomen
antennae	antena
proboscis	probóscide
wings	alas
legs	patas
markings	marcas
exoskeleton	exosqueleto
life cycle	ciclo de vida

National Standards
1a, 1c, 1d, 2a, 2c, 3a, 3b, 5b, 6a, 6b
See pages 100–101 for a complete list of the National Standards.

UNIT 2 LESSON 1

Inventing Insects

There are many kinds of insects.
What insects have you seen?
Name the insect parts in these pictures.

Mosquito.

Honeybee. *Above:* Stag beetle.

Eric Carle, illustration © 1990. Painted paper.

24

TEACH

Engage
1 Artists find their subjects by looking at and listening to the world around them. You may have noticed and had some experiences with insects such as ants, ladybugs, bees, mosquitoes, crickets.

2 **Ask: What do you know about insects?** What do you wonder about insects? Have you ever seen insects like the ones pictured here?

Explore
1 Even though there are many types of insects, they all have certain characteristics in common. **Identify and name the three body parts;** head, thorax, abdomen.

2 Identify six legs, two or four wings, antennae, proboscis, and eyes. This is a trick question: Is a spider an insect? Why or why not? (*Answer: a spider is not an insect because it has eight legs, not six; it is an arachnid*)

Now that you know the parts of an insect, let's invent our own species of insect!

Create Part 1
1 **Demonstrate** making the three body parts. Demonstrate multiple options for shapes and sizes. Use at least one free-form shape and ask for suggestions for other shapes. Demonstrate moving to a new color when the music stops. Review wiping the brush.

2 What comes next? Wings! Two or four? Remember that we're inventing as we go, building our insect one part at a time. We don't know what it will look like when we're done. We are having a conversation with the paint. Remind the children to respond to what the paint does. Remember, when the music stops, put your paintbrush in the jar and pass your jar of paint to another child at the table. Remind children to begin with the three body parts. What shapes will they use?

3 Once you see that most of the students have nearly finished painting the wings, or that some children's papers are getting full, stop the class. Let children know that you will give them another minute to finish with their color.

4 Ask students to look at their paintings to see if there are three body parts and two or four wings, because soon you will be giving out the black paint and the detail brush.

Painting One Shape at a Time

Invent an insect.

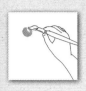

1 Start with one shape for the head. Will you use the outline or the blob method?

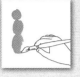

2 Add shapes for the thorax and abdomen.

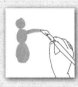

3 Will your insect have 2 or 4 wings?

Check Your Insect

Does your insect have:

3 body parts?

6 legs?

2 or 4 Wings?

eyes, antennae, and proboscis?

Unit 2 One Subject, Many Media **25**

Focus children's attention on the photos of insects. Look again at the antennae, proboscis, six legs, eyes, and markings on the insects. Remind them that the legs attach to the thorax of the insect. But don't insist on it: The art studio is a place of freedom and expression.

Part 2

1 **Introduce the tiny detail brush** and black paint. Paint a detail or two on your example. Caution children to use the black very carefully for accents and details that they might have missed. Model working very carefully so as not to smear the very wet paint.

2 If children finish early they can invent a second insect, possibly a father, mother, etc.

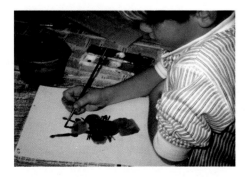

Variations/Extensions

- Children can add an environment for their insects, such as a hive or grass.
- Use dry tempera cakes instead of liquid tempera paint.
- Children who finish early can use found or natural materials to construct an insect.

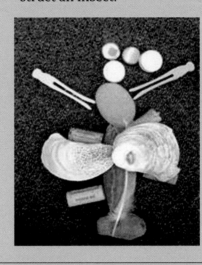

Lesson Resources

Children's Trade Books
The Very Quiet Cricket by Eric Carle (Philomel, 1990)

Other Resources
Insect Guides

"My bug is called the smoker bug because when he flaps his wings, they make smoke."

"It has an orange abdomen."

Teaching Tips

Differences are OK Be aware that children work at different speeds and with different amounts of control, and that's okay.

Insect Song A good way to help children remember the insect parts is to make up an insect song to the tune of "head, shoulders, knees and toes." Substitute "head, thorax, abdomen."

Add New Colors In addition to the primaries, add one or two new colors such as pink, light blue or light green.

Music Play music while students are painting, since it is now a classroom routine and signal from earlier lessons. When the music stops, they should stop painting.

Collect Paint When children are ready for the detail brush and black paint, collect jars of paint so that children don't get their papers so full that they just smear the whole thing. If this happens, just accept that paint is very inviting.

Record Comments As children carry on a dialogue with paint, they often develop stories about their work. Have a paper and pen or marker handy to collect children's quotes.

UNIT 2 ONE SUBJECT, MANY MEDIA

LESSON 2 Looking Carefully
Drawing Insects

PREPARE

Objectives
While drawing insects children will:
- use insect characteristics as inspiration for beginning a drawing.
- use a new tool to demonstrate growing awareness of insect parts.
- learn the proper use and care of the "thinking pen" (fine-line marker with cap left on).
- practice crayon techniques: using the tip versus the side of the crayon, blending colors, paying attention to pressure.
- revisit insects and share new observations of their parts in more detail.

Materials
- Black fineline markers
- 8 ½" x 11" (22 x 28 cm) white drawing paper
- Crayons, some unwrapped
- Materials for children to study and use as a reference:
 - photos of insects
 - photocopies of scientific drawings of insects
 - insect models
 - specimens

Setup
- Models or illustrations on the table for children to reference.
- Fine-line marker and white paper for each child.
- Crayons in reserve for later part of lesson.

Vocabulary

English	Spanish
"Thinking Pens"	marcadores de punta muy fina
draw	dibujar
detail	detalle
black	negro
shape	forma
line	línea
color	color
press	presionar
pressure	presión

National Standards
1a, 1b, 1c, 1d, 2b, 2c, 3a, 3b, 5a, 5c, 6b
See pages 100–101 for a complete list of the National Standards.

Looking Carefully

Scientists and artists look closely at insects.
Tell what you see in these drawings.
What parts of the insect can you name?

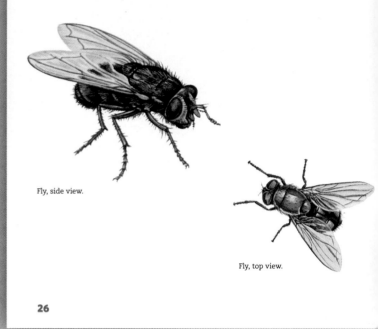

Fly, side view.

Fly, top view.

26

TEACH

Engage
1. Hold up paintings from the previous lesson and make a positive comment about each child's work as a way to review insect parts, shapes, lines, etc. You may also ask the children themselves to make positive comments.
2. Direct children's attention to the scientific drawings and **collect their observations**. Guide them to review insect parts. Ask: What do you notice?

Explore
1. **Introduce the fineline or felt-tip marker.** Show children the pen and point out its parts. It gets its name from the fine line that you can draw with it, and its pointed felt tip.

 Before markers were invented, you had to dip a pen into ink; now ink is inside the marker. Many people call this a "thinking pen" because you can use it with the cap on to plan your composition.
2. Before artists draw something as complicated as an insect, they do research. We are going to use our eyes to take a closer look at insects.
3. Have the children **look at an insect** and find something interesting. Encourage them to share their observations.

Create Part 1
1. Tell children they are going to use their thinking pens to **draw a scientific drawing or invent a new kind of insect**. Demonstrate making a plan for your insect using your capped "thinking pen." You do this to demonstrate different shape possibilities for insect parts, planning the size and spacing. Explain that this allows the artist to ease into drawing before making a mark.
2. Remind children that their insect must have:
- head, thorax, abdomen
- antennae
- two or four wings
- proboscis (tongue)
- six legs
- eyes
3. Emphasize that fineline markers are for fine lines. We are practicing **using the marker**, not for coloring in, but **for detail**. Let the children know they will be able to add color with crayons. Emphasize that they don't have to press hard on the markers! Remind them: we're inventing as we go, adding the different parts, so we don't know what it will look like until

Drawing Insects

Use a marker to draw your insect.

 1 Look carefully.

 2 Plan your insect. What shapes could you use?

 3 Draw.

 4 Add color with crayons.

Check Your Insect

Does your insect have:

3 body parts?

6 legs?

Wings? 2 or 4?

eyes, antennae, and proboscis?

Unit 2 One Subject, Many Media **27**

we're finished. If children finish drawing quickly they may want to draw another insect—maybe a family member or friend of their insect.

Part 2

1 Demonstrate crayon techniques:
- Using the tip to add a bright spot of color or color in small places
- Pressing hard, soft
- Rubbing: emphasize the use of rubbings to fill white spaces
- Blending colors
Tell children to practice techniques on the back of their paper before adding color to their drawing.

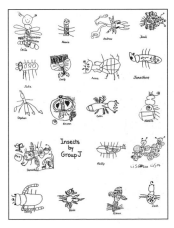

Variations/Extensions

- Use Sharpie permanent markers and add color with watercolor paint.
- Children can make a set of insect cards by drawing insects on small pieces of paper.
- Once children have invented an insect, they are ready to study actual insects in greater detail. Encourage them to do research in books and on the Internet.

Assessment

Assessment is based on a scale of 0–4

4 All objectives are met, work is done with care, and is a child's best work.

3 Some objectives are met, not the child's best work.

2 Child struggled to grasp the concept; hardly any objectives have been met.

1 Child did not grasp the concept, no objectives met, work incomplete

0 Child absent.

Art Careers

Explain to children that scientific drawing is an art career. Careful drawings of insects, animals, and humans are used in textbooks, charts, and posters.

Teaching Tips

Springboard Lesson This lesson can be a springboard into representational drawing for many children. Think of it as information-gathering that will fuel inventive drawings. Don't expect detailed drawings so early in the year.

Make It Fun Ask questions like "What crazy shape could I use for the thorax? What weird line could I use to make legs or antennae?"

Insect Chart Send home a chart like the one below for families to use together.

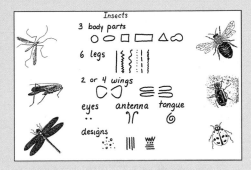

Encourage Complexity Remind children about the specific insect parts. Adding more parts is a way to help children take their drawing further, adding more complexity.

Mistakes Are OK! Tell children that they will make mistakes, and that's okay. Mistakes are a surprise, a way of saying to yourself, "Hey, self, have you thought about this?! Hey, self, I have an idea!"

Lesson Resources

Children's Trade Books
Brilliant Bees by Linda Glaser (Millbrook, 2003)

Other Resources
Music CD (Davis)
davisart.com

UNIT 2 ONE SUBJECT, MANY MEDIA
LESSON 3 Arranging Shapes
Constructing with Cut Paper

Arranging Shapes

Artists arrange shapes carefully.
What insect parts can you see?
How are the parts arranged?

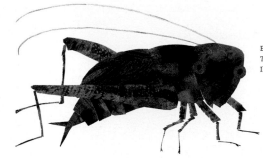

Eric Carle, from
The Very Quiet Cricket.
Illustration © 1990.

Eric Carle, from *The Very Quiet Cricket.*
Illustration © 1990.

Eric Carle, from *The Very Quiet Cricket.*
Illustration © 1990.

28

PREPARE

Objectives
While constructing insects children will:
- review and expand upon insect characteristics and structure.
- make thoughtful and aesthetic decisions about the placement of their shapes.
- learn gluing techniques.
- learn beginning techniques of making three-dimensional parts with paper strips.

Materials
- Scissors
- 4" x 6" (10 x 15 cm) pieces of colored construction paper, four per child
- 9" x 12" (23 x 30 cm) pieces of contrasting construction paper for background (in reserve)
- Glue bottles (in reserve)

Setup
- An array of colors of paper in the middle of each table.
- Cover tables with paper.
- Glue, background paper, paper strips, and scissors in reserve.
- Before the lesson, open glue bottles to see if they're working.

Vocabulary

English	Spanish
arranging	arreglar
composition	composición
glue	pegamento
dot	punto
line	línea
three-dimensional	tridimensional
rolling	enrollar
folding	plegando
tab	lengüeta

National Standards
1a, 1b, 1c, 1d, 2b, 2c, 3a, 3b, 5a, 5b
See pages 100–101 for a complete list of the National Standards.

Demonstrate trying many arrangements.

TEACH

Engage
1 Explain that Eric Carle created these illustrations using collage techniques. **Look specifically for and discuss:**
- Three body parts: head, thorax, abdomen
- How are the body parts different in shape and size?
- What do you notice about the legs?
- Where are the wings of these insects?
- Which insects have 2 wings and which have 4?

Explore
1 **Demonstrate choosing three pieces of paper** to begin your insect. Demonstrate cutting head, thorax, and abdomen; leaving shapes large.

2 Show how to cut corners off one square or rectangle to make a large, rounded shape. Demonstrate the process of trying multiple arrangements of body parts before gluing.

3 **Demonstrate gluing.** Show children how glue bottles work. Remind children that when they are gluing, the nose or tip of the bottle should almost touch the paper. Explain that children should glue body shapes—the largest shapes—first.

Create Part 1
1 Explain that glue will spread when you push down on any shape.

To glue a big shape:
- Touch the tip of the glue bottle gently to the paper. Squeeze a thin line of glue just inside the shape. The glue will spread, so don't go too close to the edge!
- Or, squeeze small dots of glue all over the shape.

- Stand the glue bottle back up so it can fill again with air.
- Turn your shape over and place it on your paper. Press and smooth the shape with your hands so that it will lie flat.

Constructing with Cut Paper

1 Cut big shapes for the three body parts.

2 Try many arrangements.

3 Glue your shapes.

4 Use scraps for cut-paper details.

Paper Sculpture Techniques

Cutting two shapes the same.

Making tabs.

Positioning.

Unit 2 One Subject, Many Media **29**

Variations/Extensions

- Children could construct insects using scraps of leftover paper.
- Distributing glue in small containers with paste brushes or Q-tips is an alternative to using glue bottles. Remind children to wipe their brushes.

Assessment

Assessment is based on a scale of 0–4

4 All objectives are met, work is done with care, and is a child's best work.

3 Some objectives are met, not the child's best work.

2 Child struggled to grasp the concept; hardly any objectives have been met.

1 Child did not grasp the concept, no objectives met, work incomplete

0 Child absent.

Teaching Tips

Aesthetic Choices Demonstrations should show the aesthetic choices involved in each step of the creative process. Each of these choices, from choosing colors to positioning wings, increases a child's sense of what it means to be an artist.

Keep Glue Low When gluing, have children touch the tip of the glue bottle to the shape. This will prevent them from holding their glue bottle far above the paper they are gluing.

3-D Parts When gluing three-dimensional parts, have children press down, hold, and count to ten.

About the Artist

"When I was a small boy, my father would take me on walks across meadows and through woods. He would lift a stone or peel back the bark of a tree and show me the living things that scurried about. He'd tell me about the life cycles of this or that small creature and then he would carefully put the little creature back into its home. I think in my books I honor my father by writing about small living things. And in a way I recapture those happy times."—Eric Carle

Lesson Resources

Children's Trade Books
The Very Clumsy Click Beetle by Eric Carle (Philomel, 1999)
The Grouchy Ladybug by Eric Carle (HarperTrophy, 1996)

Other Resources
Music CD (Davis)
davisart.com

2 Demonstrate ways to use small paper scraps as eyes or designs.

To glue a small shape:

- Draw a thin line or a small dot of glue on your paper in the place where you want to put your shape.
- Lay your shape on top of the glue and press down with your finger.
 Emphasize that only a small amount of glue is necessary. Glue is very strong!

3 Remind children that they will be arranging first, before they glue. You'll know they are ready for glue when their hand is raised.

Part 2

1 Stop the children when most have three shapes glued. Demonstrate ways to make wings three-dimensional. Refer to the directions in the Big Book.

2 Show the children how to try different ways of positioning the wings, before gluing.

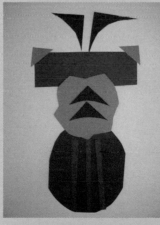

Unit 3 Opener

Transformation

Like Unit 2, this unit also builds from a framework. Starting with the framework of the face, children begin creating the head of a character—one facial feature at a time. Unlike the insect unit, subsequent lessons add additional frameworks—body parts, articles of clothing and accessories. In the process of creating, children revisit their work and add to it. Objects are transformed, and children are introduced to symbolic thinking. They begin to see that one shape or object can stand for another.

Lessons in this unit:

Lesson 1 **Seeing Faces: Collage with Found Materials**
Lesson 2 **Seeing Textures: Crayon Texture Rubbing**
Lesson 3 **Thinking About Clothing: Design Shirts, Skirts, and Pants**
Lesson 4 **Reflecting on Characters: Adding Details and Drawing**

Start noticing and collecting materials for this project as soon as possible. Children and parents enjoy hunting for treasures together, so consider sending home a list of materials to collect at the beginning of the year. (See "Supplies: Found Materials" in the Reference section of this book)

Collecting found materials is a joyful and fascinating way of seeing as an artist, and being alive in the world. It also makes us aware of all the potential materials for expression that we throw away every day! *Mirror 1* by Matthew Leighton, 1997. Frame, bottle caps, 4' x 3'. Courtesy of the artist's family.

After identifying the features of the head and face, this unit involves playing with possibilities. Any shape can be a nose or mouth or eye or ear—it's all a matter of placement. Drawing can help children revisit their work and begin drawing people. As Zach says, "It looks like a real person."

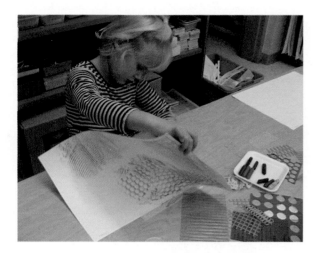

Crayons become tools for rubbing textures and patterning paper to use for clothing.

Children are motivated by interesting papers. As they work on their characters, they also apply cutting, arranging and gluing skills to solve problems.

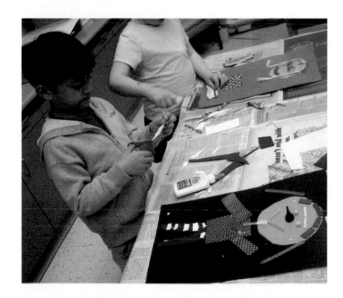

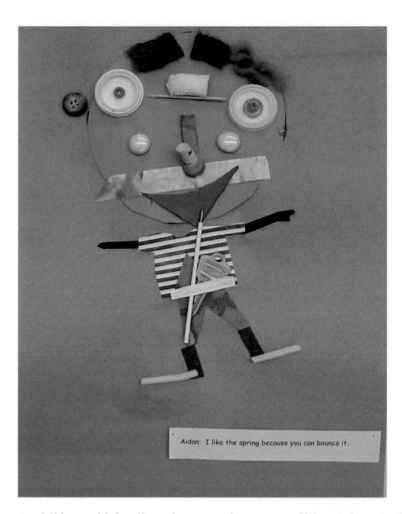

Aidan: I like the spring because you can bounce it.

As children add details and accessories, personalities and stories begin to develop. The smallest material or bead suddenly becomes something precious. The child who created this collage said, "I like the spring because you can bounce it."

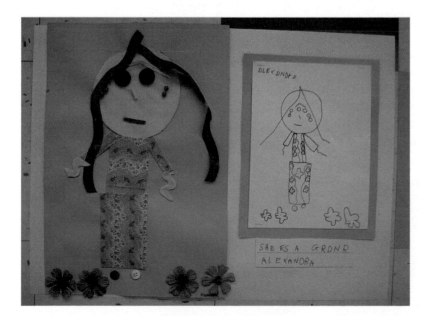

"She is a gardener." Observational drawings of characters are surprisingly easy for children to do if they start with the shape of the head. Some children are motivated to write about their characters using invented spelling.

Sometimes other kinds of characters develop, to the delight of the children.

UNIT 3 TRANSFORMATION

LESSON 1 Seeing Faces
Collage with Found Materials

PREPARE

Objectives
As children look through found materials and choose objects to represent facial features they will:
- study the parts of the head and face.
- see the transformative potential of objects.
- practice arranging, designing, and constructing a face with found objects.
- recognize emotions and invent personalities.
- review and practice techniques for using scissors.
- review and practice techniques for using glue.

Materials
- Small, light items with one flat side that can be easily attached by gluing, in boxes for easy access. Nothing sharp or splintery!
- Objects, such as thick rubber bands, rickrack, lace, or ribbons, that can be cut into small pieces and shared.
- Collections of materials that can be used for hair or features with hair (yarn, feathers, small sticks, wood chips)
- 12" x 18" (30 x 46 cm) construction paper, 1 per child (in reserve)
- 6" x 6" (15 x 15 cm) squares with corners marked off for cutting, for the face, 1 per child
- Scissors, 1 pair per child
- White glue, 1 bottle per child

Setup
- Scissors and paper squares on tables only. Once cutting is finished, put out boxes of collage materials (for making facial features) in the center of the table.
- Collections of materials for hair or features with hair can be displayed at a separate table for children to visit once their features are in place.
- Before the lesson, open glue bottles to see if they are working.

Vocabulary

English	Spanish
transform	transformar
facial features	rasgos faciales
hairline	línea de nacimiento del cabello
forehead	frente
eyebrows	cejar
eyelids	párpados
eyelashes	pestañas
nose	nariz
cheeks	mejillas
lips	labios
smile	sonrisa
chin	menton

National Standards
1a, 1b, 1c, 2a, 2b, 2c, 3a, 3b, 5b, 5c
See pages 100–101 for a complete list of the National Standards.

UNIT 3 LESSON 1

Seeing Faces
Faces can show feelings.
What feelings can you read in these faces?

Matthew Leighton, *The Watcher*, 1995. Found objects.

Nan Fleming, *Senior*, 2003. Welded recycled metal, acrylic paint, marbles.

30

TEACH

Engage
1 Draw children's attention to the artwork in the Big Book, especially the faces. **Ask: What do you see?** Explain that collage is putting together many different materials to make a composition. You use your imagination to decide how the materials will go together. We are going to practice inventing a character.

2 **Brainstorm facial features**. Make a list to refer to during the lesson. Ask children to close their eyes so they can feel the texture and placement of their facial features. Have them start with the top of the head and move to hairline, forehead, eyebrows, eyelids, eyelashes, nose, cheeks, lips, smile and teeth, chin.

Explore
1 **Demonstrate choosing a color of paper** and cutting off the corners to make a head shape.

2 Choose two objects that are the same for the eyes. (This is a task in itself; demonstrate choosing several pairs of like objects and placing them on your head shape.) Demonstrate that placement matters: show children placements that are high/low, close/far apart, etc. Discuss how the character's expression changes as you move objects around.

3 **Demonstrate taking all the objects off** and trying them a new way. You are modeling how to test possibilities.

Explore

Collage with Found Materials

Use objects to design a character's face.

1 Make a face shape.

2 Choose objects for features.

3 Arrange the objects. What expressions can you make? Choose your favorite.

4 Glue the objects down.

Create

1 After children have **tried their features a few different ways**, they are ready to glue. Show children how glue bottles work. Set expectations for the number of features they need to include. Refer to your list of facial features.

2 Demonstrate gluing using dots and lines.

3 Demonstrate attaching the head to **the top** of the large construction paper, leaving room for hair. Suggest other facial and head features such as a moustache, hair, earrings, hat, etc. to add. Emphasize to children: Don't start on the body.

Variations/Extensions

- Children can draw the face in the order they constructed it. They can practice with the "thinking pen" to get the shape and size of the face. Because they chose and arranged the parts of their faces, they will know in their hands and their minds how to draw the shapes of the parts.
- Set aside a container of materials in a separate part of the classroom for use by children who finish early. The parts can be used as the basis for a "face game" or in many other ways.
- These same directions work for making a puppet or mask.
- This lesson can also be taught using just leftover cut and torn shapes from earlier lessons.

About the Artwork

"A tractor part suggested legs and movement. Another part suggested a bent 'senior.' I added the cane for balance. . . . The 'shoes' added to the upbeat feel of this figure."
—Nan Fleming

Assessment

Assessment is based on a scale of 0–4.
4 All objectives are met, work is done with care, and represents a child's best work.
3 Some objectives are met; not the child's best work.
2 Child struggled to grasp the concept; few objectives have been met.
1 Child did not grasp the concept, no objectives met, work is incomplete.
0 Child absent.

About the Artist

Matthew Leighton found exciting ways to combine his love of art with his commitment to recycling and to social action.

Teaching Tips

Cutting Guidelines Draw a curved line on the corners of the square paper for the faces, so the children have guidelines for cutting. If there are no guidelines, the children often keep cutting until the paper is too small to hold any objects.

Facial Features As in the insect lessons, children should have a set of facial features to use as a reference. Requiring a certain number of features, such as 7, offers an exciting challenge.

Allow Thinking Time Looking through the found materials and trying out ideas can take longer than you think! Symbolic thinking takes time.

Glue Gun Have a glue gun handy for anything that may be difficult to glue.

Mirror You may want to give students a mirror so they can reference their own faces.

Sharing Ideas It is fun for children to be asked to identify an object that they transformed into a facial feature.

A Powerful Lesson This first observational drawing can be transforming. It can help reluctant drawers to realize they really can draw a person.

Lesson Resources

Children's Trade Books
Go Away, Big Green Monster by Ed Emberley (L,B Kids, 1993)

Other Resources
Music CD (Davis)
davisart.com

Seeing Textures
Crayon Texture Rubbing

Seeing Textures

Texture is the way something feels. How would these textures feel if you touched them?

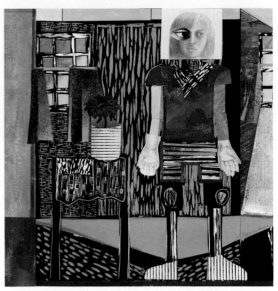

Julie Lapping Rivera, *Still Life with Figure*, 2004–05. Collage with printed and painted papers.

32

PREPARE

Objectives

While exploring the process of texture rubbing, children will:

- use their sense of touch to gain a deeper awareness of texture.
- learn a technique for creating their own textures.
- review and practice techniques for using crayons.
- engage upper body muscles.
- understand rubbing as a way to record textures.
- discuss texture discoveries using descriptive language (bumpy, rough, etc.).
- experience their own ability to change a surface.

Materials

- 9" x 12" (23 x 30 cm) or 12" x 18" (30 x 46 cm) white drawing paper
- Unwrapped crayons
- Flat objects for rubbing (see below)
- Tape
- Markers (in reserve for part 2)

Setup

- It can be helpful to tape the top of the white paper to the table. This allows children to have more control positioning objects for texture underneath.

Vocabulary

English	Spanish
texture	textura
rubbing	frontando
holding hand	mano que sostiene
rubbing hand	mano con la que se frota
overlapping	solapado
design	diseño
pressure	presión
pattern	patrón

National Standards

1a, 1b, 1c, 2c

See pages 100–101 for a complete list of the National Standards.

TEACH

Engage

1 Hold up a few of the faces the children made in the previous lesson. **Engage the children in looking at their work.** Explain that over the next few classes we will design clothing for our characters. We are going to create paper 'material' to use for our clothing. We are going to explore textures of objects as we do this. Texture is the way something feels—its smoothness or roughness.

2 Have children touch their own hair. Ask: How does it feel? Listen for a variety of descriptive words. Then ask children to touch their cheeks, clothing, the floor, bottom of their shoe, and so on.

3 **Look at and discuss the textures shown** in the Big Book image. Which textures come from nature? Which have been made by people? How would each texture feel? Ask: Why do you think the artist used so many different textures?

Explore

1 **Choose an object for a rubbing**, and demonstrate feeling the object. Show children how to place the object under their paper, and feel its outline there. Show them how they should hold the paper steady with their other hand.

2 Demonstrate how to hold the unwrapped crayon. Explain that they should use the side only!

3 **Show how to rub the crayon over the paper.** This sounds easy, but it really requires upper body strength and it helps if the children stand up.

Flat objects for rubbing.

Crayon Texture Rubbing

Create textured papers for collage characters.

1 Place the object under your paper. Feel the outline. Hold the paper.

2 Use the side of the crayon. Rub the crayon over the whole shape.

3 Move the shape. Rub it again.

4 Overlap textures. Try other colors.

Unit 3 Transformation **33**

Variations/Extensions

- Leaf rubbings are a great way to study the linear structure and symmetry of leaves. If you plan to do this, it helps to gather the leaves the day before and press them in a book.
- Try rubbing the bottoms of shoes!

Assessment

Assessment is based on a scale of 0–4.
4 All objectives are met, work is done with care, and represents a child's best work.
3 Some objectives are met; not the child's best work.
2 Child struggled to grasp the concept; few objectives have been met.
1 Child did not grasp the concept, no objectives met, work is incomplete.
0 Child absent.

About the Artist

Julie Lapping Rivera usually begins "by establishing the architecture of the image. I think of it as a stage first; then introduce the actors and scenery." She moves elements around "to achieve a balance of textures, colors and values, shapes and . . . movement."

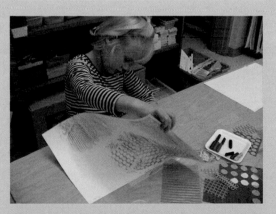

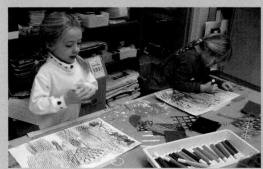

Teaching Tips

Use Dark Colors Dark-colored crayons work best.

Use Both Sides Children can use both sides of the paper.

Share Objects If there's time, children can share objects between tables.

Upper Body Strength This experience can be helpful for children who need to engage their upper body muscles.

Lesson Resources

Children's Trade Books
Fish is Fish by Leo Lionni (Dragonfly, 1974)
Pelle's New Suit by Elsa Beskow (Floris, 1989)
Peter's Chair by Ezra Jack Keats (Viking, 1998)

Other Resources
Music CD (Davis)
davisart.com

Create **Part 1**

1 Remind children to rub the entire shape.
2 Have them move their object slightly and rub it again. Ask: What happens? Explain the concept of overlapping.
3 After children have rubbed the object a few times, they can switch objects. **Encourage them to cover the whole page**, right up to the edges.

Part 2

1 Share and discuss a few rubbings. Point out overlapping, designs, patterns, and shapes. Hand out markers for the children to use to color in small places. Encourage them to use each color more than once.

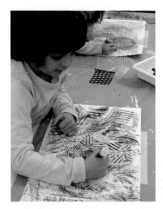

"I color coordinated mine. Color coordinating is when you put colors together that looks pretty."

Thinking About Clothing
Design Shirts, Skirts, and Pants

Thinking About Clothing

Artists play with materials to create clothing.

What kinds of clothing do you see here?
What unusual materials do you see?

Chris Roberts-Antieau, *Good with Scissors*, 2007. Fiber.

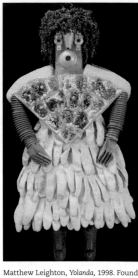

Matthew Leighton, *Yolanda*, 1998. Found objects.

34

PREPARE

Objectives

As children choose papers and create clothing they will:
- invent personalities.
- practice arranging, designing, and constructing individual pieces of clothing.
- develop a deeper understanding of clothing and clothing design.
- review and practice techniques for using scissors.
- review and practice techniques for using glue.

Materials
- Texture rubbings from previous lesson
- 4" x 6" (10 x 15 cm) decorative papers (Origami, wrapping, doilies, wallpaper, graph paper, lined paper, interesting papers from stores, construction paper)
- Scissors
- Glue (in reserve)

Setup
- Put children's collage faces, texture rubbings, and an assortment of papers in the middle of the table.
- Don't put glue or scissors out right away. Wait until the children are ready to use it.

Vocabulary

English	Spanish
personality	personalidad
character	personaje
clothing	vertimenta
shirt	camisa
pants	pantalones
skirt	falda
dress	vestido
leggings	calzas

National Standards
1a, 1b, 1c, 1d, 2a, 2b, 2c, 3a, 3b, 5c
See pages 100–101 for a complete list of the National Standards.

TEACH

Engage

1 **Focus on the art images in the Big Book**. Ask: What kinds of clothing can you see?

2 Revisit children's collage faces and discuss emerging personalities and characters. What objects did you transform when you made your collage face? Describe your character. (If an extra adult is available, have him or her record the words of each child.)

Explore

1 **Demonstrate cutting paper rubbings** to fit the size you need. Ask: If I wanted to make a shirt, how could I do it? (Accept all answers, but demonstrate the ways shown in the Big Book illustrations.)

2 Ask: How could I make a skirt or dress? How could I make pants? **Demonstrate arranging the paper pieces** you have cut.

3 Demonstrate looking through the papers and selecting two or three papers that look good with your rubbing design. These will be used as material for the clothing you are designing for your character.

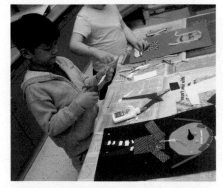

"I'm making American flag pajamas."

Design Shirts, Skirts, and Pants

Artists design fabric and create clothing. Use rubbings and other papers to make clothing for your collage character.

 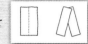 or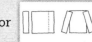

1 Make a shirt.

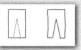 or

2 Make pants.

 3 Make a skirt.

Cutting Shapes

Cut two of the same shape:

 Cut two squares or rectangles.

 Put them on top of each other.

 Cut your shape.

Two ways to cut a curve:

 Turn the scissors as you cut.

 Turn the paper with your other hand.

Create Part 1

1 **Demonstrate gluing** a piece of clothing to your character. Review using a continuous line around the piece being glued, and an alternative method: using dots of glue.

2 After children have made their clothing, have them **start the gluing process** with the shirt or uppermost piece of clothing.

3 Let children tell you one piece of clothing that they will make before you dismiss them. Begin the next class by having children start making their pieces of clothing.

Part 2

1 Demonstrate noticing scrap pieces and seeing their potential as clothing additions (pockets, hat, belts . . .)

2 **Demonstrate how to cut two identical shapes**, such as two shoes, socks, hands, or ears: Cut two squares or rectangles and put them on top of each other. Then cut the shape.

Variations/Extensions

- Objects can carry strong associations for children. Because of a particular object and its associations, some children may want to make something besides a person. This is ok.

- This lesson can also be used to make puppets.

Assessment

Assessment is based on a scale of 0–4.

4 All objectives are met, work is done with care, and represents a child's best work.

3 Some objectives are met; not the child's best work.

2 Child struggled to grasp the concept; few objectives have been met.

1 Child did not grasp the concept, no objectives met, work is incomplete.

0 Child absent.

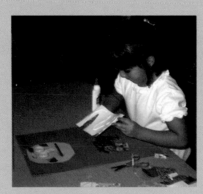

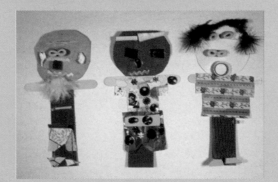

Teaching Tips

Seeing Anew Begin the class by holding up the faces the children made in the previous lesson. This allows them to step back from their work and see it from a new perspective.

Papers Decorative papers should be writing-free, with small designs. Letters are exciting, but they can be distracting and overwhelming; they take the focus away from the character.

Remove Extra Paper Once children have made their paper selections, remove all the extra papers.

Check Gluing Stop children a few minutes before the end of class and have them check to see that all pieces are glued down.

What Are You Wearing? Children may be influenced by their own clothes!

Lesson Resources

Children's Trade Books
Joseph Had a Little Overcoat by Simms Taback (Viking, 1999)
Where Does It Go? by Margaret Miller (Greenwillow, 1992)

Other Resources
Puppets and Masks by Nan Rump (Davis, 1995)
Music CD (Davis)
davisart.com

Reflecting on Characters
Adding Details and Drawing

Reflecting on Characters

Details are small things to notice.
Look at the picture on the right.
What details make the clothing more
interesting?

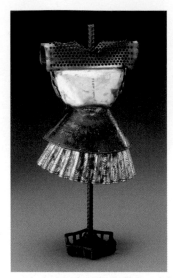 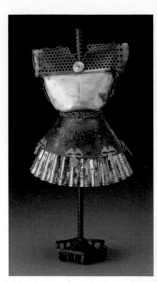

Nan Fleming, *Dressform*, 2005. Welded recycled metal, wire, wax.

36

PREPARE

Objectives
As children add accessories and draw,
they will:
- further develop the personalities
 and verbal descriptions of their
 characters.
- have an opportunity to reflect
 on their work and to enjoy their
 accomplishments.
- symbolically represent their character
 with lines and shapes.
- take pleasure in bringing a project to
 completion.

Materials
- Collage boxes
- Glue
- Scissors
- Fine-line markers
- White paper

Setup
- Put children's work and collage boxes
 on tables.
- Have white paper and fine-line mark-
 ers in reserve.

Vocabulary
English	Spanish
accessories	*accesorios*
character	*personaje*
personality	*personalidad*
story	*cuento*

National Standards
1a, 1b, 1c, 2a, 2b, 2c, 3a, 3b, 5c, 6b
See pages 100–101 for a complete list of
the National Standards.

TEACH

Engage
1 **Point out the artwork** in the Big Book. Ask: What
differences can you see between these two pictures?
(Notice the addition of the button onto the front of
the dress.) What do you think the artwork is made
of? (See About the Artwork, at right.)
2 **Revisit children's characters** and discuss their
emerging personalities.

Explore
1 Ask children to think about what accessories
they might want to add to their character.
Brainstorm a list of accessories, such as
earrings, pockets, a watch, jewelry, a belt,
glasses, shoelaces, bows, career accessories;
a briefcase, safety goggles, a hammer, a con-
struction hat, etc
2 Demonstrate looking through boxes, choosing
objects, arranging objects in multiple ways.
Review ways to glue.

Add Details and Draw

Details help show character and personality.
What details can you add?

1 Try different
arrangements.

2 Glue.

3 Draw your
finished
character.

Nan Fleming choosing details

Create

1 Encourage children to **think about what personality their character has:** What's his or her story?

2 After children have finished adding accessories and details, explain that they will draw their character using black fine-line markers. Emphasize their ability to draw their character by referencing their knowledge of the parts and process. The knowledge is in their minds and their hands.

3 Review how to use the thinking pen for planning and drawing. Emphasize size and placement of head shape near the top of the paper.

4 Suggest that children start drawing their character in the order they created it.

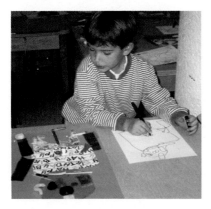

Variations/Extensions

- Have children create a friend for their character.
- Create fairies: imaginary characters from natural materials.
- Create characters from a story.
- Make a story or play using the characters or puppets your class created.
- Record students' comments about their character and the process. Often teachers elect to base a writing lesson on characters. Children can give their character a name and write about them using invented spelling.

"My clown likes to juggle and his name is Silly Guy."

Assessment

Assessment is based on a scale of 0–4.

4 All objectives are met, work is done with care, and represents a child's best work.

3 Some objectives are met; not the child's best work.

2 Child struggled to grasp the concept; few objectives have been met.

1 Child did not grasp the concept, no objectives met, work is incomplete.

0 Child absent.

Teaching Tips

New Materials Add a few new things to the collage materials boxes

Cutting Two Shapes Review the technique for cutting two shapes that are the same. It can be used for hands, feet, or shoes.

The Value of Drawing The act of constructing seems to give children both visual and tactile understanding of form. Once children build a structure, they seem quite comfortable trying to draw it. It is a great way to help children realize and become aware of their potential and ability. Even those children who are reluctant to draw are usually very proud of their newly-discovered skill. Having the students draw their finished product allows them to study their creation and reflect on why they made the decisions they did. This will allow them to revisit the same concept—the face, its features, and the human body—while switching media.

Plan First By sketching first with a closed marker, children train themselves to translate the relative sizes and shapes of their objects into the language of line. They also develop an intuitive understanding of how and where to place one object in relation to another. This is an important pre-reading writing-readiness skill.

Check Plans Ask children to demonstrate drawing the head shape for you, before they take the cap off of the marker. This allows you to spot potential problems before they occur.

About the Artwork

"The shape of the torso was suggested by a bent machine part combined with a textured cooking mold. A shapely dress form emerged. I usually do not begin welding (attaching) until I have the main elements figured out."—Nan Fleming

Lesson Resources

Music CD (Davis)
davisart.com

Unit 4 Opener

Exploring Clay

There is no other medium quite like clay for engaging children. The goal of this unit is to generate a feeling of wonder and appreciation for clay, a natural material that comes from the earth—that is earth. Working with clay helps develop children's arm, shoulder, hand and finger muscles. Group work, which is especially rewarding when working with clay, helps foster social and communications skills.

As you begin this unit, it is important to keep the children's focus on exploration rather than on making something to keep. Children will quickly sense your delight in the texture and malleability of clay. They will soon learn that clay is responsive and gives them immediate feedback. They will enjoy discovering that they have the power to change the shape of clay by using the simplest tools—their own hands.

Lessons in this unit:

Lesson 1 **Working as a Group: Clay Discoveries**
Lesson 2 **Creating Textures: Changing Clay Surfaces**
Lesson 3 **Textured Pottery: Making a Clay Plant Holder**
Lesson 4 **Sculpting in Relief: Clay People Plaques**

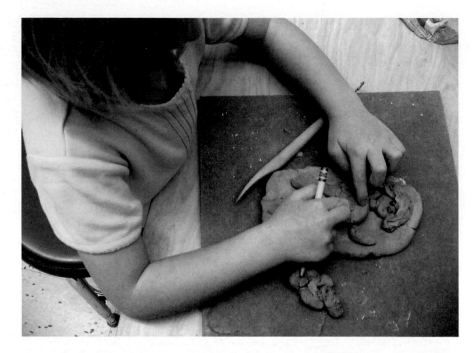

Making a self-portrait relief deepens children's understanding of parts of the human body.

Children share ideas and discoveries when they work as a group.

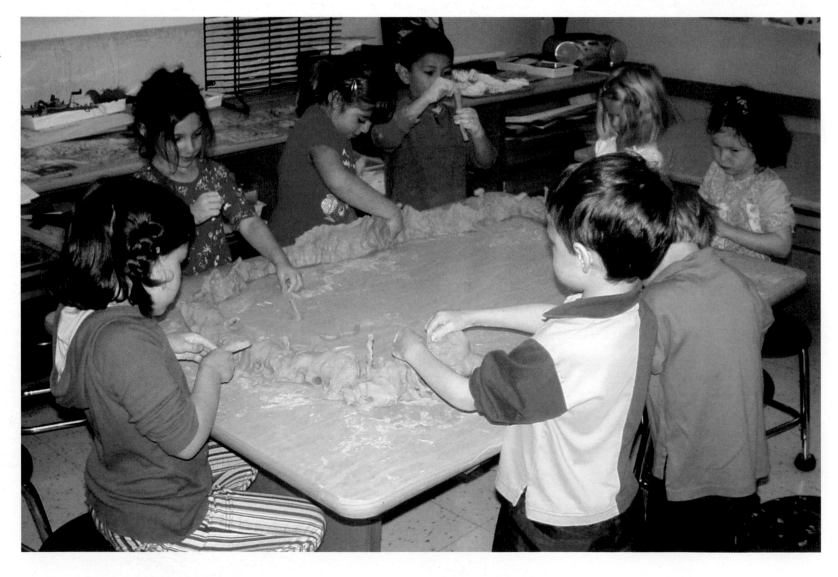

If clay sculptures are not going to be fired in a kiln, you can offer other materials—such as beads, toothpicks, and feathers—to embellish a basic structure.

If children close their eyes while they roll coils, they will feel variations in size and texture more effectively. Their hands will know just where to go and how hard they need to press.

Creating an "inventory" of balls and coils gives children a variety of sizes and shapes to work with.

UNIT 4 **EXPLORING CLAY**

LESSON 1 **Working as a Group**
Clay Discoveries

PREPARE

Objectives
While exploring clay as a group children will:
- discover different ways that their hands can change the shape and form of clay.
- learn about the properties and potential of clay by sharing ideas through social interactions.
- strengthen arm, shoulder, hand, and finger muscles.
- invent and use descriptive vocabulary to tell about their interactions with clay.
- learn to care for clay.
- use clay to express/reflect their understanding of three-dimensional forms.

Materials
- Low-fire clay, 50 lbs or more for a classroom of twenty children
- Small pans of water with less than a quarter inch (6 mm) of water (in reserve)
- Only hands—no tools!

Setup
- Place a continuous ring of clay around tables; *or*
- Place a large slab of clay in the middle of the table; *or*
- Ask children to roll or squeeze a grapefruit-sized ball of clay into a coil and attach it to their neighbor's clay.

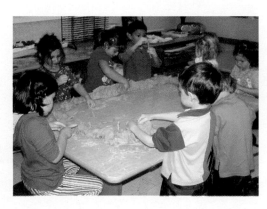

Vocabulary

English	Spanish
clay	*arcilla*
poke	*agujerear con el dedo*
pinch	*pellizear*
pull	*tirar*
in	*adentro*
out	*afuera*
through	*a través*

National Standards
1a, 1b, 1d, 2a, 2b, 2c, 3a, 3b, 4a, 4b, 4c, 5a, 5c, 6b
See pages 100–101 for a complete list of the National Standards.

UNIT 4 LESSON 1

Working as a Group
People have used clay for thousands of years.
How many things can you think of that are made from clay?

Margaret Courtney-Clarke, *Painted Kassena Dwelling.*

Photo by Diane Harr, 1973.

38

TEACH

Engage
1 As you ask questions, **manipulate the clay**, suggesting possibilities, pushing it back into a lump, and starting again. It is important that children see their teacher enjoying the feel of the clay as he or she explores it. Ask: Does anyone know what this is? Explain that natural clay is different from play dough, plasticene, and other manipulative materials.

2 After you work with the clay for a while, ask: Do you have any idea where clay comes from? **Clay comes from the earth.** It is made up of fine-grained particles of rock that are broken down over many years and then are mixed with water. The color of the clay depends on the rocks and minerals it is made of. Clay is usually found near water. Ask: Can you think of any things that are made from clay? Refer to the pictures in the Big Book, and note that flower pots, plates, bowls, cups, sculptures, bricks, and even houses are made of clay.

Explore
1 Invite children to share ideas about **how their hands and fingers can change the shape of the clay** as you work the clay in your hand. Listen for descriptive verbs.

2 **Demonstrate:**
- squeezing a tall shape with both hands.
- poking places that go in.
- poking places that go through, using different hand parts (fingers, knuckles, fist).
- pulling strong parts that go out.

Create
1 When working with clay, it is important to use all your arm and shoulder muscles. **Demonstrate using your whole hand**, not just your fingers. Demonstrate how engaging arm and shoulder muscles gives you the strength you need to work with the clay.

2 When you see that children have created something interesting, or that attention is waning, stop the children and ask them to go around the table and **share one discovery that they made about clay**. Or, ask them to tell what part of their hand they used to shape a particular part of the clay and what kind of

Clay Discoveries

How can you use your hands to change the shape of clay?

 1 Squeeze a tall shape.

 2 Poke in and through.

Make shallow spaces. Make deep spaces. Make holes that go all the way through.

 3 Pull strong shapes out.

 4 Use your arms and shoulders.

Using Water with Clay

Dip fingertips in water.

Squeeze or smooth water into the clay.

movement they used. This sharing time always gives children new ideas. Invite children to go back and try out one idea that interests them from the sharing session.

3 Demonstrate the use of water before offering it to the children. Water smoothes and remoistens the clay and enables you to slowly push 'ins' a little deeper and make 'outs' a little more dramatic. Explain the rules for using water:

- Dip fingertips in water and squeeze or smooth into the clay.
- Do not dump the water over the clay.
- Do not put the clay into the water.

4 To clean up, have children roll the clay back into a ball. Use the ball as a stamp to pick up little pieces of clay. Have children poke a deep hole into clay with a thumb. Explain that you will pour some water into the hole and close it up. The water will work itself into the clay so that it will be soft enough to use tomorrow.

5 Put the clay in an airtight container.

Variations/Extensions

- Changing places is an exciting way to extend a group clay exploration. Have children move to a different seat, such as two places to the right. Ask them to close their eyes and gently use their sense of touch to explore both the front and back of their classmates' work. When they are ready, they can slowly transform and build upon the clay shapes under their fingertips.
- Allow children to take a tour of the clay explorations before giving clean-up directions.
- Take a few pictures or invite children to draw their creations to save the memory of this experience.
- Leave a bin of clay in the classroom as a way to encourage exploration.
- You can also do this lesson individually. A clay board for each child provides a designated workspace.

Lesson Resources

Children's Trade Books

When Clay Sings by Byrd Baylor (Aladdin, 1987) I sometimes read excerpts from this book, which I think helps children appreciate the material they are about to use.

Other Resources

Children, Clay and Sculpture by Cathy Weisman Topal (Davis Publications, 1983)

Beginning Workshop: Art Experiences (Child Care Information Exchange, 1996)

I Am Clay video (http://www.k-play.com)

Music CD (Davis)

davisart.com

Assessment

Assessment is based on a scale of 0–4.
4 All objectives are met, work is done with care, and represents a child's best work.
3 Some objectives are met; not the child's best work.
2 Child struggled to grasp the concept; few objectives have been met.
1 Child did not grasp the concept, no objectives met, work is incomplete.
0 Child absent.

Teaching Tips

Keep it Calm Dimming the lights and playing music softly creates a soothing work environment.

Use Muscles Many children do not engage their arm and shoulder muscles while they work with clay or with other materials. It is actually many of these same muscles that are necessary for the development of writing skills in the future. Let children know that it is important for them to use these muscles, and that you will help them to see if they are using them by gently laying your hands on their shoulders. You'll be able to feel the movement and so will the children.

Hands Only! Hands are the only essential tools for this lesson. Refrain from giving out sticks and other implements which remove the hands from the clay and from the manipulative experience.

Record Words Record the descriptive words that children use and keep them as a reference. Descriptive words increase children's vocabularies and are a means of helping children revisit an experience.

Use Real Clay Clay is firmer than play dough. It can be built taller, encourages more intricate work, and holds its shape much better than play dough. Working with clay leads to very different and more in-depth experiences. But if clay is not available, working with play dough is a good introduction to using three-dimensional, malleable materials.

Letters When children roll coils, they naturally try to form letters.

Use Little Water Offering only a very small amount of water insures less mess.

Cleanup Rubber kitchen scrapers or spatulas can help remove clay bits from tables before washing. Children love to help scrape and wash.

PREPARE

Objectives

While using their hands and finger-tips to change the surface of the clay, children will:

- gain awareness of subtle ways they can use their fingers to manipulate clay.
- experiment with pressure, direction, proximity, and spacing.
- understand that *texture* describes the roughness or smoothness of a surface.
- be able to identify and use descriptive words to name different types of textures.

Materials

- clay balls, one per child, the size of a tennis ball
- clay boards

Vocabulary	
English	*Spanish*
texture	*textura*
coil	*espiral*
ball	*pelota*
rough	*áspero*
smooth	*suave*
bumpy	*disegual*

National Standards

1a, 1b, 1c, 2b, 2c, 3a, 3b

See pages 100–101 for a complete list of the National Standards.

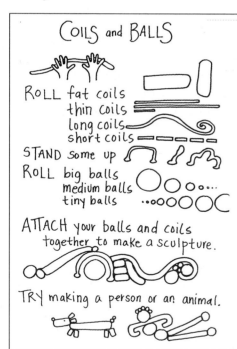

TEACH

Engage

1 Revisit the children's clay explorations from the previous lesson. **Review the concept of *texture*,** a word used to describe the roughness or smoothness of a surface. To create texture, a large portion of a surface must be covered with repeated impressions. You may want to refer to the texture rubbings children did in Unit 3.

2 Discuss the pictures of clay textures shown in the Big Book. Remind children: Fingers are the most important tool for changing the texture of a clay surface.

Explore

1 Demonstrate patting the clay into a large pancake and covering it with fingerprints. **Invite children's ideas for ways to make textures,** and demonstrate different textures made using just fingers.

2 Close your eyes and demonstrate feeling the surface of your clay. Explain that closing your eyes allows your fingers to feel the clay more effectively. Ask children to feel for differences and similarities between different parts of the clay. Ask: What does it feel like: bumpy or smooth?

UNIT 4 LESSON 2

Creating Textures

Where can you see textures?
Use your fingers to show how these textures were made.

Corey Salah, *The Green Monster*, 2002. Clay.

40

Changing Clay Surfaces

How can you use your hands to make textures in clay?

1 Push gently. Push hard.

2 Pinch. Repeat.

3 Use your knuckles.

4 Use your fist.

Clay Coils and Balls

Stand up to roll coils.

Roll fat coils, thin coils, long coils, and short coils.

Make some stand up.

Create Part 1

1 Have children turn their clay over and start again. Ask them to:
- Make some impressions close to one another but separate.
- Make some impressions that connect.
- Change the pressure that they use, to make shallow and deep impressions.
- Pull their fingers through the clay.
- Pinch a texture.
- Repeat one kind of impression over and over again.
- Change direction or the interval of their fingertips, and continue making impressions.

Part 2

1 **Remind children that they are just exploring.** Ask them to break the clay into pieces, and shape the pieces. Have them:
- roll coils.
- roll balls.
- put them together in a new way.

Variations/Extensions

- Use a big slab to collect children's coil and ball creations.
- Children can select a 4" (10 cm) square area of their most unusual texture and cut it out to become part of a classroom texture chart.
- Squeeze shapes are often suggestive of fantastic creatures. Reading books such as *Goodnight, Dear Monster* by Terry Nell Morris, and *Where the Wild Things Are* by Maurice Sendak, gives children ideas for parts of creatures to include. Children can add beads, toothpicks, feathers, and other found objects if you do not plan to fire the clay works.

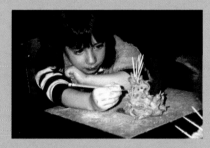

Assessment

Assessment is based on a scale of 0–4.
- **4** All objectives are met, work is done with care, and represents a child's best work.
- **3** Some objectives are met; not the child's best work.
- **2** Child struggled to grasp the concept; few objectives have been met.
- **1** Child did not grasp the concept, no objectives met, work is incomplete.
- **0** Child absent.

Teaching Tips

Only Practicing Sometimes it's hard to let go of creations. Remind children that they are practicing the skills they need for pottery and sculpture projects.

Coil Know-How Rolling coils is a skill to practice. Standing up and using the weight of your body makes rolling coils easier. Closing your eyes makes your fingers even more sensitive. It helps your fingers know just where they need to go and how hard they need to press. This can be an exciting whole-class exploration in itself.

Lesson Resources

Children's Trade Books
Goodnight, Dear Monster by Terry Nell Morris (Random House, 1980)
Where the Wild Things Are by Maurice Sendak (HarperCollins, 1988)

Other Resources
Music CD (Davis)
davisart.com

LESSON 3 **Textured Pottery**
Making Pocket Pottery

Textured Pottery

People use clay to make useful objects. Useful objects made from clay are called pottery.

Diane Harr, *Flower Pot*, 2005. Low-fire clay, glazed.

42

PREPARE

Objectives
While making a clay plant holder, children will:
- create a piece of pottery using the slab technique.
- learn a technique for joining two pieces of clay together.
- create texture and design using natural materials.

Materials
- Clay slab cut from a tube of clay, about the thickness of a finger, 5" x 5" (13 x 13 cm), 1 per child
- Golf-ball-sized ball of clay, 1 per child
- Paper towels, 1 per child, to crumple to support clay pocket
- Clay boards, 1 per child
- Natural materials to press into clay to create texture (small pine cones, wood, small shells, dried flowers, small sticks, and the like)

Setup
Set out one slab and one ball on each clay board.

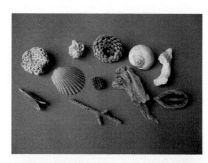

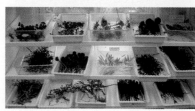

Vocabulary
English	Spanish
pottery	*cerámica*
kiln	*hornó*
slab	*losa*
border design	*diseño del borde*
central design	*diseño central*

National Standards
1a, 1c, 2a, 2c, 3a, 3b, 5a
See pages 100–101 for a complete list of the National Standards.

TEACH

Engage
1 **Introduce the word pottery:** useful objects such as bowls, vases, plates, and mugs that have been made from clay and fired in a hot oven called a kiln. Explain to children that clay can be functional (useful) as well as expressive (suggesting feelings or ideas).
2 Discuss the artwork shown in the Big Book. How do children think it was made?

Explore
1 **Demonstrate pressing a large slab** with your palm. Explain that if you stand up to press a slab, you can use the weight of your body to help you. This technique is also a quiet alternative to pounding.
2 Demonstrate pressing a smaller slab for the "pocket" of the plant holder. Explain that if you crumple a paper towel and place it on the large slab, it will support the smaller slab and keep it from collapsing.
3 Show children how to **attach two pieces of clay** to each other by pressing with their fingers. Explain that children are pressing in a "u" shape to join the slabs. Be sure the paper towel is not between the two slabs.

Create
1 Have children press a large slab using their palms. **Encourage them to stand** so they can use their body weight to flatten the clay.
2 Press a small slab for the "pocket." Crumple a paper towel to support the pocket. Carefully lay the small slab over the paper towel, making sure that the paper towel is not under the edges where the two slabs will be joined.
3 Attach the two slabs to each other by pressing with fingers.
4 Children can **decorate their plant holders,** while the clay is still wet, with materials from nature. Introduce the idea of a central design and a border design. Emphasize using the natural materials in more than one way.

Making Pocket Pottery

Use the slab method to create pottery.

 1 Make a large slab.

 2 Make a smaller slab.

 3 Paper helps to make a pocket.

 4 Press the clay with your fingers to join the slabs.

 5 Add textures.

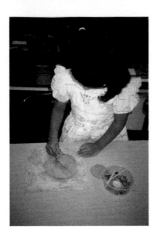

Variations/Extensions

- Finish the plant holders by bisque firing them.
- Add glaze to your holders.
- If you prefer not to glaze, paint the holders with watercolors or tempera. Choosing either warm or cool colors adds another dimension to this lesson. Coating them with polymer medium will add shine.

- Children can go on a walk to collect dried flowers and plant stalks to place in their plant holders.
- Children enjoy drawing completed pottery. Suggest that they begin with the overall shape and then add details and textures. These can make great cards.

Assessment

Assessment is based on a scale of 0–4.
4 All objectives are met, work is done with care, and represents a child's best work.
3 Some objectives are met; not the child's best work.
2 Child struggled to grasp the concept; few objectives have been met.
1 Child did not grasp the concept, no objectives met, work is incomplete.
0 Child absent.

Teaching Tips

Collect Materials Ahead of time, start collecting dried flowers and plants to add to the pots.

Removing Paper Gently pull paper towels out of the pockets when the clay is leather-hard.

Packaging To send these home, place on a piece of cardboard and wrap with newspaper.

Finishing It's a teacher's job to trim off excess clay from the plant holders, use a pencil or stick to poke a hole at the top so they can hang, and write children's names on the backs. Check to be sure the pocket is properly joined.

Lesson Resources

Children's Trade Books

The Pot that Juan Built by Nancy Andrews-Goebel and David Diaz (Lee & Low, 2002)
Helen Cordero and the Storytellers of Cochiti Pueblo, by Nancy Shroyer Howard (Davis, 1995)

Other Resources

Children, Clay, and Sculpture by Cathy Weisman Topal (Davis Publications, 1983)
Music CD (Davis)
davisart.com

PREPARE

Objectives
While creating self-portraits in clay, children will:
- deepen their understanding of the human body.
- understand the difference between free-standing and relief sculpture.
- use analytical thinking to break the human body into simple forms, and to reconstruct it using balls and coils.
- think critically and strategically about placement and spacing of clay parts to create a human form.

Materials
- Clay slab, 5" x 6" (13 x 15 cm), 1 per child
- Golfball-sized clay lump, 1 per child, extra in reserve
- Clay board, 1 per child
- Pencils, only if needed for details, in reserve (see Tips)
- Wooden manikin for referring to body parts (optional).
- Have clay boards, slabs and balls ready.
- Check clay a few days ahead of time to make sure the consistency is right: It should be easy for children to manipulate, and parts should join easily without the use of slip.

Vocabulary

English	Spanish
relief	relieve
attaching	unir
balls	pelotas
coils	espirales
slab	losa
base	base

National Standards
1a, 1c, 2b, 2c, 3a, 3b, 4a, 4b, 4c, 5a, 6b
See pages 100–101 for a complete list of the National Standards.

Sculpting in Relief

Relief sculpture stands out from a flat background.
What parts stand out in this relief sculpture?
What story does it tell?

Lamidi Fakeyi, *Carved Door*, 1977. Mahogany.

44

TEACH

Engage

1 Figure sculptures are sculptures that represent people. Ask: Have you ever seen a figure sculpture in a park, city, or museum? What do you remember?

2 Explain that a **relief sculpture is a sculpture that has figures and forms projecting from a flat surface.** It can be very effective to stand against a wall to demonstrate the properties of relief sculpture. Point out the relief sculpture in the Big Book and ask children to identify the parts that stand out from the background. Where do they see textures and details? What are the children doing ?

Explore

1 In preparation for sculpting a figure with clay, we need to physically review the parts of the body. Sing and pantomime the song "Head, shoulders, knees, and toes." Have children stand and go through body awareness exercises, referring to a mannikin if desired.

2 Demonstrate flattening a clay slab with the palm of your hand. The slab should be no thinner than your thumb. Show children how to turn the clay board around while gently pressing the clay. When you are finished, demonstrate turning over the clay slab so that you are working on a very flat surface.

3 Demonstrate rolling balls and coils for the main body parts, and gently laying them out on top of the clay slabs. Wait to attach.

4 Show children how to gently press the separate clay body parts to join them.

Clay People Plaques

Make a relief sculpture of yourself.

 1 Make a slab.

 2 Roll balls and coils for body parts.

 3 Arrange balls and coils on slab to form your body.

 4 Gently attach body parts by pressing.

 5 Add details.

Create Part 1

1 Have children:
- Roll a ball for the head and press it on gently, near the top.
- Roll coils and balls for body parts. Lay them gently on the slab.
- Gently press parts together.
- Add small parts with small balls and coils.

Part 2

1 Discuss different ways to make hair, eyes, and fingers. If necessary, allow children to use pencils to add small details. Remind them to be gentle!

2 Some children will already have added small details. Use these children's works to show others the possibilities.

Variations/Extensions

- Bisque fire the self-portraits when they are dry.
- To finish, the teacher can coat the sculptures with clear glaze, or children can paint them using watercolor, tempera, or glaze, and finish them with clear polymer medium when dry. Keep in mind that painting three-dimensional textured pieces takes a good deal of control.
- This lesson can be followed with a lesson on drawing self-portraits.
- Working from a previously drawn self-portrait is another way to begin. It is also a way of revisiting and building upon children's understanding of the human form.

Assessment

Assessment is based on a scale of 0–4.
4 All objectives are met, work is done with care, and represents a child's best work.
3 Some objectives are met; not the child's best work.
2 Child struggled to grasp the concept; few objectives have been met.
1 Child did not grasp the concept, no objectives met, work is incomplete.
0 Child absent.

About the Artwork

Relief sculptures often show scenes from everyday life. Each panel of this door shows Nigerian children playing games.

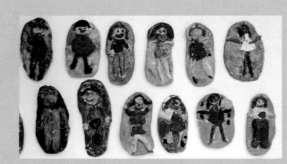

Teaching Tips

Sculpture Simplified Sculpting in relief allows children to make a figure sculpture without the problem of making it stand.

Slab as Surface Some children "see" the slab as the body and add the head and arms to the edges of the slab. As you demonstrate, clarify that the slab acts as a surface so that all the parts of the body can be built on top.

Drawing Easier After 3-D Many children have more success representing themselves three-dimensionally than drawing themselves. After creating three-dimensional representations, children often find it easier to draw a person.

Body Awareness Body sculpting exercises enable children to become more aware of all the parts of the body, particularly joints and appendages, and how they move.

Pencils Children should use pencils only for details. Remind children not to press hard; pressing hard cuts the clay and can ruin the relief sculpture. You should decide whether or not it is appropriate to make pencils available at all.

Finishing To finish, trim extra clay, write children's names on the back of the sculptures and poke a hole in the top of each.

Lesson Resources

Children's Trade Books
From Head to Toe by Eric Carle (HarperCollins, 1997)

Other Resources
Music CD (Davis)
davisart.com

Unit 5 Opener

Line Printing

Line printing is a process for creating lines that makes use of a simple printmaking technique. Using the line printing tool, children have control over their marks and often find that they are able to print structures before they can actually draw them. A line becomes a tool for thinking when it is used to discover the beginnings of writing, reading, mathematics, and design.

Lessons in this unit:

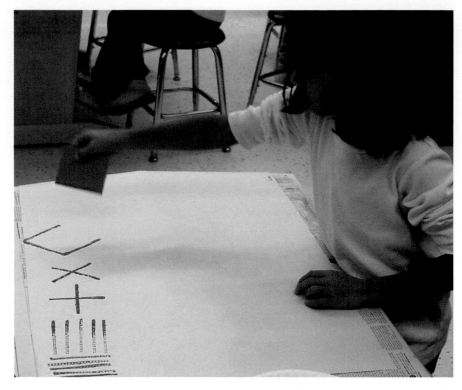

Line printing helps clarify the differences between horizontal, vertical, and diagonal lines and leads to the creation and recognition of shapes.

Straight line printing tools can be made from pieces of corrugated cardboard cut from a box. Always print with the edge that you can see through.

Paper coffee cups, masking tape rolls and empty toilet paper rolls can easily be cut to make curved line printing tools.

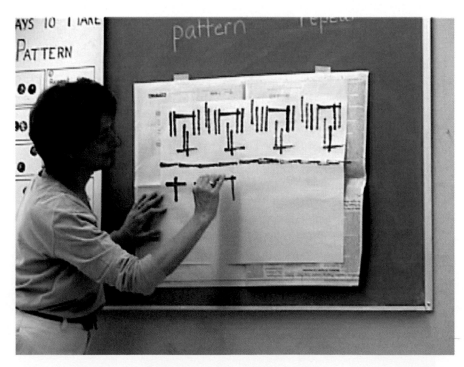

Demonstrations make the concept of pattern come to life for children.

Limiting children to one color at first keeps the children focused on the lines themselves.

Line compositions have a wonderful simplicity.

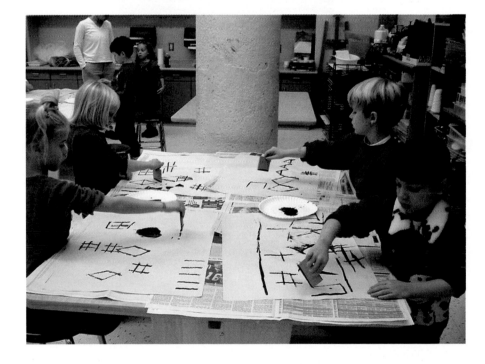

Printing on large paper requires sufficient table space, but allows children room to experiment. This unit emphasizes practicing basic lines. It also encourages experimentation and capitalizing on the discoveries of the children.

Children can return to their line prints at a later time and add color with paint or markers. The results can be stunning!

Discovering Basic Lines
Line Printing Experiments

Discovering Basic Lines

There are many kinds of lines.
This photograph was taken
 inside an airport.
What kinds of lines can you find?

Cincinnati/
Northern Kentucky
International Airport.
Photo by C. Topal.

46

PREPARE

Objectives
While printing basic lines,
children will:
- develop awareness of eye-hand orientation.
- develop awareness of placement and spacing of lines.
- practice proper hand grip and pressure.
- understand and practice the process of making a clear print.
- understand and experiment with the idea of repetition.
- develop a line vocabulary.
- develop awareness of different kinds of lines.
- understand that they can build with lines.

Materials
- Large cardboard line tool, 3" x 2½" (8 x 6 cm), 1 per child, extras in reserve in case of accidents (see Teaching Tips)
- Small cardboard straight line tool, 1½" x 2½" (4 x 6 cm) 1 per child (optional, in reserve)
- Reusable line tools (available from Davis)
- 9" x 12" (23 x 30 cm) newsprint for practicing, 1 per child
- 18" x 24" (46 x 61 cm) white paper, 1 per child
- 1 color of paint to start, a second color of paint to add later (optional)
- Styrofoam trays or small paper plates

Setup
- Cover tables with newspaper.
- Place 18" x 24" (46 x 61 cm) paper at each seat.
- Put 9" x 12" (23 x 30 cm) practice paper on top.
- Distribute trays or paper plates; keep paint in reserve.

Vocabulary

English	Spanish
line printing	impresión por líneas
horizontal	horizontal
vertical	vertical
diagonal	diagonal
crossing	cruce
zigzag	zigzag
broken	roto
long lines	líneas largas

National Standards
1a, 1c, 1d, 2a, 2b, 2c, 3a, 3b, 5a, 5c
See pages 100–101 for a complete list of the National Standards.

TEACH

Engage
1 Point out to children that **lines are all around us**. Have children look around the room, at the walls, floors, and at one another's clothing. Can they find any lines? Use the basic lines below as a reference.

2 Display the fine art in the Big Book. **Where do the children see lines in these works?** Notice that the artist used diagonal lines to show movement and energy. Some lines also show texture, or create shapes when they touch.

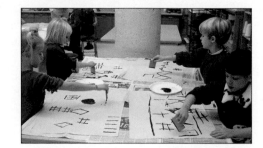

Explore
1 To introduce children to the process of line printing, first introduce and **demonstrate how to use the tool**. Explain that you:
- dip the line tool into the paint.
- press the tool firmly onto paper.
- lift.
- repeat.

2 Demonstrate repeating the same line many times. Encourage children to discover how many clear line prints they can make from one dip.

3 Introduce and demonstrate the printing of horizontal, vertical, and diagonal lines, clarifying and naming the different orientations.

Straight line tools. Rest tools on sides of tray when not in use.

Line Printing Experiments

Begin with the basic lines.

 1 Print vertical lines.

 2 Print horizontal lines.

 3 Print diagonal lines.

 4 Print broken lines, crossed lines, and zigzag lines.

How can you make a long line by printing?

Printing with the Line Tool

1 Dip.

2 Press.

3 Lift.

4 Repeat.

Create

1 **Ask children to print:**
- a row of vertical lines.
- stacks of horizontal lines.
- crossing horizontal and vertical lines to form a +.
- a broken line.
- a long line made by printing and lifting and printing again, not by sliding the tool along the paper.
- a row of diagonal lines, slanting to both the left and right.
- crossing lines diagonally in an X.
- a zigzag.

2 Hold up children's work and **point out interesting ways lines were used.** Also point out spaces created between the lines.

3 Hold up the smaller line tool. Ask children to suggest ways they might use this new tool. Suggest trying smaller versions of the basic lines.

4 Demonstrate how to use the tool for making connections between lines. This often leads to the formation of shapes. Remind children to print using the smaller side of the tool.

Variations/Extensions
- Give half the children one color of paint and the other half a different color, and then switch the colors.
- On small paper, have children draw a sketch of their line printing composition with a fine-line marker.

Lesson Resources

Children's Trade Books
The Dot and the Line by Norton Juster (Sea Star, 2000)
Lines by Philip Yenawine (MOMA, 2006)

Other Resources
Thinking with a Line CD-ROM by Cathy Weisman Topal (Davis Publications, 2005)
Music CD (Davis)
davisart.com

Assessment

Assessment is based on a scale of 0–4.
4 All objectives are met, work is done with care, and represents a child's best work.
3 Some objectives are met; not the child's best work.
2 Child struggled to grasp the concept; few objectives have been met.
1 Child did not grasp the concept, no objectives met, work is incomplete.
0 Child absent

"It's a factory."

Teaching Tips

Making Tools To make line printing tools, use a paper cutter to cut rectangles from corrugated cardboard boxes, mounting board, or any other firm material.

Using the Tools If you use corrugated cardboard, print with the side you can look through. This is the sturdiest side. Have extra line tools handy in case they are dropped into paint.

Demonstrations Demonstrate only what is necessary to introduce the process and the concepts children need to get started. An open-ended demonstration allows children to make their own discoveries.

Start Simply Emphasize only vertical and horizontal lines at the beginning, introducing diagonal lines when you notice them appearing in the work of a few children.

Paper Full? When you see children running out of space, hand out the small line tool or another piece of paper.

Squeeze Bottles These make initial distribution and refilling paint trays easier.

Lines Not Blobs When adding paint to the trays, squeeze it out in a line, not a blob.

Dip, Don't Scoop Encourage children to dip the tools in the paint rather than scoop the paint with the tools.

Save Line Prints Revisit them during the color mixing lesson (Unit 9). Line printings make beautiful compositions.

PREPARE

Objectives

When creating patterns, children will develop and practice:

- working with a set of rules.
- systematic approaches to building a pattern.
- using mathematical variables such as number, grouping, direction, alternation, position, and length.
- analytical thinking skills.
- hand orientation, placement, and spatial skills.

Materials

- Large line tools
- Small line tools (in reserve)
- 6" x 18" (15 x 46 cm) practice paper for printing patterns
- 18" x 24" (46 x 61 cm) paper for printing patterns
- 1 color of paint to start, a second color of paint in reserve
- Styrofoam trays or small paper plates
- Found objects, one for each child (in reserve if needed)

Setup

- Cover tables with newspaper.
- Place 18" x 24" (46 x 61 cm) paper at each seat.
- Place 6" x 18" (15 x 46 cm) practice paper on top.
- Distribute trays or paper plates on tables; keep paint in reserve.

Vocabulary

English	Spanish
pattern	patrón
repeat	repetir
alternate	alternar
horizontal	horizontal
vertical	vertical
diagonal	diagonal
spacing	espaciado
placement	colocación
position	posición
number	número

National Standards

1a, 1b, 1c, 2a, 2b, 2c, 3a, 3b, 5a, 6b

See pages 100–101 for a complete list of the National Standards.

TEACH

Engage

1 **Define the concept of pattern.** Ask: What is a pattern? A pattern is formed when an art element is repeated many times in the same way. Patterns are everywhere! They are especially easy to find in textiles, clothing, pottery, and jewelry from all over the world. To explore pattern is to look through a window into the world's rich cultural heritage.

2 Using the image in the Big Book, ask: Where do you see a pattern? What repeats?

Explore

1 **Review how to use the printing tool** on practice paper. Remind children to dip, press, lift, and repeat. Review dipping rather than scooping the paint, pressing firmly without pounding, and lifting straight up to avoid smearing.

2 Start at the left side. **Demonstrate making a simple pattern** using the line tool: Repeat a line, with equal space between lines, all the way across your paper. Repeat another line in a different place and repeat it across the paper. Explain that you have made a simple repeated pattern. You might want to clap the pattern.

3 Continue adding lines into the pattern, changing position and direction of the lines.

4 Make a mistake, such as leaving out a line, and let the children correct you.

UNIT 5 LESSON 2

Lines Make Patterns

Patterns are made from repeated lines or shapes.

Find patterns in this weaving. What repeats?

Cloth woven by Mam Indians, Guatemala.

48

Building a Pattern

Use the line tool to make a pattern. Work from left to right.

1 Repeat a line across your paper. Keep spaces the same.

2 Add lines to make groups.

3 Change the position. Add lines that go up or down.

4 Change the direction of the lines.

Printing with the Line Tool

1 Dip.

2 Press.

3 Lift.

4 How could you add to your pattern?

Create

1 As children experiment, point out some important ways to create pattern. They can:
- Change the number of printed lines in a grouping.
- Change the position of a line, such as moving it up or down in relation to the other lines.
- Change the direction of the printed line, and use vertical, horizontal, and diagonal lines.
- Alternate lines and spaces.

2 Emphasize using a horizontal line to divide patterns, especially when the pattern becomes too confusing to follow.

Variations/Extensions

- To extend work with patterning, add one or more of the following: the small line tool, a second color, or a small found object—one per child.
- Repeat the same sequence on another day on a new color of paper. This allows children to revisit making a pattern now that they know the procedure.

Lesson Resources

Children's Trade Books
Kente Colors by Deborah M. Newton Chocolate and John Ward (Walker, 1997)

Echoes for the Eye: Poems to Celebrate Patterns in Nature by Barbara Juster Esbensen and Helen Davie (Harper Collins, 1996)

A Pair of Socks by Stuart Murphy and Lois Ehlert (Harper Trophy, 1996)

Other Resources
Music CD (Davis)
davisart.com

Assessment

Assessment is based on a scale of 0–4.

4 All objectives are met, work is done with care, and represents a child's best work.

3 Some objectives are met; not the child's best work.

2 Child struggled to grasp the concept; few objectives have been met.

1 Child did not grasp the concept, no objectives met, work is incomplete.

0 Child absent

Teaching Tips

Use Pattern Eyes Look around your home for examples of patterns. Tell children to keep their eyes open, too!

Left to Right While demonstrating, emphasize working from left to right and from top to bottom. Encourage children to do the same. This echoes the mechanics of reading.

Pattern Practice Line printing is an easy way to practice making patterns and to gain a concrete understanding of how to create and change a pattern.

Great Wrapping Paper Pattern printings generally cover big areas and can be used as wrapping paper.

Mounting Pattern prints make a striking display when mounted close together to cover a wall.

One Material at a Time The most common mistake I make is to offer too many materials too fast. As a general rule, begin with the large line tool and encourage exploration and exchange of ideas. At the same time, be prepared to offer additional tools and materials when you wish to extend and deepen an exploration.

UNIT 5 LINE PRINTING
LESSON 3 Lines Make Letters
Printing Letter Forms

Lines Make Letters

Which letters have straight lines?
Which letters have curved lines?

50

PREPARE

Objectives
When printing letters, children will develop and practice:
- letter recognition.
- letter construction.
- an understanding of the differences among letters.
- hand orientation.
- analytical thinking skills.
- placement skills.
- spatial awareness.
- proper hand grip and pressure.
- printing curved lines.

Vocabulary

English	Spanish
curves	curvas
the alphabet	el alfabeto
letters	letras
uppercase	mayúscula
lowercase	minúscula

National Standards
1c, 2a, 2c, 3a, 3b, 4b, 5a, 6b
See pages 100–101 for a complete list of the National Standards.

Materials
- Large line tool, 1 per child, extras in reserve
- Large curve tool, 1 per child, extras in reserve
- Small line and small curve tools, in reserve (see Teaching Tips)
- 18" x 24" (46 x 61 cm) paper
- Tempera paint, 1 color
- Styrofoam trays or small paper plates

Setup
- Cover tables with newspaper.
- Children should have paper and large curve and line tools to begin.
- Place paint on trays in reserve.

TEACH

Engage
1 Discuss children's work from previous line printing lessons. Ask: Did anyone make a letter? How did you do it?

2 Point out the street signs in the Big Book. **Which letters have straight lines?** Which letters have curved lines? Which letters have diagonal lines? How could you print them with your line tool?

Explore
1 Invite children to **discuss their strategies for printing letters**, while you model their suggestions. Begin with the letters that are made with horizontal and vertical lines (E, F, H, I, L, T) as they are easiest to construct.

2 Call children's attention to letters that are made with diagonal lines. These letters (A, K, M, N, V, W, X, Y, Z) are more difficult to construct.

3 Encourage children to try the most challenging letters to construct: letters with curves! (B, C, D, G, J, O, P, Q, R, S, U) Introduce the large curve tool.

Create Part 1
1 Reinforce that there can be more than one strategy for making letters. Encourage children to explore more strategies on their own.

2 When children return to their seats to get started, have them **practice using the tools without paint** to form letters.

3 Practice making letters with the large straight line tool and the large curve tool.

4 Some children may work with one letter again and again, creating a design of letters. Other children might practice random letters as they fill the page. Others may try to print their name or a sign. Consider sharing these various approaches about halfway through the work time, and then encouraging children to go back and try something that they learned from the discussion.

Printing Letter Forms

Design letters using line printing tools.

1 Practice without paint first.

EFHILT

2 Make letters with horizontal and vertical lines.

AKMNVWXYZ

3 Make letters with diagonal lines.

BCDGJOPQRSU

4 Make letters with curved lines.

ABCDEFGHIJKLMNOPQRSTUVWXYZ
Alphabet

Part 2

1 If you wish to work with lowercase letters, introduce the small line tool and the small curve tool when children are ready. But wait until children have printed many different letters with the larger tools. It can be overwhelming to have too many variables at once. You may wish to introduce these other tools another day. Or, consider exploring the curved line tools during a work time, before focusing on letters, so that the children can become familiar with how they work.

Variations/Extensions

- Children will naturally try to print their names, but can be challenged to print the alphabet in uppercase and lowercase.
- You might encourage children to begin by practicing the letters in their names, since those are the letters they probably know best.

- Children can do a final copy on colored paper.
- Once prints have dried, children can add borders and other designs with markers.

Assessment

Assessment is based on a scale of 0–4.

4 All objectives are met, work is done with care, and represents a child's best work.

3 Some objectives are met; not the child's best work.

2 Child struggled to grasp the concept; few objectives have been met.

1 Child did not grasp the concept, no objectives met, work is incomplete.

0 Child absent

Teaching Tips

Making Curved Tools To create the large 3" (8 cm) curved line tool, cut paper coffee cups in half, vertically, to create half circles. The cardboard circles inside masking tape rolls also make excellent semi-circle curved line tools when cut in half.

Small Curves To create the smaller, half-size curved line tools, cut toilet paper rolls in half vertically, and then in half horizontally to create four small 1½" (4 cm) curves. Make sure that children use the flat side for printing.

Letters While printing basic lines, a few children are sure to print a letter. Use these children's inventions as springboards to initiate an exploration of printed letters. As much as possible, let the discoveries come from the children.

Sequence Materials If you delay handing out paint, you can encourage children to spend a few minutes thinking and planning the construction of letters. This saves countless mistakes and a lot of paper.

Mind Your Fonts If using a printed alphabet as a reference, remember to choose an appropriate font: Use the simple rounded "a" instead of the more complex "**a**".

Save Line Prints Revisit these during the color mixing lesson (Unit 9). Letter designs make beautiful compositions when spaces are filled in with mixed colors.

Lesson Resources

Children's Trade Books
Alphabet City by Stephen T. Johnson (Puffin, 1999)
The Graphic Alphabet by David Pelletier (Scholastic, 1996)
Albert Builds an Alphabet by Leslie Tryon (Aladdin, 1994)

Other Resources
Music CD (Davis)
davisart.com

Lines Make Shapes
Building a Composition

Lines Make Shapes

Be a shape detective.

What shapes can you find?

Pont du Gard, Nîmes. Photo by Rose Leonard.

52

PREPARE

Objectives

When building with shapes, children will develop and practice:
- hand orientation and spatial awareness.
- placement and printing skills.
- constructing a variety of geometric shapes.
- an awareness of shapes in the environment.
- integrating a variety of line, shape, and design elements to express ideas.
- using proper vocabulary to describe shapes and their attributes.

Materials
- Large straight line tool, 1 per student (extras in reserve)
- Small straight line tool (in reserve)
- Large curved line tool (in reserve)
- Small curved line tool (in reserve)
- 12" x 18" (30 x 46 cm) practice paper
- 12" x 18" (30 x 46 cm) paper, or larger, white; or construction or fadeless paper in a variety of colors
- Tempera paint, 1 color
- Trays, enough for children to share easily
- Found objects (optional, in reserve)

Setup
- Put out large paper with practice sheet set on top.
- Large line tools should be at each place.
- Keep paint in trays in reserve.

Vocabulary

English	Spanish
nonobjective	sin objectivo
realistic	realista
geometric shape	forma geométrica

National Standards

1a, 1c, 2a, 2b, 2c, 3a, 3b, 4a, 4b, 5a, 5c, 6b

See pages 100–101 for a complete list of the National Standards.

TEACH

Engage

1 Direct children's attention to the Big Book pictures and ask them to **be shape detectives**. What shapes can they find?

2 **Discuss geometric shapes**. Ask: How might you make these shapes with the straight line tool? What shapes can be made with the addition of the curved line tool?

Explore

1 Demonstrate making a square, rectangle, and triangle with the straight line tool on practice paper. Have the children **practice these shapes first without paint** in order to figure out the placement and spacing of lines. Then they can use the paint.

2 Have children try connecting shapes.

3 Once children have had some practice time, give them the curved line tool. Ask them to make a circle and invent another shape with some curved lines.

Building a Composition

Use your line tools. Make geometric shapes. Invent shapes. Make a composition.

 1 Practice making geometric shapes. Use the straight line tool.

 2 Practice making geometric shapes. Use the curved line tool.

 3 Invent some shapes.

 4 Put shapes together to make a composition.

Create

1 Give children a choice: They may start a composition on their second sheet of paper, or continue to add to their first.

2 **Share the discoveries you notice** and invite children to share their strategies. Introduce and discuss *realistic* and *nonobjective* (nonrepresentational) compositions. Offer smaller line tools to make connections and to work inside larger shapes.

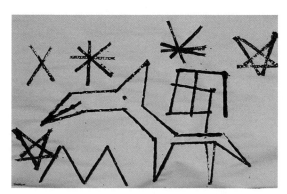

Variations/Extensions

• You may be surprised at how many geometric shapes children can identify, name, and define. Ask, How do you know that this shape is a _____?

• When children are finished, they could practice drawing their printed composition.

Lesson Resources

Children's Trade Books

When a Line Bends, a Shape Begins by Rhonda Gowler Greene and James Kaczman (Houghton Mifflin, 2001)

The Greedy Triangle by Marilyn Burns and Gordon Silveria (Scholastic, 1995)

So Many Circles, So Many Squares by Tana Hoban (Greenwillow, 1998)

Other Resources

Music CD (Davis)

davisart.com

Assessment

Assessment is based on a scale of 0–4.

4 All objectives are met, work is done with care, and represents a child's best work.

3 Some objectives are met; not the child's best work.

2 Child struggled to grasp the concept; few objectives have been met.

1 Child did not grasp the concept, no objectives met, work is incomplete.

0 Child absent

Teaching Tips

Curves Later I would not hand out the curved line tools until children have created several geometric shapes with the large line tool. This lesson can be very effective—maybe more effective—without any curves.

Found Objects Later It's always easy and fun to print with found objects and add them to compositions, but adding found objects can be a bit like giving out candy. It is easy for children to get carried away! Constructing shapes is more challenging work, and ultimately very rewarding work. Save found objects to carefully add for detail and embellishment at the end of this lesson.

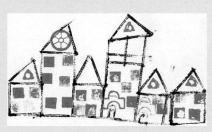

Adding Color These prints can be saved to revisit during the color mixing lessons in Unit 9. It is also effective to use oil pastels, crayons, paints, or a combination of media to add color to selected areas of printed compositions. When working with oil pastels, work on a newspaper pad and look for small areas to fill in. It is too tiring and hard on the hands to fill an entire composition with oil pastels. But, after adding some areas of oil pastel, it is really fun to paint in the rest of the composition, taking care to work inside the shapes so that the line construction remains visible.

Unit 6 Opener

Design

Young children have a strong sense of design and a desire to create. When they understand that artists are responsible for designing most of the objects that we use and wear, they begin to realize the importance of design in their everyday lives. The exciting news about designing is that very simple lines and shapes can be used to create complex designs.

Lessons in this unit:

Lesson 1 **The Art of Placement: Designing Wrapping Paper**
Lesson 2 **Seeing Symmetry: Building Radial Designs**
Lesson 3 **Arranging a Composition: Designing with Cut Paper**
Lesson 4 **Creating Order: A Found Object Ornament**

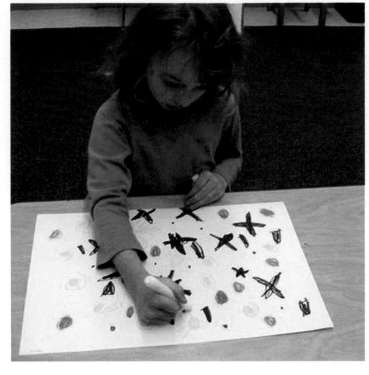

When they create wrapping paper, children become aware of spacing, repetition, and the way designs magically gain complexity.

A template helps children grasp the concept of radial symmetry.

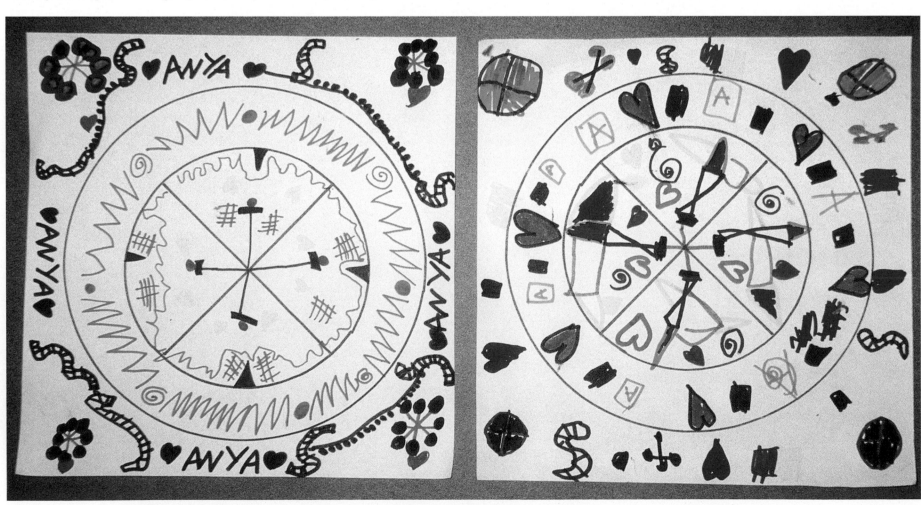

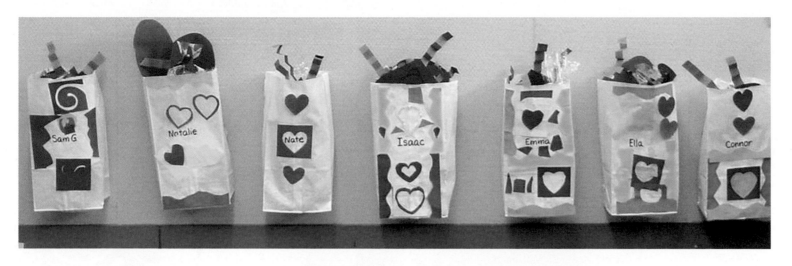

Grouping children's work for display offers opportunities for discussion and pride.

Cutting shapes can be a powerful experience for children, as they discover their own ability to change materials.

These relief sculpture creations can become pins, ornaments, or small wall hangings.

Children quickly learn that sculptural materials can be found almost anywhere! This sculpture, by Laura Chapman, was made with colorful forks.

The Art of Placement
Designing Wrapping Paper

The Art of Placement

Artists designed these papers.
What lines and shapes repeat?
Notice the spaces between them.

54

PREPARE

Objectives
While creating an all-over design,
children will:
- use art elements and design
 principles.
- use the language of the visual arts.
- evaluate their work.
- express their natural aesthetic
 preferences.

Materials
- Markers, 1 set of 8 per group of
 4 children
- Paper (size may vary depending
 on use)

Setup
Place paper and markers at each seat.

Vocabulary

English	Spanish
design	diseño
motif	motivo
repetition	repeticíon
balance	balance
rhythm	ritmo
variety	variedad
emphasis	enfasis
unity	unidad

National Standards
1a, 2a, 2b, 2c, 3a, 3b, 5c
See pages 100–101 for a complete list of
the National Standards.

TEACH

Engage
1 Ask children to look around the room and point out
some objects they see, such as tables, chairs, lamps,
books, carpet, etc. Explain that every object and
every piece of clothing they see and use is the work
of a designer or an artist.

2 **Look at examples of wrapping paper,** either in the
classroom or shown in the Big Book. Point out one
line or shape on a section of wrapping paper and
note how the designer repeated and varied that par-
ticular line or shape. By repeating simple lines and
shapes, it is easy to create a complex design.

Explore
1 **Demonstrate choosing a line or a shape** as
a *motif* to repeat. Show children how to place
each line or shape the same distance from
others.

2 Demonstrate stepping back and looking to see
if you need to add more of one kind of line or
shape before going on to another.

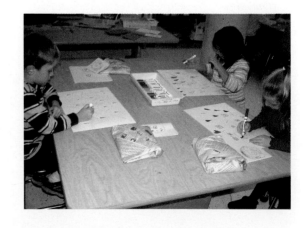

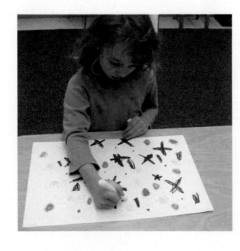

Designing Wrapping Paper

Create beautiful wrapping paper
using simple lines and shapes.

1 Choose one line or shape to repeat.

2 Draw your line
or shape many times.
Keep spaces even.

3 Choose a new line
or shape.
Repeat it many times.

4 What other shapes
can you repeat?

Create

1 Set a number of times, such as 10, for children to
repeat each motif. Remind children: As you place
each mark, try to keep the spacing the same and
to cover all parts of your paper. Emphasize the
importance of spacing allover designs.

2 Explain that when the children have placed one
motif all over their paper, they should choose a
new line or shape, maybe a new color, and repeat
the process. Continue choosing a new color and
a new line or shape and repeating it all over the
page. Remind children that they are developing a
design and the end result will be a surprise!

3 Draw children's attention to the evolving com-
plexity of their designs!

Assessment

Assessment is based on a scale of 0–4.

4 All objectives are met, work is
done with care, and represents a
child's best work.

3 Some objectives are met; not the
child's best work.

2 Child struggled to grasp the con-
cept; few objectives have been met.

1 Child did not grasp the concept, no
objectives met, work is incomplete

0 Child absent.

Variations/Extensions

• These directions can be used with
a variety of media.
• This lesson works well for printing
with found objects.
• Some children may draw pictures
with repeating shapes and lines.

Teaching Tips

Other Useful Items You can alter
these directions to fit a specific use.
It is important for children to have
some experience designing an item
for use, such as wrapping paper,
cards, book covers, frames, book-
marks, placemats, and the like.

Solicit Strategies It is fun to ask the
children for strategies to draw some
of their favorite shapes, such as stars,
letters, or hearts.

Ideas Are Paramount Sometimes a
beginning design will spark an idea
for a picture. Children may take this
opportunity to make very complex
pictures, letting go of the original pur-
pose to create an allover design. Our
intention is to spark children's ideas.
Accept these and enjoy their creativ-
ity. Invite children to share stories
about their work.

Many Media These directions can be
used with a variety of media.

Found Objects This lesson works well
for printing with found objects.

Pictures Some children may draw
pictures that include patterns with
repeating shapes and lines.

Lesson Resources

Children's Trade Books
Shape Patterns (Let's Investigate)
by Marion Smoothey
(Benchmark, 1993)
All About Pattern by Irene Yates
(Chrysalis, 2002)

Other Resources
*Introducing Pattern, Its Development
and Application* by Dennis Palmer
(Watson-Guptill, 1970)
Music CD (Davis)
davisart.com

Seeing Symmetry
Building Radial Designs

Seeing Symmetry

Radial designs move outward from a central point.

Find the central point in these pictures.

What lines, shapes, and colors repeat?

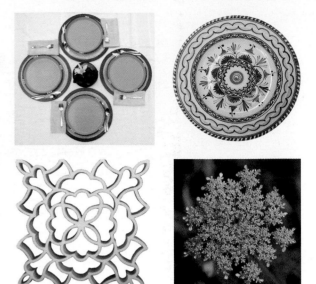

56

PREPARE

Objectives

When creating radial designs, children will:

- develop and practice hand orientation, placement, and spatial skills.
- learn to work within a set of rules.
- use mathematical variables such as number, direction, and position.
- develop and practice systematic approaches to building from a core design.

Materials

- Markers, 1 set per 8 children
- White photocopy paper, 1 per child (extra in reserve)

Setup

- Place photocopy template (see example below) onto white paper and trim to square. Have extras in reserve.
- Put paper and markers out on tables.
- Shrink some templates to offer for to children who finish early.

Vocabulary

English	Spanish
radial	simetría
symmetry	radial

National Standards

1a, 1b, 2a, 2b, 2c, 3a, 3b, 6b

See pages 100–101 for a complete list of the National Standards.

TEACH

Engage

1 Refer to the radial designs shown in the Big Book. **Point out that all the examples have a central point**. The designs move outward from that central point.

2 Can the children think of other examples of things that they see that look like these? (bicycle wheels, the sun with its rays, a merry-go-round)

Explore

1 **Define radial designs** as those that start at a center point and radiate out like the rays of the sun or the spokes of a wheel. Explain that designs like these have *symmetry*: if you divide them in half they look the same on both sides of the center line.

2 **Show children the wedge template**. Demonstrate putting a line or shape in one of the wedges, and repeating it in the other three wedges. Explain that putting the line or shape in the same position in each wedge will help create radial symmetry.

3 Make a mistake and invite children to help you fix it—not by crossing out, but by inventing another design solution.

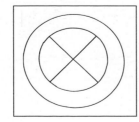
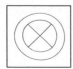

Students enjoy using the templates in a variety of sizes.

Building Radial Designs

Follow the rules to create a design with radial symmetry, or balance.

1 Draw a line or shape in the middle of one wedge.

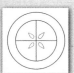

2 Repeat the line or shape in the same place in the other wedges.

3 Choose a new shape and repeat. Always put the shape in the same place in each wedge.

4 Make a different design in the outside circle and in the corners.

Create

1 Hand out the templates. Ask children to start in the middle of a wedge. **Plan a line or shape to repeat.** Repeat the same line or shape in each wedge in the same place.

2 Choose a new shape or line to place in a new spot on the wedge, and repeat. Try to put the lines or shapes in the same position in each wedge.

3 Tell children they may use the outside circle and the corners in any way they wish.

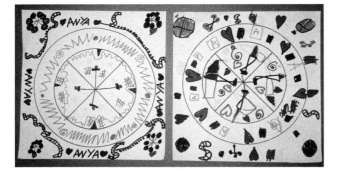

Variations/Extensions

- Radial designs often appear in the spontaneous drawings of young children. Rhoda Kellogg, in a thorough study of children's visual representations, found that a number of configurations are universal in young children's work. Among these configurations are shapes, symmetrical and radial designs, mandalas, and suns.
- A study of snowflakes can add complexity and interest to a study of radial designs.
- These directions work well as a line printing activity. They can also be used with a variety of media, including stitchery.

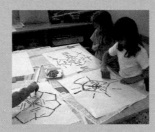

Teaching Tips

Start with the Template This helps children understand radial design and helps them get started.

For Early Finishers Start with a large square but shrink the photocopies to offer a challenge to children who finish early.

For Home Use Children enjoy taking photocopies of the configuration home to share with their parents and siblings.

"Mistakes" Children will make mistakes, especially as they generate more complicated designs—and that adds to the charm. Celebrate unique ideas rather than calling attention to mistakes.

Assessment

Assessment is based on a scale of 0–4.

4 All objectives are met, work is done with care, and represents a child's best work.

3 Some objectives are met; not the child's best work.

2 Child struggled to grasp the concept; few objectives have been met.

1 Child did not grasp the concept, no objectives met, work is incomplete.

0 Child absent.

Lesson Resources

Children's Trade Books
Snowflake Bentley by Jacqueline Briggs Martin (Houghton Mifflin, 1998)
A Drop of Water by Walter Wick (Scholastic, 1997)

Other Resources
Music CD (Davis)
davisart.com

UNIT 6 DESIGN

LESSON 3 **Arranging a Composition**
Designing with Cut Paper

PREPARE

Objectives
As they create cut paper composi-
tions, children will:
- identify and distinguish between dif-
 ferent types of shapes.
- expand upon cutting skills with an
 emphasis on cutting curves.
- learn criteria for an effective
 composition.
- learn ways to evaluate and improve
 compositions.

Materials
- Colored paper (see Teaching Tips)
 - 4" x 4" (10 x 10 cm) squares,
 2 per child
 - 2" x 6" (5 x 15 cm) rectangles,
 2 per child, 1 with wide zig-zag line,
 1 with wide wavy line
 - 9" x 12" (23 x 30 cm) paper
 for background
- Extra squares and rectangles (in
 reserve)
- Glue sticks or jars of glue (in reserve)
- scissors
- Pencils (in reserve, for drawing
 diagrams)
- Newspaper

Setup
- Cut squares and rectangles of differ-
 ent sizes (see Materials).
- Make scissors available, but not glue.
- Have newspaper on tables when chil-
 dren are gluing.

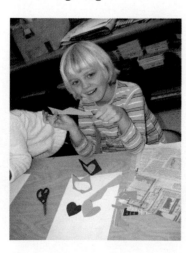

Vocabulary

English	Spanish
positive shape	*forma positiva*
negative shape	*forma negativa*
curve	*curva*
spiral	*espiral*
star	*estrella*
heart	*corazón*
zigzag	*zigzag*
composition	*composición*
overlap	*solapar*

National Standards
**1a, 1b, 1c, 1d, 2a, 2b, 2c, 3a, 3b,
4a, 4b, 5a, 5b**
See pages 100–101 for a complete list of
the National Standards.

UNIT 6 LESSON 3

Arranging a Composition
Artists arrange shapes carefully.
Where are the straight-edged shapes?
Where are the curved-edge shapes?
What makes the arrangement pleasing?

Henri Matisse, *The Lagoon*, from *Jazz*, 1947. Cut paper collage.

58

TEACH

Engage

1 Discuss Matisse: When the artist Henri Matisse
 became confined to a wheelchair, he was unable to
 paint. But he still wanted to create, and that's when
 he discovered **the power of scissors**! Let's look at
 some of the shapes he made.

2 As you talk about the artwork in the Big Book, listen
 for children's descriptive vocabulary. Shapes gener-
 ally fall into two major categories: straight-edged
 shapes and curvy-edged shapes.

3 Point out the white shapes: They were all cut from
 one piece of paper. The white shape in the middle is
 called a positive shape—it is the shape Matisse cut
 out. But every piece of paper is a shape! Often the
 negative shapes are as interesting as the positive
 shapes—or more!

Explore

1 Review the scissor poem (see Unit 1,
 Lesson 5).

2 **Demonstrate each of the ways to cut**, while
 referring to the diagrams. As you demon-
 strate, remind children about the mechanics
 of cutting.

3 Demonstrate:
- opening the scissors wide and cutting firmly
 for a long cut.
- snipping to make fringes.

4 Emphasize two ways to cut a curve:
- by turning the cutting hand.
- by turning the paper.

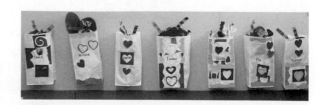

Designing with Cut Paper

Make a pleasing composition.

1 Cut straight-edged shapes.

2 Cut curved-edge shapes.

3 Discover negative shapes.

4 Arrange:
- Large shapes first.
- Overlap a shape.
- Make some shapes touch.

Unit 6 Design **59**

Create Part 1

1 Refer again to *Lagoon*. Ask: What makes Matisse's arrangement pleasing? (*shapes show some relationship to one another; spaces between the shapes are interesting; variety of shapes used; colors go well together; other answers possible*)

2 Tell children that they will be **arranging their shapes carefully before they glue them down.** Some criteria artists use:
- Place larger shapes first.
- Make some of your shapes touch the edges of the background paper.
- Have some shapes touch each other.
- Overlap some shapes.
- Look at the negative shapes—the shapes around the shapes you have cut—as well as the positive shapes.
- Use all your shapes.

3 As they work, encourage children to look at one color's effect upon the others.

Part 2

1 Demonstrate each of the above criteria. Review how to use the glue stick. After children try a few different arrangements, give them a glue stick.

Variations/Extensions

- Children can use shapes to create a group mural, cards, a composition, or to decorate a paper bag.
- If children create their compositions on paper bags, be aware that many convenience stores are willing to give bags to teachers, or to sell them at a reduced cost. If the bags have logos or slogans, use colored paper to cover them before children begin. Notice the backgrounds in Matisse's work.
- To make this a two-day lesson, focus on cutting the first day and save all the shapes in envelopes. Children can arrange and glue the shapes on another day.
- Cutting spirals and stars offers a challenge to more experienced cutters.

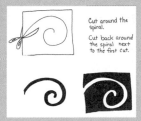

Cut around the spiral.

Cut back around the spiral next to the first cut.

Teaching Tips

Fadeless Paper This also works well for this lesson.

Encourage Discovery Cutting shapes can be a magical and powerful experience for children. While demonstrating, comment on the many possible ways to change shapes and encourage children to make their own discoveries.

Hearts Cutting a heart is a challenge that children often set for themselves. It can be helpful to share a few heart-cutting strategies.

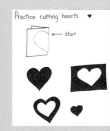

Practice cutting hearts. ♥

← start

Intuitive Design young children often arrive at an effective organizational structure intuitively. While it is good to point out criteria for arranging, accept and enjoy what the children do.

Closing To conclude the lesson, have children share something they especially like about their composition.

Assessment

Assessment is based on a scale of 0–4.

4 All objectives are met, work is done with care, and represents a child's best work.

3 Some objectives are met; not the child's best work.

2 Child struggled to grasp the concept; few objectives have been met.

1 Child did not grasp the concept, no objectives met, work is incomplete.

0 Child absent.

Lesson Resources

Children's Trade Books
Meet Matisse by Nelly Munthe (Little, Brown, 1983)
Henri Matisse by Mike Venezia (Children's Press, 1997)

Other Resources
Music CD (Davis)
davisart.com

Using Scissors

First children make a handshake. Say "Hello. Hello. Hello."

Then thumb goes in the little hole. We know, we know, we know.

Next, fingers in the big hole. Two or three is what we said.

Now elbow goes straight to your side. You're pointing straight ahead.

Then your fingers open wide. It's almost time to snip.

Remember we're just practicing. We're trying not to rip.

Creating Order
A Found Object Ornament

Creating Order

Artists look at everyday objects and see materials to use for art.

What everyday objects did this artist find?

How did she choose to arrange the objects?

Laura H. Chapman, *Family Tree #1*, ca. 2000. Plastic forks.

60

PREPARE

Objectives

When designing with found materials, children will:

- see potential in everyday objects.
- select and arrange objects using their natural aesthetic preferences.
- experiment with different arrangements, both formal and informal.
- use the language of the visual arts to explain their creation.

Materials

- Flat materials to construct a solid base:
 - cardboard or mounting board pieces, no larger than about 4" (10 cm) across
 - popsicle sticks, various sizes
 - bottle caps
 - burlap, 1" (3 cm) pieces
 - cardboard scraps
- additional materials to extend and decorate the composition, such as toothpicks, beads, pieces of broken jewelry, cut-up rickrack, cut-up rubber bands, cut-up paper straws, yarn pieces, etc.
- white glue

Setup

- Cover tables in newspaper.
- Put smaller materials in boxes, baskets, or bowls, sorted by type of material.

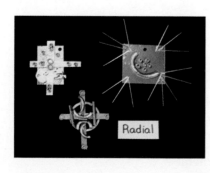

Vocabulary

English	Spanish
rows	*filas*
direction	*dirección*
symmetrical	*simétrico*
radial	*radial*
realistic	*realista*
corners	*esquinas*

National Standards

1a, 1c, 2a, 2b, 2c, 3a, 3b, 4a, 5b

See pages 100–101 for a complete list of the National Standards.

TEACH

Engage

1 Artists can see possibilities for expression in everyday objects. Discuss Laura Chapman's sculpture and her thoughts about choosing and arranging materials. (See About the Artist, right.)

2 **Brainstorm ways to arrange materials**. Invite suggestions from the children. Refer to the direction chart and demonstrate arranging:
- in a row.
- according to a direction.
- symmetrically.
- in a radial configuration.
- in a realistic arrangement.

Explore

1 Discuss choosing materials for the base: the base should be flat, so that children can glue found materials securely.

2 Discuss adding smaller materials to the base. Emphasize that children should **experiment with arrangements** of those materials. Ask that they try at least two of the arrangements discussed in Engage.

3 Review gluing techniques.

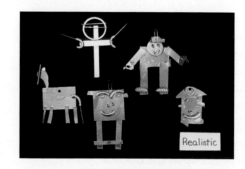

A Found-Object Ornament

Arrange everyday objects in a pleasing way.

1 Construct a base from flat materials.
 - Arrange.
 - Glue.

2 Choose smaller materials.
 - Arrange.
 - Glue.

3 Sketch your arrangement.

Ways to Arrange Things

| vertical | horizontal | symmetrical | radial | realistic |

Create Part 1

1 Allow children time to choose a few materials for the base.

2 **Experiment with two different ways to arrange those materials**. Remind children of possible arrangements: symmetrical, radial, in rows, or realistic.

3 Have children choose their favorite arrangement.

4 Glue.

Part 2

1 Offer smaller materials to embellish the base arrangement.

2 Review and demonstrate the technique for gluing small pieces:
 - Put a dot of glue on the base.
 - Place the small piece into the glue.
 - Use just enough glue to attach the piece.

3 When children are almost finished with their bases, offer additional very small materials if you wish.

Variations/Extensions

- An exciting option is to spray paint the completed designs. Do this outside. Before you paint, alert children to the fact that colors will be covered and they can choose to have theirs sprayed or not.

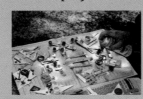

- To make these compositions into special pins, you can attach a large safety pin to the back of the creations, using duct tape.
- Glue a paper clip to the back of creation if you want it to hang.
- Drawing offers a way for children to revisit the shapes, textures, and organizational format of their creations. They really enjoy doing this! The drawings make beautiful cards if these designs are to be given as gifts.
- Have children describe their arrangements. Record their use of language.

About the Artist

Laura Chapman was inspired by the colors of plastic forks she saw at a party store and decided to buy forks in every one of the nineteen colors. Then she tried different ways of arranging them and decided to pick out a pair of forks from each of the nineteen colors. She lined the pairs up on dowels, or wooden rods, as you would thread beads. She writes, "I discovered a plan that put all 190 of the unique pairs in rows, and these rows formed a triangle—a treelike shape." She did this for both sides of the sculpture, keeping the triangle shape but changing the placement of the colors. "On one side, each row is a single color and the lighter, warmer colors are near the bottom. On the other side, each row has cool, dark colors on the left and warmer colors on the right. The sequence of colors is the same. After I finished this sculpture, it was like a 'family tree' of related colors."

Assessment

Assessment is based on a scale of 0–4.

4 All objectives are met, work is done with care, and represents a child's best work.

3 Some objectives are met; not the child's best work.

2 Child struggled to grasp the concept; few objectives have been met.

1 Child did not grasp the concept, no objectives met, work is incomplete.

0 Child absent.

Teaching Tips

Check Materials Check your collections of found and natural materials before you begin.

Seek Donations Framing stores often have scraps of mounting board that they are happy to donate.

Limit Materials It helps to give children a specific number of materials that they can choose at the beginning.

Lesson Resources

Music CD (Davis)
davisart.com

Unit 7 Opener

Sewing

The process of sewing has all the elements that grab children—it is soothing, grown up, and repetitive, yet it can be infinitely varied. Sewing offers a kinesthetic, tactile, and sensory-motor way of learning. It is a developmentally appropriate challenge to children's skills.

The skills involved in sewing develop spatial awareness and eye, hand and mind coordination. Sewing often engages children with different learning styles, helping them feel successful. And, perhaps most importantly, sewing takes time. As children gain confidence in their skills, they become more invested in their work and return to it again and again. The winter months, when children spend more time inside, are a great time to introduce a sewing project.

Lessons in this unit:

Lesson 1 **Stitching Up and Down: Practicing Stitches**
Lesson 2 **Using Skills in a New Way: Sewing on Burlap**

Using a second color, this child fills in the spaces between her first set of stitches. Sewing teaches children to perform actions in a specific sequence.

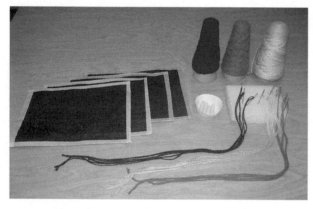

The basic materials for sewing on burlap are threaded needles and a piece of chalk for drawing lines and shapes.

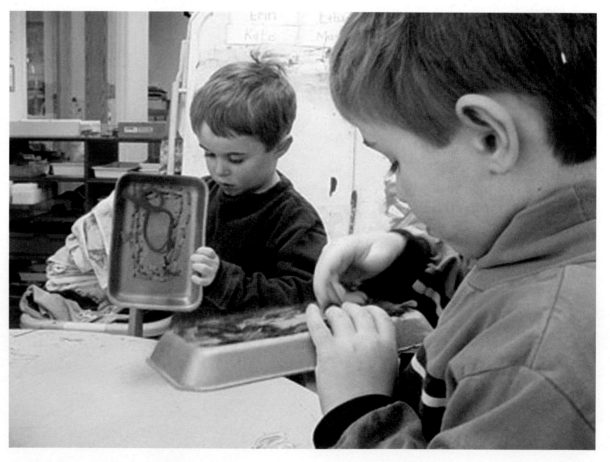

The act of sewing is absorbing.

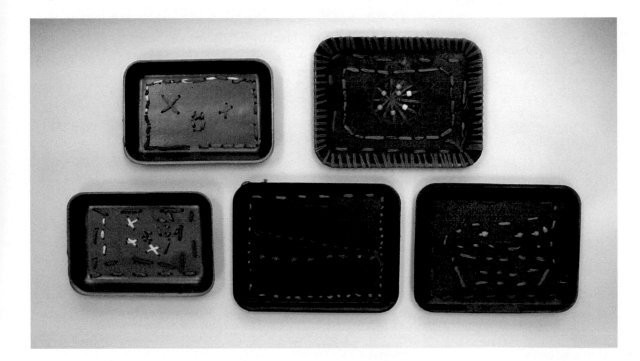

Once children understand the mechanics of the basic running stitch, they can apply their new skill in diverse ways.

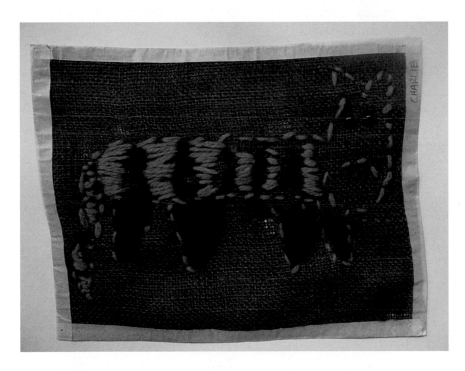

Results can be dramatic!

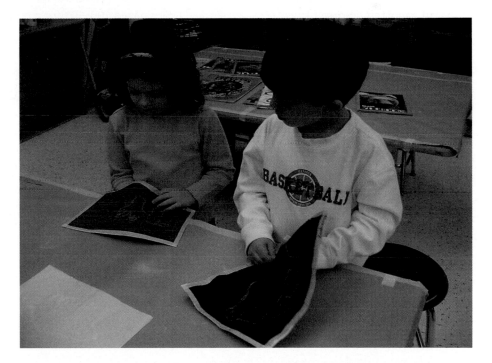

Drawing a planned design in chalk beforehand gives the children a line to follow with their yarn.

UNIT 7 **SEWING**

LESSON 1 **Stitching Up and Down**
Practicing Stitches

PREPARE

Objectives
While children practice the process of sewing, and in particular the running stitch, they will:
- learn that sewing has played an important role in every culture.
- learn how to control a needle and thread.
- learn how to differentiate between the front and back of a tray.
- use spatial and perceptual skills, such as following a sequence and predicting the placement of the next stitch.
- learn the difference between the *running stitch* and the *overhand stitch*.

Materials
- Standard weight yarn (not too thick) in assorted colors
- Needles (plastic blunt needles or metal tapestry needles, blunt size 18)
- Styrofoam trays (see Supplies, p. 63) with holes poked across one side of the tray, one per child
- Permanent markers (for the teacher only)
- Scissors (see Teaching Tips)

Setup
- Write children's names on trays ahead of time using permanent markers.
- You should use the needle to poke holes across one side of each child's tray. The holes should be about a finger's width (about ½" or 1 cm) apart, using the needle.
- One needle, threaded with about 18" (46 cm) of doubled thread, with a knot at the end, per child to begin.
- A brick of Styrofoam or an empty egg container will effectively hold extra needles and threaded needles when children are finished.

Vocabulary

English	Spanish
sewing	coser
running stitch	puntada corrida
overhand stitch	puntada por encima
Styrofoam	espuma de poliestireno
holes	orificios
needle	aguja
eye of the needle	ojo de la aguja
blunt point	punta roma

National Standards
1a, 1c, 1d, 2c, 3a, 3b, 5a
See pages 100–101 for a complete list of the National Standards.

UNIT 7 LESSON 1

Stitching Up and Down
All over the world, people sew.
Where can you see stitches?
Are they for decoration or for holding fabric together?

62

TEACH

Engage
1 Engage children in discovering stitches on their clothes and shoes. Have them show a stitch to their neighbor.

2 Reinforce that **sewing has a practical use and can also be decorative**. Refer to examples in the Big Book. Emphasize that people sew all over the world. Ask: Has anyone in this classroom needed stitches to repair a wound?

Explore
1 **Introduce the needle**, its eye, and blunt point. Demonstrate how to hold the needle.

2 Make a set of rules for needle safety in the classroom.

3 Show children a Styrofoam tray, the holes poked in it, and demonstrate how to hold it.

4 Examine the needle and thread together. What do they notice? Draw their attention to the knot in the thread. Why is it there?

5 Introduce the tray as having a front and a back. The back is where the knots go.

Create **Part 1**
1 Explain that there are many different kinds of stitches. We are going to practice the running stitch. Demonstrate choosing the first hole.

2 **Demonstrate poking a threaded needle into the first hole** and up from the back of the tray. Gently pull your thread through so the knot sits on the back.

3 Explain that sewing is just a pattern of ups and downs. To make this clearer, say the words "up" and "down" as you make stitches. Exaggerate pulling the thread all the way through each time.

4 Finish sewing the first side of the tray. Then demonstrate poking holes for the next side.

5 **Show children problems they may run into**:
- Catching the string on the corner.
- Going "down, down" or "up, up." Explain that this is a common mistake but it also makes another stitch-the overhand stitch!
As a class, discuss problems as they arise and brainstorm how to solve them.

Practicing Stitching

Learn the running stitch.

1 Start at the back. Push the needle **up.**

2 Pull the thread through.

3 Push the needle down through the next hole. Pull the thread **through.**

4 Sew all the way across.

Needle Safety

Sit with plenty of space around you.
Pull **up** with your needle, not **out.**
Keep your needle away from others.
Put needles away when you are finished.

6 Demonstrate "un-sewing" and reinforce using other children as problem-solving resources.

7 Demonstrate the steps to follow when the thread begins to run out:
- Leave 2" to 3" (5 to 8 cm) of yarn.
- Push the needle to the back of the tray.
- Cut the thread off **right next to** the needle. (Children tend to cut it off right next to the tray.) Discuss reasons for leaving ends longer.
- Use the remaining thread to tie a knot. (These threads can also be left untied for a teacher to tie later.)

Part 2

1 When the children have gone once around the tray, show them how to take a second color and go back through to **fill in the spaces between the stitches**.

2 Demonstrate how to sew an X and a star, a flower, or a snowflake shape (see diagrams). In each case, start by demonstrating and discussing the placement of the dots. Demonstrate coming up into the middle dot each time and poking the needle down through an outside dot.

Variations/Extensions
- Children can design and plan their own stitches. Challenge them to make different shapes.
- When planning for X's, stars, and flowers, some children may want to poke their own holes. This is at your discretion, but it can be made easier if you mark the holes with a permanent marker.

Assessment
Assessment is based on a scale of 0–4.
4 All objectives are met, work is done with care, and represents a child's best work.
3 Some objectives are met; not the child's best work.
2 Child struggled to grasp the concept; few objectives have been met.
1 Child did not grasp the concept, no objectives met, work is incomplete.
0 Child absent.

Lesson Resources

Inventing Kindergarten by Norman Brosterman (Abrams, 2002)

Other Resources
Music CD (Davis)
davisart.com

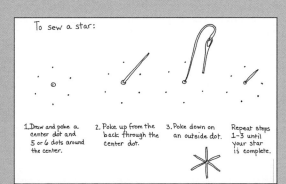

To sew a star:
1. Draw and poke a center dot and 5 or 6 dots around the center.
2. Poke up from the back through the center dot.
3. Poke down on an outside dot.
Repeat steps 1–3 until your star is complete.

Teaching Tips

Filling Spaces A child came up with the idea of filling in the spaces between the original running stitches on both sides of the tray. The rest of the children in the class jumped at this discovery and could not wait to try it. This is another spatial and perceptual challenge, but one that children love to accomplish!

Poke Holes First This project works better if a teacher pokes holes in one side of the tray before the lesson begins. Then children develop a sense of how the holes are spaced, and they can just start with the sewing. Once they have sewn across the first side, they can poke their own holes. This prevents random sewing across the tray, and keeps them sewing in sequence.

Scissors At first, you should hold onto the scissors. Remember, children really like to cut!

Extra Needles Have them available and threaded, in reserve.

Limit Colors Limit the number of colors available in the beginning.

Yarn Colors Pair colors that stand out from each other, so children can visually discriminate between them. Yarn colors should also contrast with tray colors.

Share Examples It's surprising how many stitchery examples one can find when looking through closets and drawers.

Have Extras Ready Once children feel in control of their stitches, they are eager to keep going. Make extra trays, yarn, and threaded needles available for them.

Kindergarten Occupation Both sewing and perforating were included in Friedrich Froebel's "occupations" for children when he conceived the original idea of kindergarten in the mid 1800s.

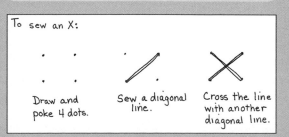

To sew an X:
Draw and poke 4 dots.
Sew a diagonal line.
Cross the line with another diagonal line.

Using Skills in a New Way
Sewing on Burlap

UNIT 7 LESSON 2

Using Skills in a New Way

Some artists use their sewing skills
 to make designs.
Where can you see the running stitch?

64

PREPARE

Objectives
While children design and sew on
burlap, they will:
- learn that once you have mastered
 a skill, such as sewing the running
 stitch, there are infinite ways to vary it.
- understand that hands and minds
 must work together to figure out the
 many logistics of sewing.
- learn that complex designs can grow
 from a simple beginning.
- use stitches to attach a bead.

Materials
- Burlap, 8½" x 11" (22 x 28 cm),
 1 per child
- Threaded needles, 1 per child, many
 extra in reserve if possible
- Standard weight yarn (not too thick)
 in assorted colors
- Needles (plastic blunt needles or
 metal tapestry needles), blunt size 18
- Chalk, 1 piece per child (in reserve)
- Scissors (at the discretion of the
 teacher)
- Pony beads or beads with a wide
 enough hole for the needle

Setup
Cut burlap into 8½" x 11" (22 x 28 cm)
pieces, if necessary.
Have threaded needles, with about
18" (46 cm) of thread when knotted at
the end, in a small brick of Styrofoam
(in reserve).

Vocabulary
English	Spanish
running stitch	*puntada corrida*
burlap	*arpillera*

National Standards
1a, 1b, 1c, 1d, 2b, 2c, 3a, 3b
See pages 100–101 for a complete list of
the National Standards.

TEACH

Engage
1 Hold up an example of stitchery from the previous
 lesson and **review key ideas** such as: all knots go
 on the back; pulling thread all the way through; and
 how to make the running stitch. Refer to the stitched
 examples shown in the Big Book. How do children
 think the stitches were made?

2 Explain that to practice the running stitch we are
 going to use a special material—burlap. Ask: Why do
 you think burlap might be special for sewing? (*It has
 holes; it is made of small threads loosely woven together.*)

Explore
1 Explain that children are going to use the running
 stitch to **sew a simple line or shape on burlap**. Show
 different possibilities of simple shapes and lines by
 drawing and planning with a finger. Shapes should
 be at least as big as a fist.

2 **Demonstrate using chalk** to draw the shape
 or line on the burlap. Drawing with chalk is
 a good way to mark an idea, and it wipes off
 easily. Explain that children will receive chalk
 after they practice their idea and show it to
 the teacher.

Create Part 1
1 **Review needle safety** and classroom rules.
2 Review procedures for the running stitch.
3 Demonstrate holding the burlap near where
 you want to make the first stitch. Demon-
 strate starting from the back, the side without
 chalk, poking the needle up. Sewing is hard.
 Hands and minds have to work together. Let
 children know that at first it will be difficult
 to hold the fabric with one hand and poke up
 from the bottom with the other. It takes many
 tries to poke the needle up at just the right
 spot. Demonstrate making mistakes by pok-
 ing up in several spots.

Sewing on Burlap

Think of a line, a shape, or an idea.
Draw with your finger first.

1 Draw with chalk.

2 Hold the fabric. Poke the needle up from the back.

3 Pull gently.

4 Measure. Poke the needle down.

5 Repeat the running stitch. Draw a second line or shape.

Unit 7 Sewing **65**

4 Explain that this line or shape is the first step in evolving a stitchery design. After children have stitched one line or shape, encourage them to draw and sew another!

Part 2

1 Demonstrate that sewing is a way of attaching things. **Show children how to add a bead** to the design (see diagram at right). Demonstrate the steps:
- Poke the needle up from the back.
- Place the bead onto the needle.
- Slide the bead down to the burlap while pulling the thread all the way up.
- Poke the needle down into the burlap **right next to** the bead and pull thread through to the back.

Variations/Extensions

- Children can add X's and flowers, stars, and snowflake shapes to the basic design.
- They can attach other objects, such as buttons and small pieces of fabric or netting, as long as the blunt needle can fit through them.
- You can do this lesson as a long-term project, with a subject such as animals, by following the same procedure. However, before working directly on the burlap, have children draw a plan with chalk on a piece of paper the same size as the burlap.

Assessment

Assessment is based on a scale of 0–4.

4 All objectives are met, work is done with care, and represents a child's best work.

3 Some objectives are met; not the child's best work.

2 Child struggled to grasp the concept; few objectives have been met.

1 Child did not grasp the concept, no objectives met, work is incomplete.

0 Child absent.

Sewing a Bead

Teaching Tips

Reinforce Edges Taping the edges of the burlap with masking tape makes it firmer for children to hold while sewing. Another option is for children to do an overhand stitch around the perimeter of the burlap before starting the stitchery design.

Colors Choose yarn colors that contrast with the color of the burlap.

These three boys all decided to use an octopus as the subject for their sewing.

Lesson Resources

Children's Trade Books
Corduroy by Don Freeman (Puffin, 2007)
The Keeping Quilt by Patricia Polacco (Aladdin, 2001)

Other Resources
Music CD (Davis)
davisart.com

Unit 8 Opener

Animals

There is something empowering about being able to draw or sculpt an animal that looks realistic. This unit introduces children to artist's strategies for drawing animals from observation. This unit also emphasizes the importance of practicing—and taking a chance. Each lesson reviews basic approaches to drawing animals and adds a new challenge for children to put their new skills to use.

When I overheard a child saying, "I'm sweating!" and another child responding, "It takes courage!" it became clear that although drawing animals is never an easy task, it is one that children welcome and face with determination and excitement. The support of an empathetic teacher can make all the difference.

Lessons in this unit:

Lesson 1 **From 3-D to 2-D: Ways to Draw Animals**
Lesson 2 **Understanding Space: An Animal Composition**
Lesson 3 **Understanding Form: Clay Animal Sculptures**

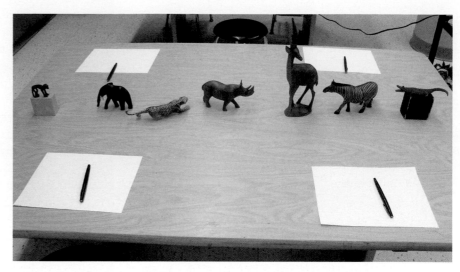

Three-dimensional models allow children to observe animal features and proportions at close range.

"You never get to the horizon line. If you get to where the horizon line is, then it seems farther off. It seems like you can't get to it. Your eyes play tricks on you.

"If someone was on the horizon line and you were to walk towards them, the horizon line would move away. Another person might look at you and think that you were on the horizon, but from your point of view, a different part of the sky would be on the horizon line.

"The truth is, wherever you are is the horizon, because the horizon is where the sky touches the ground. And the sky touches the ground on all parts of the world."—Simon, age 6

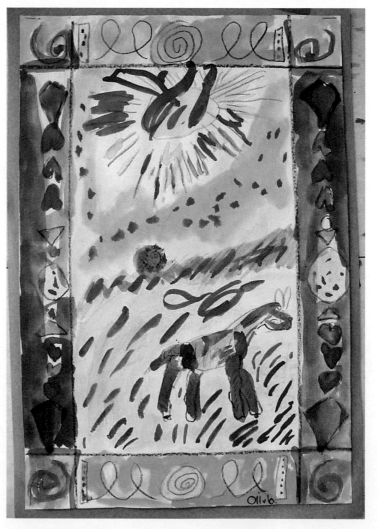

If you create a border for children to work within, you can reinforce concepts of symmetry, pattern, and repetition in the context of a drawing or painting lesson.

Black crayons are excellent drawing tools for creating a composition. No matter how the children paint in the composition, the details of the drawn lines stand out.

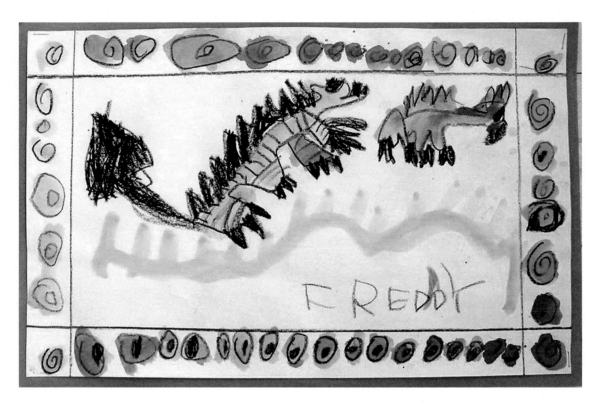

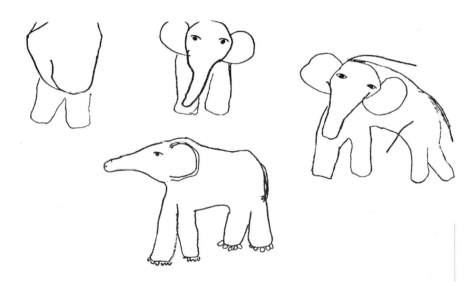

Using models makes the concept of point of view—front, side, top, and three-quarter—clearer to children. Some children are capable of astonishing powers of observation and expression, even at age five.

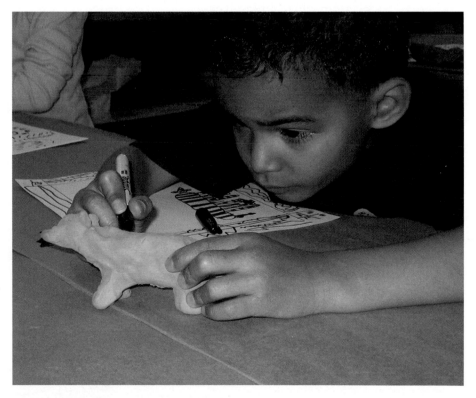

Children can add details, using markers, to fired animal sculptures.

UNIT 8 ANIMALS

LESSON 1 **From 3-D to 2-D**
Ways to Draw Animals

PREPARE

Objectives
While practicing three approaches to drawing animals, children will:
- have the opportunity to explore and make mistakes while discovering which approach or combination of approaches works best for them.
- learn new techniques for drawing animals.
- observe the unique characteristics of a particular animal.
- confront the many challenges involved in rendering a three-dimensional form in two dimensions.

Materials
- Animal models, 1 per child
- Fineline black markers, 1 per child
- 8 ½" × 11" (22 × 28 cm) white paper

Setup
- Set 1 one piece of white paper and 1 black marker per child.
- Have available an assortment of animal models from which children can choose.

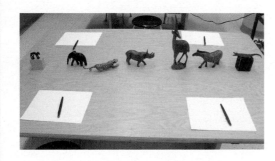

Vocabulary

English	Spanish
shape	forma
contour	contorno
outline	contornear
detail	detalle
texture	textura
point of view:	punto de vista:
front, back,	frente, atrás,
side,	lado,
three-quarter,	tres cuartos,
top	parte superior

National Standards
1b, 2b, 4a, 4b, 5a, 5b, 5c, 6b
See pages 100–101 for a complete list of the National Standards.

UNIT 8 LESSON 1

From 3-D to 2-D

Artists drew these animals.

Some were drawn long ago.

Do you think the artists saw these animals or just imagined them?

Prehistoric cave paintings, 22,000–13,000 BCE. Lascaux, Perigord, France.

Eliott Offner, *Porcupine*, 1987. Woodcut.

66

TEACH

Engage
1 Animals have been important to humans since the beginning of time. **Focus on the cave paintings** in the Big Book. Tell the story of the boys who discovered the cave paintings and discuss them. Ask: Why do you think these images were painted?

2 Drawing and painting animals is difficult for even the most experienced artists. Today we are going to practice a few different strategies for thinking about and beginning to draw an animal.

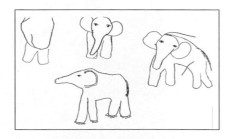

Explore
1 **Demonstrate three different approaches** to drawing an animal. Start with the **Shape Approach**:
- Feel the shape of your animal with your eyes closed.
- Begin with an oval for the body.
- Add the head, neck, tails, whiskers, and other details.

2 Next, try the **Outline or Contour Approach**:
- Look closely at your animal.
- Begin at the top of the animal's head.
- Without taking your eyes off your animal, let your marker record each detail as it moves around the outside edge of the animal. Train your eyes to draw and your hands to see. This approach often captures the unique qualities of a particular animal, but it takes practice to achieve this high level of concentration.

3 Finally, have children try the **Detail and Texture Approach:**
- Begin with only the details of the eyes, nose, mouth, ears, and horns—the features on the animal's head and face.

Ways to Draw Animals

Try all three ways. Keep trying—it takes practice!

1 Shape

Feel the shape. Begin with an oval for the body. Add other shapes.

2 Outline

Practice first. Start at the head. Draw what you see. Focus on the edge of the animal.

3 Detail and Texture

Look for eyes, nose, whiskers, claws, ears, horns, and other markings.

Look for textures.

Start with the head and work down.

- Try to show the animal's texture by repeating the line and shape markings you see.
- Work down to the hooves and tail. This approach works best with animals that have distinctive markings or long fur.

Create Part 1

1 Encourage children to **try drawing one animal using each approach**. Reassure them that drawing animals is difficult, and if they aren't making any mistakes they aren't trying anything new! Don't cross out, just begin again in a new place.

2 If children finish early, they can try a second animal.

Part 2

1 Ask children to **reflect on their experiences**. What approaches did they use? Did anyone combine approaches? Did anyone figure out a new approach?

2 Encourage children to try drawing an animal from different points of view. Show an animal model from the front, top, side, and three-quarter point of view.

Variations/Extensions

- It's exciting to try this lesson using black paint and a brush, or crayons, on larger paper.

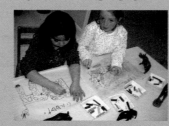

Children enjoy coloring their practice drawings with earth-color crayons.

- This lesson can focus on animals from certain areas of the world, or on local animals. Or it can focus on just one animal, such as elephants, and how their characteristics differ in different countries or continents.
- Invite a pet into the classroom for observation drawing of a live animal.
- These drawings can be easily shrunk on a photocopier and then used to add illustrations to notes and mailings home.
- Suggest that children continue practicing drawing animals while at home, using a live pet or models.

About the Artwork

The ancient paintings shown in the Big Book were discovered in 1940 in central France by a group of young boys. When their dog fell into a hole, they explored a tunnel that led to an underground chamber that contained the paintings. The paintings have been found to date from about 15,000 BCE.

Assessment

Assessment is based on a scale of 0–4.
4 All objectives are met, work is done with care, and represents a child's best work.
3 Some objectives are met; not the child's best work.
2 Child struggled to grasp the concept; few objectives have been met.
1 Child did not grasp the concept, no objectives met, work is incomplete.
0 Child absent.

Teaching Tips

Animal Models Many children have animal models at home that they would be willing to bring in and share.

Small Achievements It's important to hold up the drawings and point out how much the children have achieved.

Which Approach? Hold up children's work and have children guess which approach was used.

Coordinate with Class Work It's difficult to remember animals in a vacuum. It makes sense to coordinate animal drawings with classroom studies of a particular animal or animals and their habitats.

Scenes Some children will draw a scene around their animal. Keep these works in mind when introducing the next lesson on animal composition.

Lesson Resources

Children's Trade Books
Maria's Cave by William Hooks (Coward, McCann, 1977)
How Artists See Animals by Colleen Carroll (Abbeville, 1996)
Animals: Through the Eyes of Artists by Wendy and Jack Richardson (Children's Press, 1991)

Other Resources
Music CD (Davis)
davisart.com

Understanding Space
An Animal Composition

Understanding Space

Some artists show space around animals.

Which animals are nearest?

Which are farthest away?

How can you tell?

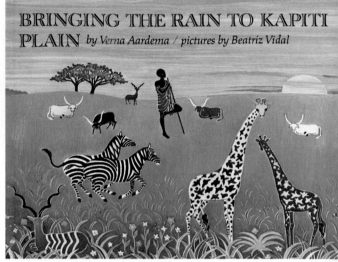

Cover art from *Bringing the Rain to Kapiti Plain*, by Verna Aardema, pictures by Beatriz Vidal, 1981.

68

PREPARE

Objectives
As children draw animals and create a setting, they will:
- continue practicing techniques and building confidence in their ability to draw animals.
- solve the problems of portraying a three-dimensional scene on a two-dimensional surface.
- begin to evolve a new perception of space.

Materials
- Animal models
- Fineline black markers
- Crayons (in reserve)
- White paper, 9" × 12" (23 × 30 cm) or slightly larger, 1 piece per student

Setup
- Set out one piece of paper and 1 fine-line marker per child.
- Allow children access to at least 1 animal model.

Vocabulary

English	Spanish
shape	*forma*
outline	*contornear*
detail	*detalle*
texture	*textura*
composition	*composición*
design	*diseño*
balance	*balance*
horizon line	*línea del horizonte*
foreground	*primer plano*
background	*fondo*
space	*espacio*

National Standards
1a, 1b, 1c, 2a, 2b, 2c, 3a, 3b, 6b
See pages 100–101 for a complete list of the National Standards.

TEACH

Engage
1 Read *Bringing the Rain to Kapiti Plain* (see Resources). Looking at the illustrations gives children an opportunity to look at animals in context.
2 **Discuss how the artist creates a feeling of distance**. Discuss the concepts of foreground, background, and horizon line.

Explore
1 **Review the shape, outline, detail, and texture methods** of drawing animals. Also review drawing animals from different points of view, referring to children's drawings from the previous lesson.
2 Ask children to **think about the animal** they've drawn. They should consider questions such as these:
- What is your animal's habitat?
- Will you place your animal in the jungle, in the forest, on the plains, on a farm, or in a rainforest?
- What does your animal eat? How does it get its food?
- What other animals would share its habitat?
- How does it get water?

Create Part 1
1 Ask children to decide whether to hold their papers horizontally or vertically.
2 Encourage children: start by drawing your animal, and let the story of the animal evolve as you draw.

Part 2
1 Reintroduce *Bringing the Rain to Kapiti Plain*. Draw children's attention to the way the colors in the land change throughout the book.
2 **Review crayon techniques**, especially using the side of the crayon to cover big areas. Emphasize blending together more than one color.

An Animal Composition

Draw one large animal or several animals.

1 Where will your animal be?
In the jungle, the desert, the woods,
a rainforest? In your arms?
In a circus? At the zoo?

2 Will your drawing be vertical or
horizontal?

Does your drawing tell a story?

Try Different Points of View

Top view

Front view

Back view

Three-quarter view

Side view

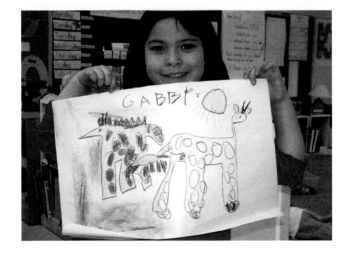

Variations/Extensions

• This lesson can be done with a variety of media: crayons, markers, fine-line pens, and paints. Adjust the paper size accordingly.

• Working within a frame often helps children achieve a more unified and pleasing composition. It makes it necessary for children to repeat shapes, lines, and colors both in the frame and composition. Use a template to mark off a 1½" (4 cm) border on each side. Keep extra frame templates available for children who finish early and want to do another drawing.

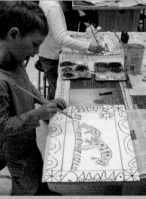

Suggest that children repeat shapes in borders and at corners to create balance.

Assessment

Assessment is based on a scale of 0–4.

4 All objectives are met, work is done with care, and represents a child's best work.

3 Some objectives are met; not the child's best work.

2 Child struggled to grasp the concept; few objectives have been met.

1 Child did not grasp the concept, no objectives met, work is incomplete.

0 Child absent.

Teaching Tips

Recognize Accomplishments
A child's feeling of confidence hinges on recognizing his or her accomplishments. A teacher is instrumental in pointing out specific examples of achievement.

Record Stories As children draw, stories evolve. Keep index cards or paper strips on hand to capture children's quotes and stories.

Lesson Resources

Children's Trade Books
Bringing the Rain to Kapiti Plain by Verna Aardema, illustrated by Beatriz Vidal (Puffin Books, 1992)
The Water Hole by Graeme Base (Puffin Books, 2004)

Other Resources
Music CD (Davis)
davisart.com

LESSON 3 Understanding Form
Clay Animal Sculptures

Understanding Form

You see something different on each side of a sculpture.

What parts of a pig do you see?

What do you think the girl sees?

Eliott Offner, Pig, 2001. Bronze.

70

PREPARE

Objectives
As children work at sculpting an animal, they will:
- experience what it means to make a sculpture in the round.
- solve structural problems they encounter.
- think about the specific characteristics and gestures of a particular animal.
- extend their understanding of clay and its unique qualities.

Materials
- Animal models
- Moist terra cotta (low-fire) clay, a fist-sized ball for each child
- Clay boards, one per child
- Pencils, sharp sticks, or toothpicks to use as clay tools (in reserve)
- Small dishes with no more than ½"(1-2 cm) of water (in reserve, if necessary)

Setup
Put out the clay on a clay board for each child.

Vocabulary

English	Spanish
sculpture in the round	escultura abstracta
form	forma
terra cotta	terracota
sturdy	resistente
balance	balance

National Standards
1b, 1c, 2c, 3a, 3b
See pages 100–101 for a complete list of the National Standards.

TEACH

Engage
1 Focus on the images in the Big Book. Point out that if children were in a room with these sculptures, they could walk around them and see all sides. Ask: What do you think you would see if you looked at these sculptures from the back? From the side?

2 **Introduce the concept of sculpture in the round:** unlike relief sculpture, which has a flat back and might hang on a wall, sculpture in the round can be looked at and appreciated from any angle.

Explore
1 Just as there are many approaches to drawing animals, **there are also many approaches to sculpting them**. Hold up a model of a four-legged animal. Ask for suggestions of ways to begin sculpting it from clay.

2 As children give you suggestions, refer to directions in the Big Book and demonstrate some of their ideas.

3 Demonstrate the two ways to add legs. Emphasize that clay legs need to be thicker and shorter than they are in real life.

Create Part 1
1 Ask children to **think about what their animals are doing**. Are they standing, sitting, scratching, running, pointing, or sleeping? Discuss their possible positions.

2 Encourage children to have a dialogue with the clay and keep an open mind. The clay itself might show them an animal or a position they want to create. Discuss and demonstrate solving a problem.

Clay Animal Sculptures

Think about an animal you know well.
How could you begin to build it with clay?

1 Gently squeeze a shape.

2 Model or add legs if needed.

3 Position your animal.
What is it doing?

4 Reinforce weak parts.

Part 2

1 When all the children have an animal developing, stop the class and have them **smooth their animals**. Encourage them to turn their clay boards and examine the animals from all points of view. Have them gently reinforce any weak parts.

2 Ask children to think about their animals' unique markings, textures, and details. Have them add appropriate textures, but encourage them to be selective! Follow the form of the animal when adding texture. Caution children to press gently when using clay tools.

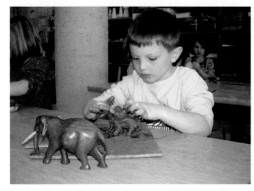

Some children like to choose an animal model to study as they work.

Teaching Tips

Help with Focus Have the children tell you what animal they intend to sculpt: it helps them focus. It is also important to recognize that the children's intentions may change as they work.

Sturdy Limbs and Necks There are many different ways to create animals from clay. Encourage children to be creative and try new things. However, emphasize that the animals need to have sturdy legs and necks if they have heavy bodies or heads.

Connect Forms in Multiple Places Encourage children to make connections between forms whenever possible. For instance, a thin tail will be the first thing to dry and fall off. However, if it is connected to the sculpture in a second place, it will have a better chance of surviving.

Use Water Sparingly Add water only as needed. The sculptures can become very wet and collapse.

Check All Work Before sculptures dry, plan to check for and fix structural problems. Write names on bottom.

Feeling Aids Understanding Children will have an easier time drawing the animal if they understand how it's formed. Feeling the models with their eyes closed helps them "see" the shapes. Similarly, mimicking animal poses helps them understand the animal's position, weight, and stance.

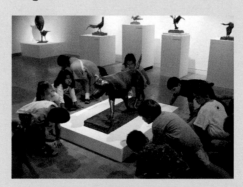

About the Artist
Elliot Offner says "By sculpting the subjects of nature, I call attention to . . . form . . . Everything I do has to have motion."

Variations/Extensions

- Children can add details to fired animals using permanent markers or black paint and detail brushes. Have them plan the details beforehand by drawing their animals and including any textures or markings they want to add.

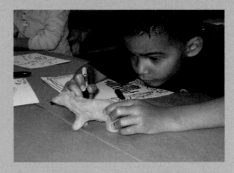

- Have students make a second, larger or smaller sculpture. The second sculptures usually are easier and faster to complete because students already have been through the process.

Assessment
Assessment is based on a scale of 0–4.
4 All objectives are met, work is done with care, and represents a child's best work.
3 Some objectives are met; not the child's best work.
2 Child struggled to grasp the concept; few objectives have been met.
1 Child did not grasp the concept, no objectives met, work is incomplete.
0 Child absent.

Lesson Resources

Children, Clay, and Sculpture by Cathy Weisman Topal (Davis, 1984)

Other Resources
I Am Clay (Video 2006)
Music CD (Davis)
davisart.com

Unit 9 Opener

Color

Mixing new colors is part of the fun and intrigue of painting. Children love to solve problems, and solving color problems is good preparation for later challenges in art.

Mixing appeals to the scientifically-minded child because the results are predictable. The mixing process is very much like a laboratory experiment. Mixing also appeals to the restless youngster because the results are dramatic and immediate. For all children, mixing colors is always a bit like magic!

Lessons in this unit:

Lesson 1 **Color All Around: Mixing Primary Colors**
Lesson 2 **Seeing Colors: Mixing Tints that Match**
Lesson 3 **Seeing People: Matching Skin Tones**

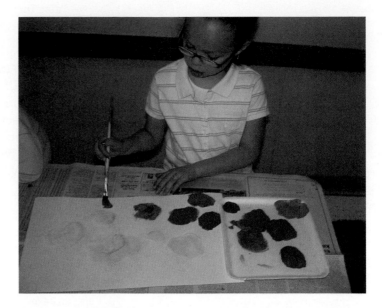

Mixing colors creates opportunities for wonderful surprises. Children love naming colors as they watch them emerge.

Displaying a color wheel in the classroom, and referring to it when opportunities arise, helps reinforce color concepts.

Mixing the colors of one's own skin and clothing is not easy, but it is satisfying! Learning a little about color mixing enables children to help one another figure out how to make a desired color when the need arises.

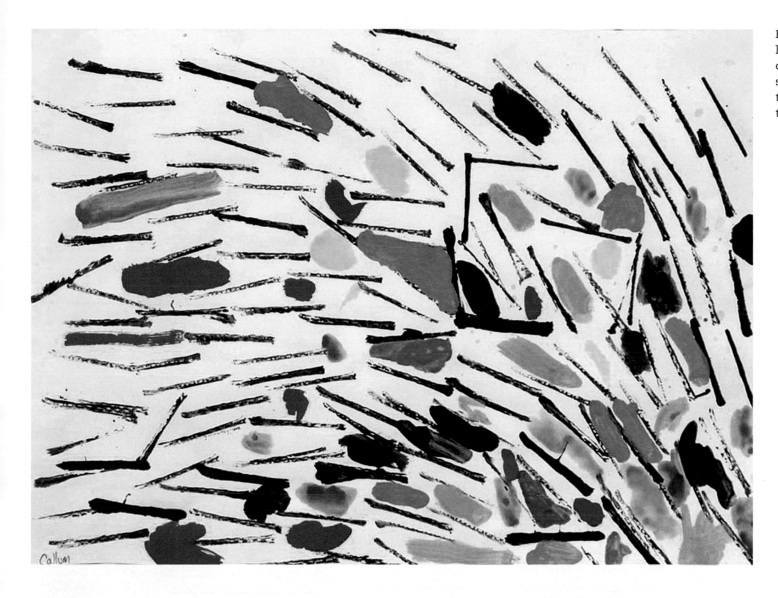

Black line paintings or line prints make beautiful compositions when the spaces are filled in with colors the children have mixed themselves.

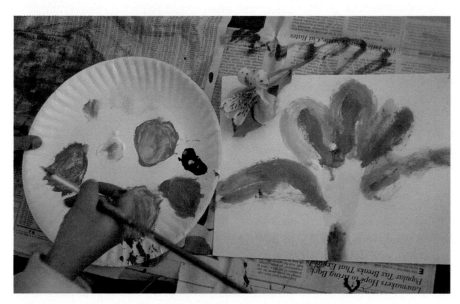

Matching the tints of a flower is an exercise in observation as well as an exciting color-mixing challenge.

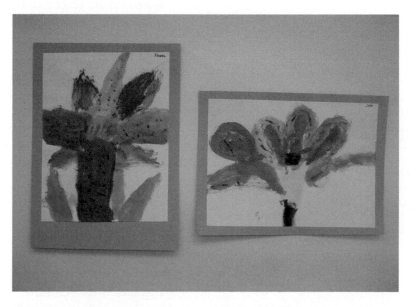

Close observation of flowers can result in detailed paintings like these.

Color All Around
Mixing Primary Colors

Color All Around

Artists make their own paint colors.
Name the primary colors you see.
Name the secondary colors you see.

Robert Delaunay, *Hommage à Blériot*, 1914. Tempera on canvas.

72

PREPARE

Objectives
As children mix and paint hues, they will:
- use the primary colors to mix secondary colors and new hues.
- see subtle differences between and among hues.
- describe hues using their own vocabulary.
- use the scientific process of making a prediction, doing an experiment, and reflecting on their findings.
- recognize negative spaces that can be filled with color.

Materials
- Styrofoam trays, plastic plates, or mixing trays, 1 per child
- Easel paint brushes, not too thick, about ⅜" (1 cm), 1 per child (1 additional per child in reserve)
- Any previous line work (see Teaching Tips)
- Tempera paint (yellow, red, and blue) in squeeze bottles

Setup
- Cover tables with newspaper.
- Have children's previous line work available (see Teaching Tips).
- Set out 1 tray, with a dollop of yellow paint only, per child (red and blue paint in reserve).

Vocabulary

English	Spanish
primary colors:	colores primarios:
yellow	amarillo
blue	azul
red	rojo
secondary colors:	colores secundarios:
green	verde
orange	anoranjado
purple	violeta
color wheel	rueda de color
hues	tonos
palette	paleta

National Standards
1a, 1b, 1c, 1d, 2a, 2b, 2c
See pages 100–101 for a complete list of the National Standards.

TEACH

Engage
1 Explain to children that there are three colors that are very important. **Red, yellow, and blue are called the primary colors**. They are important because all other colors are created from those three colors. When artists placed the colors in rainbow order in a circle they found they could see and understand relationships between them.

2 **Discuss the artwork in the Big Book**. Ask: Where do you see primary colors? Define and identify secondary colors: orange, green, and violet. Explain that the order of the colors, or pure hues, on the color wheel comes from the order of the colors in the rainbow. We are going to make some predictions about what will happen when we mix the primary colors.

Explore
1 **Demonstrate using your brush** to pick up some of the yellow paint from your palette. Paint with yellow on your paper.

2 Demonstrate painting yellow in a second place. Emphasize that children should use each color in more than one place in their paintings. Point out how many times yellow is used in the Delaunay painting.

3 Squeeze a dime-sized dollop of red paint onto the palette. Tell children: This is your pure red paint source. Do not mix other colors into it.

4 Demonstrate dipping the very end of the brush into the red paint. Explain that children will mix the red paint into the dollop of yellow until they have a pure yellow-orange hue with no streaks. They will then paint the yellow-orange in more than one place on their papers.

5 Encourage children to control their mixing, as they will need space to mix more colors.

Create Part 1
1 Before children begin to paint, have them **compare the mixed hue you created with the pure yellow** painted on the paper. Create a sense of wonder and excitement as you invite children to suggest a name for this new hue!

2 Allow children to begin to paint. After they have used the pure yellow, they should start mixing oranges. They should **repeat the mixing-and-painting process** until they have made three different oranges: yellow-orange, orange, and red-orange.

3 Have children paint pure red in more than one place.

Mixing Primary Colors

Use the three most important hues to make secondary colors.

 1 Pick up yellow paint from your palette.

 2 Paint areas of yellow on your paper.

 3 Dip the tip of your brush in red.

 4 Mix to make a pure hue. Paint your hue in at least two places.

 5 Repeat. Make three different hues.

The Color Wheel
The color wheel organizes colors and helps us see how they work together.

Unit 9 Color **73**

4 Once children have painted with red, hand out the tiniest bit of blue. Explain that blue is a stronger and darker color and can overpower other colors. Children need to keep this in mind when they are mixing three purples. (Don't demonstrate here; allow the children to make their own discoveries.)

5 Have children paint pure blue in more than one place.

Part 2

1 Once children have mixed at least three oranges and three hues of purple, stop the class. Ask: What secondary color hasn't been mixed yet? What colors should we use to mix it?

2 Encourage children to **mix at least three hues of green.** They will probably need refills of yellow and blue paint. Collect the old brushes and replace them with new ones. Some children may need a new palette.

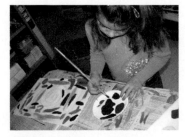

Variations/Extensions
- At the end of the lesson, let children predict what will happen when all colors on the palette are mixed. Compare browns.
- If a previous line work is not available, this lesson can be done on white paper. Be sure to remind children to repeat each mixed hue three times to create unity.

Teaching Tips

Work with Art From Previous Lessons Black line paintings or line prints from Units 1 or 5 make beautiful compositions when the spaces are filled in with mixed colors.

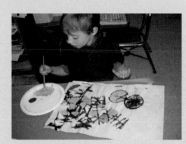

Don't Use Water One goal for this lesson is figuring out how to mix colors without the use of water. Washing all the color out of a brush and drying it complicates the mixing process. That can come later.

Try It First Trying this lesson beforehand helps you become comfortable with the mixing procedure and the amount of paint necessary.

Use Squeeze Bottles These make paint distribution quicker and less messy.

Display a Palette Save one palette to display along with the finished paintings. This helps others understand how these beautiful colors were created.

Assessment
Assessment is based on a scale of 0–4.
4 All objectives are met, work is done with care, and represents a child's best work.
3 Some objectives are met; not the child's best work.
2 Child struggled to grasp the concept; few objectives have been met.
1 Child did not grasp the concept, no objectives met, work is incomplete.
0 Child absent.

Lesson Resources

Children's Trade Books
Color Dance by Ann Jones (Trumpet, 1989)

Other Resources
Music CD (Davis)
davisart.com

LESSON 2 **Seeing Colors**
Mixing Tints That Match

Seeing Colors

Look closely at a flower.

How many different colors can you see?

How do you think the artist mixed these
colors?

Georgia O'Keeffe,
Bleeding Heart, 1932.
Pastel on paper-faced
cardboard

74

PREPARE

Objectives

As children mix tints and other hues
to match the colors they perceive in
flowers, they will:

- learn about tints.
- study a flower in detail.
- deepen their understanding of color
 mixing.
- hypothesize ways to mix specific
 colors.
- learn the procedure for rinsing and
 wiping the brush between dramati-
 cally different colors.

Materials

- Paintbrushes, ⅜" (1 cm), 1 per child
 (extra in reserve)
- Detail brushes, 1 per child (in reserve)
- White paper, 8½" × 11" (22 × 28 cm),
 1 per child (extra smaller pieces
 available for early finishers)
- Mixing trays, 1 per child (extra in
 reserve)
- Tempera paint in yellow, red, blue,
 and white
- Containers of water less than half full
 (in reserve)
- Flowers to observe, 1 per child

Setup

- Set out a mixing tray with white and
 one necessary primary color, a brush,
 a flower, and a piece of white paper
 for each child.
- Add containers of water when
 needed.

Vocabulary

English	Spanish
tint	tinte

National Standards

1a, 1c, 2a, 3a, 3b, 5c

See pages 100–101 for a complete list of
the National Standards.

TEACH

Engage

1 Draw children's attention to the Georgia O'Keeffe
painting in the Big Book. Ask: Has the artist shown
this flower from close up or far away? How many
colors has she used?

2 Tell children: You're now ready for a new challenge!
**We are going to mix hues to match the colors in a
flower**.

Explore

1 **Review color mixing** with children. Look
closely at a flower and make a list, with the
children, of the colors you'll need to mix.
Have children point out some lighter colors in
the flower. Ask: How do you think they were
made?

2 Introduce the idea that *a color mixed with white
is a tint*. Identify the lightest tint in the flower.
How might we make it?

3 Follow the children's suggestions for mix-
ing the tint. Reinforce the idea of confining
mixing to a small area. Paint some areas on
your paper. Mix the next slightly darker tint
and again add it to your paper to reinforce the
procedure.

Mixing Tints That Match

Mix the colors you see in a flower. Paint with them.

1 Start with the lightest tint you see.

2 Mix a small area of pure tint, with no streaks.

3 Paint with one color at a time.
Paint in more than one place.
Use up the paint on your brush.

4 Mix a slightly darker tint.

5 Wash and wipe your brush.

Mix your next tint or hue.

Create **Part 1**

1 The children have two choices for this painting lesson: They can mix all the colors they see in their flower and use them to make a painting of subject matter they choose; or they can use the colors they mix to paint a flower in the style of Georgia O'Keeffe. Invite children to offer ideas for how they would begin to paint their flower.

2 Encourage children to mix and paint increasingly darker tints. When you notice that they need the addition of another primary color, demonstrate the procedure for rinsing and wiping the brush before dipping into a new color.

Part 2

1 Hold up a few examples of paintings to share.

2 Brainstorm strategies for making a very dark color without the addition of black. (Blue and brown work well.)

3 Offer children a detail brush to use for adding finer lines and shapes to their paintings.

Variations/Extensions

- Have children make a one-color found-object collage.
- Collect paint swatches from a paint store that show a variety of subtle tints. Have children try to mix the tints.
- This lesson also works with fall leaves. Children can collect leaves with more than one color!
- This is a great lesson to offer for a teacher workshop. It can be done in a relatively short amount of time. It's challenging and exciting, and gives teachers a feeling of accomplishment.

About the Artist

Georgia O'Keeffe said, "Nobody sees a flower—really—it is so small it takes time—we haven't time—and to see takes time, like to have a friend takes time."

Teaching Tips

Flowers to Use Alstroemeria (a type of flower) work well for this lesson because they have a range of tints, a countable number of petals, line details, and a visible stamen and pistil; they do not wilt easily; and there are many blossoms to each stem, making them affordable. The teacher can easily cut off individual blooms with a stem and a leaf to pass out to each child.

One Flower Type for All Giving every student flowers of the same colors makes paint distribution easier.

Swirl, Don't Splash When introducing water, encourage children to wash their brush by gently swirling it in the water container without splashing. This is a way of generating respect for one's own work and the work of classmates.

Assessment

Assessment is based on a scale of 0–4.

4 All objectives are met, work is done with care, and represents a child's best work.

3 Some objectives are met; not the child's best work.

2 Child struggled to grasp the concept; few objectives have been met.

1 Child did not grasp the concept, no objectives met, work is incomplete.

0 Child absent.

Lesson Resources

Children's Trade Books

Georgia's Bones by Jen Bryant (Eerdman, 2005)

Through Georgia's Eyes by Rachel Rodriguez and Julie Paschkis (Henry Holt, 2006)

My Name is Georgia by Jeanette Winter (Harcourt Brace, 1998)

Other Resources

Music CD (Davis)

davisart.com

Seeing People
Matching Skin Colors

Seeing People

Skin has many different colors.
Describe the skin colors you see.
How many different skin colors
 do you have?

William Johnson,
Three Friends, 1944–45.
Serigraph on paper.

76

PREPARE

Objectives
While mixing unique skin colors and painting self-portraits, children will:
- understand that regardless of small differences in color, we are all alike on the inside.
- learn that all skin colors are hues, tints, or shades of brown.
- practice brush rinsing and drying procedures.
- practice mixing skills and procedures.

Materials
- Tempera cakes and white liquid tempera
- Paintbrushes: number 6 or 7 water-color brush if using tempera cakes
- Paintbrush: number 1, 2, or 3 water-color brush for details
- Mixing plate or tray
- White paper, 8 ½" × 11" (22 × 28 cm), 9" × 12" (23 × 30 cm), or larger
- Containers half filled with water
- Paper towels for drying brush after rinsing
- Mannequin

Setup
- Cover tables in newspaper.
- Have ready one piece of white paper, a size 6 or 7 paint brush, tempera cakes, a paper towel, and a mixing tray per child.
- Put a dime-sized dollop of white and an even smaller one of brown paint on the mixing tray.
- Water containers and tempera cakes can be shared by students.

Vocabulary
English	Spanish
skin color	color piel

National Standards
1a, 1c, 1d, 2b, 3a, 3b, 5b
See pages 100–101 for a complete list of the National Standards.

TEACH

Engage
1 Art is a way to learn about people. We can learn about people through the art they make, through the titles and explanations they give us for their work, and through portraits and other works in which people are the main focus. Refer to the artwork in the Big Book and **draw attention to the variety of skin colors** the artist has shown.

2 Point out that each of us has a unique color. We are each different hues, tints, or shades of brown. Have children examine the differences in color between the top and the underside of their forearm and palm. Have them compare arm colors with a neighbor and **think together about the colors necessary to mix a match of the colors** with paint.

Explore
1 **Review the procedures for mixing a tint**. Demonstrate mixing skin colors:
- Decide whether you will start with white or brown.
- Look at your skin and choose other colors you might need to add, such as white, brown, red, yellow, and blue.
- If your skin is more golden, you might want to add a touch of yellow; if it's rosier, add a tiny touch of red. If it's deeper in tone, add the tiniest touch of blue.
- Test the color on the back of your hand. Does it match?

2 **Review holding the brush** near the ferrule to paint precise details.

Matching Skin Colors

Practice mixing your skin color. Paint on the back of your hand to see if the colors match.

 1 Start with white and brown.

 2 Paint a head shape near the top of the paper.

 3 Paint areas of skin that will be showing.

 4 Wash and wipe your brush.

 5 Mix colors for clothes. Start with your top.

 6 Add details when paint is dry.

Create

1 Have children **start their self-portraits** by painting a head shape near the top of the paper using the "blob method" (see Unit 1, Lesson 7), allowing room for hair and hats.

2 Ask children to decide what clothes they will be wearing and where their skin will be showing (neck, arms, hands, legs, or feet). Demonstrate painting hands or other body parts, using the "blob method." With the skin color they have created, have children paint these body parts using the blob method, leaving space for clothes.

3 Discuss **finding and mixing the main colors of the children's clothing.** If their clothes have many patterns, advise them to paint one color at a time and allow it to dry before adding details.

4 Demonstrate placing one article of clothing in your painting. Tell children to paint all of the colors first. They can add black with a detail brush at the end, once the paintings have dried.

Variations/Extensions

- Instead of giving children brown, you may want to encourage them to mix it for themselves using the primary colors.
- Once paintings are dry, children can add details using a small watercolor brush and black paint or fine-line markers.
- This lesson can be geared to reflect the seasons and the weather: snow clothes, summer clothes, rain gear, or bathing suits. Or it can depict a favorite outfit, the clothes the children are wearing, dress-up clothes, or favorite pajamas.
- Instead of the whole body, ask children to focus on the head and chest, as William Johnson did.
- This lesson can also focus on drawing, using markers or crayons.

Teaching Tips

Use Bright Colors If the main color of children's clothing's is black or brown, encourage them to choose another, brighter color.

Blot with Tissue If something bleeds or runs, blot with a tissue, not a paper towel. Tempera cakes are easier to control than liquid tempera and allow children to work on a smaller scale, but liquid tempera will also work.

Blob Method This is a nonthreatening approach that helps children get started. Be sensitive to those children who follow their own strategies.

Mix Small Amounts When mixing skin color, emphasize using very small amounts of color. It's easy to add more, but adding too much means you may have to start over.

Mixing Is Empowering It is empowering for children to mix their own skin color and to begin to see the variety of skin tones that they are able to make from just a few colors. Several manufacturers have come out with multicultural paints, markers, and crayons, which can also be helpful.

Assessment

Assessment is based on a scale of 0–4.

4 All objectives are met, work is done with care, and represents a child's best work.

3 Some objectives are met; not the child's best work.

2 Child struggled to grasp the concept; few objectives have been met.

1 Child did not grasp the concept, no objectives met, work is incomplete.

0 Child absent.

Lesson Resources

Starting Small: Teaching Tolerance in Pre-school and the Early Grades by Vivian Gussin Paley (Teaching Tolerance, 1997)

Other Resources
Music CD (Davis)
davisart.com

Unit 10 Opener

Buildings and Cities

Looking at and painting the important shapes is a first step in developing any composition. Before artists can do this, they must analyze or break down an object into its basic shapes. This is a special way of looking and a first step towards visual literacy. It is a way of looking that artists are especially good at, but that most people do not come by naturally.

Being visually literate—or seeing as an artist sees—includes looking through eyes that find rectangles, squares, and triangles instead of specific things like doors, windows and roofs. It's important for teachers of visual arts to help children learn the skill of seeing in this special way.

Lessons in this unit:

Lesson 1 **Seeing Shapes: Painting Houses Expressively**
Lesson 2 **Seeing Buildings: Drawing from Observation**
Lesson 3 **Making Choices: Cut Paper Cityscapes**

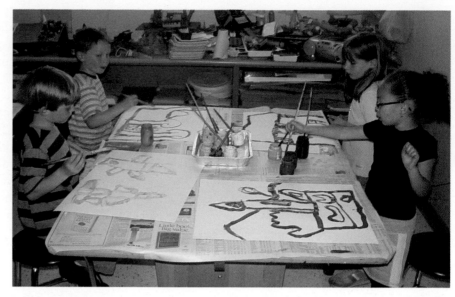

Using just one color of paint for planning allows children to focus on main lines and shapes and on how they fill the page.

When the black line paintings are finished and dry, children can fill in the spaces with color.

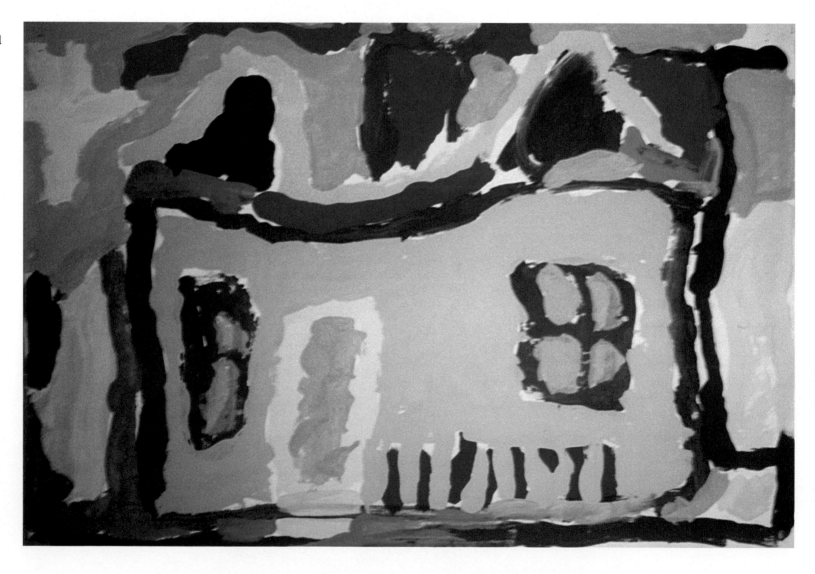

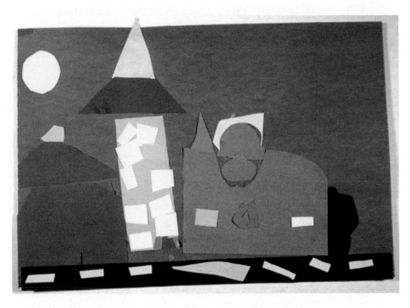

Details cut from paper strips add personality and color contrasts to collage cityscapes.

It is important to review gluing techniques with every collage lesson, as gluing small shapes can be especially challenging..

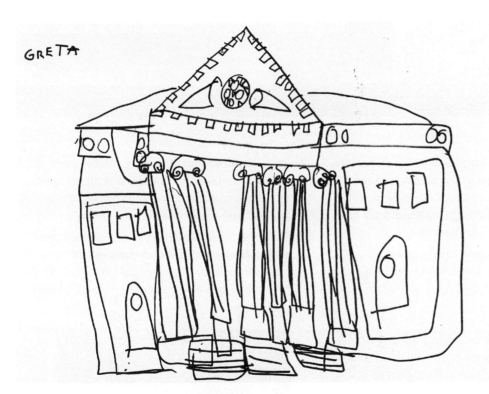

GRETA

Buildings with interesting shapes and features give children a reference point and inspire wonderful drawings.

With the proper preparation, outdoor drawing sessions can be exciting and productive for everyone.

UNIT 10 BUILDINGS AND CITIES

LESSON 1 Seeing Shapes
Painting Houses Expressively

PREPARE

Objectives
While designing an imaginary or realistic house, children will:
- break a common form into its component shapes; this is a form of analytical thinking.
- gain awareness of planning procedures used by painters.
- learn to articulate their approaches to painting blob and outline/contour shapes.
- engage in a form of peer review.
- use colors expressively.

Materials
- Tempera paint, in jars or separate containers, enough for at least 1 per child and a few extras
- Paintbrushes, 1 for each jar or container of paint
- White paper, 18" × 24" (46 × 61 cm), 1 per child, trimmed if desired
- Black paint and thin brushes for adding details at the very end, if desired (in reserve)

Setup
- Cover tables with newspaper.
- Put paper for each child on the tables.
- Have jars of paint, with brushes, ready on the tables, including the primaries, their tints, secondary colors, variations such as red-orange, marigold, spring green, and so on.

Vocabulary

English	Spanish
door	puerta
window	ventana
windowpane	cristal de la ventana
chimney	chimenea
porch	porche
stairs	esaleras
shutters	persianas
roof	techo
columns	columnas

National Standards
1b, 1c, 2a, 3a, 3b, 5b, 5c
See pages 100–101 for a complete list of the National Standards.

TEACH

Engage
1 Houses are a favorite painting subject. Have children point out the colors they see in the artwork in the Big Book. Now that we know about so many beautiful colors, let's use them to design an imaginary or realistic house. Discuss children's ideas.
2 **Brainstorm parts that a house might have** (windows, door, roof, chimney, doorknobs, shutters, stairs, garage, fence, porch lights, numbers, etc.).

Explore
1 **Discuss strategies for how to begin painting a house.** Emphasize these two ways:
- Start with a big outline of the main shapes, or
- Start by painting a detail, such as a door or window. Children will use just one color as they begin.
2 Refer to the Explore section in the Big Book for step-by-step instructions.
3 Review procedures for wiping the paintbrush and passing paint.

Create Part 1
1 Have children start painting. When most of the children have painted the main shapes, ask them to stop, and allow them to walk around and view other students' work.
2 Gather children together to **share the interesting house details they noticed**. Often children will have a story that they would like to share. Then allow them to go back to their paintings.

UNIT 10 LESSON 1

Seeing Shapes

Many artists show houses in their work.

Houses are made up of shapes.

What shapes can you see in this painting?

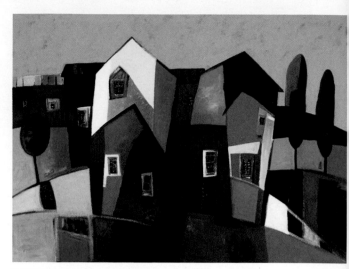

Downe Burns, *Daydream Conversations No. 1*, no date. Acrylic on masonite.

78

Painting Houses Expressively

Think about the shapes that make up your house.
Mix beautiful colors to paint them.

1 Paint the large main shapes.

2 Add the roof.

3 Add windows, doors,
fences, and other details.

Part 2

1 As children fill their paintings with paint, encourage them to **fill in shapes, leaving the outline**. This clarifies the features of the houses. Demonstrate carefully painting in and around to fill in shapes. Review painting with the blob and outline methods.

2 As children come close to finishing, you may wish to offer black paint and a small brush for special details.

Variations/Extensions

- This lesson can also be taught using 9" × 12" (23 × 30 cm) paper and oil pastels with a watercolor wash.
- Try limiting a table to either warm or cool colors to begin. On day two, or during the second part of the lesson, switch colors or tables.

Teaching Tips

Use Large Paper The size of the paper depends on the size of the table. This is a great lesson for large paper, if you have the space.

Music as a Cue Use appropriate music as a cue for passing the paint.

Take Two Days Filling in areas, adding details, and overpainting are easier once the paintings have dried. Artists like to have a chance to step away from their work. When they return, they bring new ideas to it. If you choose to do this, leave the painting in and around shapes and adding details for the second day. As a way of renewing enthusiasm, hold the children's work up so they can see it and plan what they will do next.

Assessment

Assessment is based on a scale of 0–4.
4 All objectives are met, work is done with care, and represents a child's best work.
3 Some objectives are met; not the child's best work.
2 Child struggled to grasp the concept; few objectives have been met.
1 Child did not grasp the concept, no objectives met, work is incomplete.
0 Child absent.

Lesson Resources

Children's Trade Books
The Big Orange Splot by Daniel Pinkwater (Scholastic, 1977)
My Painted House by Maya Angelou and Margaret Courtney-Clarke (Clarkson Potter, 1994)

Other Resources
Music CD (Davis)
davisart.com

Seeing Buildings

Architects draw and plan buildings.

When you draw a building, you notice many things.

What shapes do you see?

What details do you see?

80

UNIT 10 BUILDINGS AND CITIES

LESSON 2 Seeing Buildings
Drawing from Observation

Objectives
While drawing buildings from direct observation, children will:
- learn that there are many styles of architecture.
- develop and practice observational drawing skills.
- enjoy an outdoor drawing experience.
- feel like a "real artist."

Materials
- Drawing boards or clipboards, 1 per child
- Newspapers (to sit on)
- White paper, 9" × 12" (23 × 30 cm), 3 sheets per child
- Fineline markers

Setup
- Scout out buildings to draw and a place where children can sit comfortably with enough room.
- Visit the site at the time you are likely to be there with the children, and note where the sun is; it is best if the sun shines on the building and not in the children's eyes.

Vocabulary

English	Spanish
architecture	arquitectura

National Standards
1a, 1b, 1c, 2a, 2b, 2c, 3a, 3b, 5a, 5b, 5c
See pages 100–101 for a complete list of the National Standards.

TEACH

Engage
1 Refer to the photographs in the Big Book. Ask: **What is architecture?**
- the art and science of designing and constructing buildings
- the buildings themselves, and other large structures
- a style and method of design and construction

2 Ask: What is an architect? Define an architect as a person who designs buildings and supervises their construction. Architects use drawings to plan, study, and record the buildings in their communities.

Explore
1 Explain that children will be drawing buildings they see outdoors. Drawing helps you see in another way. When drawing buildings, you notice details that you would otherwise overlook.

2 **Discuss procedures and expectations for working outside:**
- Place newspaper where you want to sit.
- Sit on the newspaper. Cross your legs in front of your body.
- Position the drawing board on your lap. Will you hold it vertically or horizontally?

3 Practice looking for shapes in the architecture of a building using your own photographs or the images in the Big Book.

Drawing from Observation

Draw a building in your neighborhood. Sit outdoors.

1 Will your picture be tall or wide?

2 Look carefully. Start with the largest shapes, or start with a detail.

3 Notice the windows. What shape are they?

4 What shape are the doors?

Unit 10 Buildings and Cities **81**

Create

1 Discuss strategies for starting a drawing of a building:
- Use a capped marker to plan your drawing.
- Start with the large shapes and then add the details, or
- Start with an interesting detail and work out from there.

2 Demonstrate making a mistake and then figuring out a way to use it.

3 Once outside, ask questions to help the children focus:
- What are the largest shapes?
- What shapes are the windows?
- How are the rectangles different from one another?

Teaching Tips

Set Firm Guidelines Drawing outside is a wonderful way for children to experience and study the built environment. However, firm behavioral guidelines should be set beforehand. Explain directions and procedures before venturing outdoors. Children can then begin working as soon as they find places to sit.

Choose Interesting Buildings Those with interesting shapes and details or a particular architectural style are best. Do a practice sketch to test the practicality of this choice.

Check Lighting Scout out a destination before bringing the class. It is hard to draw buildings when they are in shadow, so check the lighting conditions for the time of day your class would be there.

Check Seating Make sure seating conditions are acceptable. Laying out sections of newspaper, when it is not windy, to serve as seating pads is a good way to designate places to sit.

Have a Plan B Plan an alternate lesson in case the weather does not cooperate.

Ask for Help Plan ahead by asking for a cooperating teacher or parent volunteer to accompany you and the children outside.

Other Nearby Buildings For children who finish early, are there other buildings to draw? It is helpful if these can be seen from where the group is sitting.

Pencils Possible Pencils may be used for this lesson, but often children spend a majority of their time erasing.

Variations/Extensions
- When it is not feasible to go outdoors, try working from postcards or pictures.
- When children return to the room, hold up their drawings and see if children can guess which strategy the child used and where he or she began.
- Children can use indelible markers to draw buildings and add watercolor when they come back into the classroom.
- Children can construct a building from blocks or small pieces of wood and sketch it.

Assessment
Assessment is based on a scale of 0–4.
4 All objectives are met, work is done with care, and represents a child's best work.
3 Some objectives are met; not the child's best work.
2 Child struggled to grasp the concept; few objectives have been met.
1 Child did not grasp the concept, no objectives met, work is incomplete.
0 Child absent.

Lesson Resources

Children's Trade Book
Architecture SHAPES by Michael J. Crosbie and Steve Rosenthal (Tien Wah, 1993)

Other Resources
Music CD (Davis)
davisart.com

UNIT 10 BUILDINGS AND CITIES

LESSON 3 Making Choices
Cut-Paper Cityscapes

Making Choices

A city skyline is full of shapes.

Where can you see rectangles?

How many different kinds of rectangles can you see?

Pittsburgh, Pennsylvania skyline.

82

PREPARE

Objectives

While creating cut paper cityscapes, children will:

- practice cutting a variety of geometric shapes.
- experiment with the idea of overlapping shapes to show distance.
- use aesthetic judgment to make color decisions.
- understand that, unlike painting, the medium of paper collage gives them a variety of placement options.
- use negative and positive shapes.

Materials

- Construction paper, 11" × 16" (28 × 41 cm) in assorted colors, for backgrounds, 1 per child
- Large construction paper scraps, 4" × 6" (10 × 15 cm), for buildings, 3 to 5 per child
- Scissors
- Glue (in reserve)
- Paper strips (in reserve for Part 2)

Setup

- Have available an array of 4" × 6" (10 × 15 cm) paper scraps and other large scrap papers on tables for children to choose from.
- Scissors should be available to hand out once color choices are made.
- Set background papers out on a separate table for children to choose from.

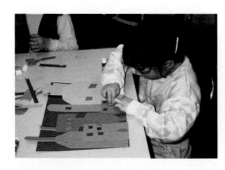

Vocabulary

English	Spanish
geometric shapes	formas geométrica

National Standards

1c, 2a, 2b, 2c, 3a, 3b, 5c

See pages 100–101 for a complete list of the National Standards.

TEACH

Engage

1 Refer to the Big Book images and other resources. Point out the city skylines. **Ask: What shapes can you see in the buildings?** (*Mostly rectangles and squares.*) How are the buildings different from one another?

2 Explain that children are going to use paper shapes to make their own city skylines.

Explore

1 **Demonstrate choosing three colored papers** that look good together to become city buildings.

2 Demonstrate cutting rectangles and squares to build the foundations of the buildings.

 Remind children to arrange their shapes in multiple ways before they decide on a final composition.

3 Show how overlapping shapes can be used to show distance. When one building overlaps another, it looks closer and the building behind it looks farther away.

4 Discuss different roof shapes, and demonstrate ways to cut rooftops.

5 Demonstrate finding ways to use all the shapes, positive and negative.

Create Part 1

1 **Let children begin.** When they have cut an assortment of shapes and begun to assemble them, demonstrate strategies to create doorways by cutting and folding (see Big Book).

2 Allow children to choose background paper in a color they like. Encourage them to think about the time of day in their city—how would that affect the color they choose?

3 When they have arranged their compositions using all cut pieces, review gluing techniques. Keep the glue in reserve until then.

Cut Paper Cityscapes

How would you show a city using shapes?

1 Cut rectangles and squares.

2 Cut rooftops.

3 Plan doorways.

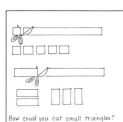

4 Arrange your shapes.
Try different arrangements.
Glue.

Part 2

1 Delight in children's compositions, point out interesting compositions, and invite comments. Using the photographs of cities as resources, **brainstorm details** that can be added to their cityscapes, such as windows, doors, fire escapes, walkways, stairs, TV antennas, doorknobs, fences, signs, lampposts, mailboxes, and so on.

2 To add windows, demonstrate cutting a paper strip into squares, rectangles, and triangles that are the same size. Children can also add an additional building, sky, people, or other details.

How could you cut small triangles?
How could you make a very thin strip?

Variations/Extensions

- Variations/Extensions, p. 83, starting with second bullet]
- Smaller background paper, 9" x 11" (23 x 28 cm), can also be used and makes the lesson quicker to complete.
- Children will find it easy and rewarding to revisit their work by drawing.

Assessment

Assessment is based on a scale of 0–4.
4 All objectives are met, work is done with care, and represents a child's best work.
3 Some objectives are met; not the child's best work.
2 Child struggled to grasp the concept; few objectives have been met.
1 Child did not grasp the concept, no objectives met, work is incomplete.
0 Child absent.

Teaching Tips

Collect Scissors Children can get caught up in cutting, but gluing takes time. Collecting the scissors helps put the focus on arranging and gluing.

Try New Colors Construction paper comes in many different colors; some manufacturers even offer a package of "designer colors." It's fun to use new colors, and children perceive the difference.

Remove Extra Paper Once children have chosen three or four building papers, remove the rest.

Two-Day Lesson This works well as a two-day lesson. Save Part Two for the second day. Prepare paper for drawing in case children finish early.

Lesson Resources

Children's Trade Book
Castle by David Macaulay (Houghton Mifflin, 1977)

Other Resources
Architecture in Education: A Resource of Imaginative Ideas and Tested Activities (K-12) by Marcy Abhour (Foundation for Architecture, 1986)
The Block by Romare Bearden and Langston Hughes (Viking, 1995)
Music CD (Davis)
davisart.com

Reference

Program Overview

"One cannot speculate on the purpose of art and art education without pondering in one's mind the ultimate question of what life is for. It is fashionable nowadays to discourage ultimate questions with a smile, but one does so at one's own peril. . . art training is not one of the minor fillers of the curriculum, but relates to the very fundamentals of education. What are these fundamentals? Reading, writing, and arithmetic? Certainly these are indispensable skills; but should we not realize by now that they are just skills? And that even as a list of skills the list is incomplete? If I am not mistaken, the three fundamentals of education are:

- Perceiving
- Thinking
- Forming

And the tools needed to exert these faculties of the mind are numbers, words, and shapes. Of these three sets of tools the first two have been considered the only essential ones since the Middle Ages. We must now rehabilitate the third."

Rudolph Arnheim,
"Perceiving, Thinking, Forming,"
Art Education Magazine, March 1983

Philosophy and Structure of the Program

Kindergarten brings children and families from diverse experiences together in a school setting for the first time. It is in kindergarten that children and families form their attitudes about what it means to be a student in a school, and their expectations of what it means to learn.

This curriculum sets forth an **investigative, exploratory approach** to encountering artist's tools and materials. Experimenting with the potential of tools, materials and processes takes the mystery out of being an artist, and opens up the possibility of artistic expression to everyone.

There are **ten units** in the program. Each theme of the ten units explores specific processes and approaches to learning offered by the visual arts. The lessons build sequentially throughout the year to develop children's skills with a variety of expressive media. Every lesson includes suggestions for varying and extending explorations. Units can also be rearranged and adjusted to fit a wide range of teaching situations. Whenever possible, coordinate the presentation of a unit with the classroom curriculum. Be sure to keep an open exchange with kindergarten classroom teachers.

The order of the lessons within a unit was designed for a reason. Skills and concepts deepen over the course of a unit. Units one and two are especially helpful to do at the beginning of the year.

Aims and Content

The intention of *Explorations in Art Kindergarten* is to capitalize on young children's curiosity and readiness to explore. Children are naturally motivated and excited about learning. The main goal is to cultivate an attitude and aptitude for **joyful learning**. This is done by placing the focus on uncovering the potential and possibilities of studio art materials. This program encourages children to **make discoveries** and to realize that there are many ways to use any medium.

Through sharing ideas and possibilities, children come to **respect the work of other classmates**, as well as that of other artists and cultures. When children explain their work, share their intentions, or point out interesting qualities they observe in a classmate's work, they are **acquiring and using descriptive language**. While qualifying their work, children are engaging their **analytical thinking skills** and increasing their **vocabulary**.

Perhaps the most important goal of this program is to create an environment that not only **builds each child's confidence** in his or her own creative abilities, but at the same time **fosters respect for the creative abilities of classmates**. In this way, everyone in the class is thinking and working as an artist.

The Effective Kindergarten Art Teacher: Notes on Teaching

Recording children's words

This habit offers you insight into children's thinking and learning styles. As you circulate through the room, take notes and direct quotes using index cards, a clipboard, or extra strips of paper. It is such a simple way to learn about individual children.

Helping children improve their work

Evaluation at the kindergarten level does not mean criticism. Rather, it means looking at artwork with a critical eye. It means being able to identify what is working well and what needs improvement in any given work of art.

It is important for all children to come away from evaluations feeling positive about some aspect of their paintings. For this reason, it is best to abide by the rule that comments about any work of art must be positive and helpful. Evaluations should also help children decide where to proceed from any given point. Evaluations may focus on technique, design, style of working, or the emotional impact of explorations.

Enthusiasm

A teacher's enthusiasm is contagious! Take time to immerse yourself in whatever media and concept you are presenting.

Demonstrating and giving instructions

Demonstrating is an effective way to spark interest and convey information. Demonstrations should be basic and minimal. Show only what children need to know in order to get started. Demonstrations should be open-ended. It is always preferable to show more than one approach to solving a problem. Invite children's ideas and follow their suggestions as much as possible. Demonstrations should not be perfect; make a mistake and talk about using the mistake, and how it can lead to more interesting work. Help children develop the habit of planning and practicing. One way to do this is to demonstrate using your finger to "draw" your plan before actually making a mark. When children compliment you, it's time to stop.

The power of story

Reading books to generate interest in a lesson is a powerful way to get the attention of the children while sparking images and ideas. Many of the lessons in this program include children's book selections.

Commenting on children's work

Listen to what children say about their work and invite them to talk about how they began or the story their work tells. When giving comments, be specific and positive. Use art elements and design principles to help you look closely and to reinforce concepts and vocabulary.

Art elements and design principles

The art elements—line, shape, color, texture, value, form, and space—are part of every work of art. They are the building blocks from which works of art are made. The same elements are the keys to unlocking and understanding the vision of an artist and the way a particular work of art affects the viewer. Composition refers to how the art elements are arranged in any given work of art.

By focusing on one element at a time and developing skill in using and looking for that element in the environment and in works of art, children can grow and develop as artists, communicators, and people who understand and appreciate the achievements of other artists.

Music can help to set the tone

Playing soft music without lyrics sets a tone for the studio art class. Appropriate music can settle a class down and help children focus. Listening to music allows them to become deeply involved in the art they are creating. Music can also become a signal to begin or stop working. A CD player or tape player that is easily accessible is valuable to have in the art room.

Allow time for children to share

Build children's confidence by giving them a chance to use their art terms as they share their work and ideas with other members of the class. As children explore and articulate their discoveries, they naturally become more aware of art elements and principles in their environment.

Bringing works of art based on similar concepts into the classroom can spark new associations, new vocabulary, rich discussions, and additional questions and ideas. When children's work ideas are appreciated, celebrated, and respected, they in turn respect and appreciate the achievements of classmates and other artists.

Documenting

As one of many educators who became intrigued with the pre-primary schools in Reggio Emilia, I keep coming back to the importance of observing and listening to children as a way to be fully engaged. Recording direct quotes and images of children engaged in their work have led me to discover the unlimited potential and intelligence of children. Displaying these artifacts is a way to begin documenting children's experiences in the classroom and sharing the extraordinary things that happen daily in the kindergarten classroom.

Display

By arranging displays with care we can show our respect for the children's work. Through displays, a teacher makes it possible for the children themselves to communicate their pleasure and achievements to family and friends. Post key words and concise explanations helps viewers to understand the objectives of the lesson. It is important to include standards and a rationale to explain how this lesson is a critical part of the child's education. Direct quotes and images bring displays to life. Posting a question is a way to further engage viewers.

Parents become stronger participants in the life of the classroom when they can follow the interesting work that is taking place. When children's words and images are placed next to their work, parents become much more interested and stay longer.

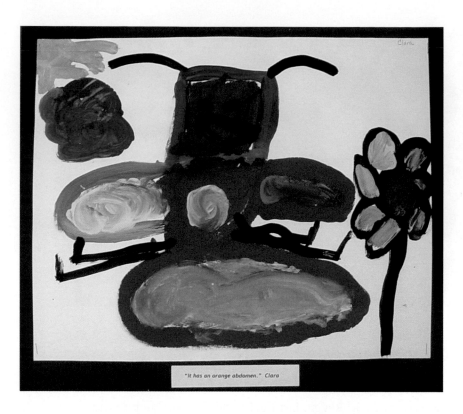

"It has an orange abdomen." Clara

What to do when a child finishes early

Children will finish projects at varying times; there will always be children who finish early. It is helpful to have bins of natural materials, blocks, or other manipulative materials available for children to arrange and explore. It is important to set a routine and a space so children know what to expect and how to manage themselves in the classroom.

Drawing what you made is a great activity for children who finish early. Drawing gives children a chance to revisit, reflect, and take pleasure in their work and its details. Children will begin to look for the paper and drawing tools as they complete their work. I knew something important was happening when a child said, "I'm done with my sculpture, I need paper so I can draw it!"

Cleanup

It is important for children to learn responsibility and enjoy the full process of creation. Think about how to best organize clean up beforehand. Designate spaces and procedures for getting and putting away materials.

Maintaining Order in the Classroom

Engage children from the moment they enter the classroom, Pose a question about the fine art. Begin to demonstrate the use of a new tool. Hold up a book that you are about to show. Keep discussions short and to the point.

Keeping children on task. The best way to keep children on task is to keep them engaged. Sequencing the introduction of materials can be magical. Each addition is a new provocation. It is equally exciting to add a slightly new concept or challenge as children are just about to complete one phase of a project. Most lessons are organized into Part One and Part Two—this helps teachers orchestrate sequencing.

To help children focus, engage them from the moment they enter the room or are getting ready for art by asking a question, such as "Can you guess from all the visual cues what we will be working on today during our studio art class?" Or "Can you point out something that you especially like in the art work?" Or present them with some kind of a problem to figure out, such as "How many warm colors can you find in the painting in the front of the room?"

Discipline

"A good disciplinarian is a teacher who effectively encourages growth-producing behavior and stops or redirects negative behavior."

The Rights of Children and the Role of the Teacher

To be a good disciplinarian it really helps to keep the "three rights of children" in mind:

1. The right to be free of harm—both physical and psychological.

2. The right to use materials and equipment at the school.

3. The right to learn.

Here are the "Three Roles of the Teacher":

1. **Stimulant Role** Creating an environment that is worthwhile for children to be involved in.

2. **Model Role** In terms of behavior (consistent, firm, positive, fair) and in terms of interest in and enjoyment of the subject matter.

3. **Protective/Guiding Role**

Other guidelines

- "Catch" each child doing right, kind actions and producing interesting, creative work. As much as possible, reward positive behavior.

- Honor and respect the intelligence and the work of the children and of the other teachers in the school.

- Whatever the lesson, take a few minutes to try it yourself to work out logistics and to build your own enthusiasm.

Additional Strategies

Develop a signal for getting children's attention when you need it. A bell, a flick of the lights, or a hand-clapping rhythm are common signals that teachers use to encourage children to "Stop, Look, and Listen". Thank the children by name as each responds to the signal. Rewarding positive behavior is the most effective way I know to encourage a productive tone in the classroom.

Recruit a parent or volunteer helper A second adult in the room is a great advantage. Often parents are looking for ways to contribute to the life of the school. The kindergarten art classroom offers the perfect opportunity! Make your requests for volunteers through letters home or notes in the school newsletter. It is important that the volunteer comes consistently or on a regular basis. An adult who enjoys art is an added bonus!

Volunteers can help:

- Put student names on artwork
- Prepare and distribute materials
- Mount work
- Record children's descriptions, titles, comments, and ideas
- Support children who have trouble getting started
- Work individually
- Put up displays
- Help to keep the art room in order

Communicating with Parents

Consider writing a letter to parents telling them a little about the art program for kindergarten. Cite unit or lesson headings. Include a sentence about your philosophy, and let parents know ahead of time about requests for materials. Consider including the list of found materials to start collecting.

Interpreting and Reporting Progress: Assessment

While assessing children engaged in studio art explorations, it is important to leave room for risk-taking and unplanned discoveries and directions. These opportunities are a vital part of the creative process; acknowledging these diverse approaches is how teachers learn, change, grow and improve. Celebrate the differences you see.

Assessment in this program is based on a scale of 0-4

4: All objectives are met, work is done with care, and is a child's best work

3: Some objectives are met, not the child's best work.

2: Child struggled to grasp the concept; hardly any objectives have been met.

1: Child did not grasp the concept, no objectives met, work incomplete

0: Child absent.

Note that a child's "best work" depends on each child's individual ability.

Creating lists of children's names ahead of time makes recording assessment numbers easier. It pays to do this as soon as possible.

Supplies and Materials

It is important to note that this curriculum uses a lot of found materials, so it helps to go over the supply list early on. Over time you will find that you have accumulated a wealth of exciting and beautiful materials.

In general, prioritize buying **a few high quality materials** and teaching children to use them with respect. Children will be more successful with colors that are truer, more vibrant, and flow more easily, and with brushes that do not fall apart or leave hairs on the paper. Good quality materials seem to last much longer and are more satisfying to use.

Watch out for the great many glitzy materials that are available today. Many of these materials can be fun additions to work, but in general, they are superficial and costly and tend to get used up quickly without much thought.

Keep in mind that most people want to help children, teachers, and schools if they can and are happy to donate supplies if asked. Sometimes members of the community are looking for ways to make a contribution to the school. Think about raising awareness and inviting donations by sending out a list of supplies that you are unable to purchase at the first parent meeting or in the school newsletter.

Following are supplies to keep in mind so that you do not miss opportunities.

Natural Materials

Materials surround us in the environment. Be on the lookout for materials that can be used for exploration and expression in the classroom. Collect them and sort them with the children into separate containers. Types of materials will depend on where you live. Be open to what the children collect and let them be the guides. It is great fun to discover potential materials. It is part of what it means to think and work as an artist.

Sticks, bark, seedpods, flowers, shells, and stones come in an endless variety of shapes, sizes, colors and textures. When you have gathered a supply of these materials, they begin to come in handy in many unexpected but fabulous ways.

Natural materials are all around us, wherever we live.

Found Materials

Many of the lessons make use of small found materials. Keep a bag handy for collecting bottle caps, pieces of broken toys, small machines that don't work and can be taken apart (such as watches and clocks), broken jewelry, dried out marker caps, shampoo bottle caps, beads, old keys and other small metal parts, small pieces of wood, feathers, ribbon, leather remnants, razor blade holders and other extruded materials, rubber bands, nuts and bolts, buttons. You will be surprised at the materials you are able to collect. If there is a recycle center nearby, you might want to drop in to see what kinds of items are available. If you wish to create a collection of found materials for the classroom, refer to the book *Beautiful Stuff: Learning with Found Materials* by Cathy Weisman Topal and Lella Gandini. Worcester, MA: Davis Publications, Inc., 1999.

Gather small found objects to save to add to line prints.

Collections of found materials can be irresistible.

Many different textured materials work well for rubbings.

Storing art materials in accessible containers saves precious art room time.

Containers

Containers of all sizes, especially clear, white, and black are always helpful for organizing, distributing and storing materials. Save a collection of plastic containers for distributing water.

Baskets. Baskets come in handy for storing and distributing stones, shells and collections of all kinds of materials. Keep a few baskets of materials handy to pull out for children to arrange when they have completed an assignment.

Bags. Brown paper lunch bags are great to distribute to a class of children for collecting materials. They limit the amount that comes into the classroom!

Small bags with no markings can be used for special design projects. White bags work best. When you come across appropriate bags at a store, ask for enough the class. A piece of construction paper can easily cover any advertising that may appear.

Baskets are useful, attractive containers for many kinds of art materials.

Baby food jars. Keep your ears open for new siblings and request that parents save baby food jars. They have many uses, especially for paint and glue distribution.

Jars come in handy for many uses.

Cardboard

Cardboard boxes can be cut up and saved. Bigger pieces can be used as bases for sculptures, while smaller pieces come in handy for many design projects. Toilet paper rolls and masking tape rolls can be cut and used as curved line printing tools. Save some boxes, such as those that reams of photocopy paper come in. They are great for storing groupings of materials—such as sewing supplies, line printing supplies, collage items for Unit 3, and animal models.

Cardboard, whether cut up or in box form, has a multitude of uses in the Kindergarten art room.

Styrofoam Trays

Grocery stores are usually happy to give you a sleeve of trays if they know they are for a school. The first sewing lesson depends on these, so get a couple of sleeves when you get the chance! Any color or size will do.

Paper Plates

Large paper plates with a shiny coating are great for color mixing. Small plates are the perfect size for distributing paint for line printing. Paper plates make clean up easy because they can be thrown away at the end of class. This saves a lot of clean-up time, a lot of water and a lot of mess.

Paper

If you plan on mounting a drawing, painting, print, or collage, think about trimming an inch off two sides of the paper before distributing it to children. This makes framing artwork much quicker.

White. Choose 18 x 24" (46 x 61 cm) paper for painting. 9 x 12" (23 x 30 cm) or 12 x 18" (30 x 46 cm) heavy white paper for drawing. Heavier paper costs more, but is well worth the investment if you can afford it. It is generally more satisfying for children to draw and paint on thicker paper.

Fadeless Paper. This comes in 12 x 18" (30 x 46 cm) packages of assorted colors. I love the one sided paper!

Newsprint. 12 x 18" (30 x 46 cm) sheets of newsprint come in handy for drawing and printing practice.

Watercolor Paper. This often comes in packs at a lower cost.

Construction Paper. Order 18 x 24" (46 x 61 cm) for mounting. When ordering colors, be aware that black or dark blue will be used often! Order 12 x 18" (30 x 46 cm) especially in primary and secondary colors, plus brown, and black. Ordering small packages of special colors allows you to generate some excitement towards the end of the year. Some companies offer discounted packages of assorted colors.

Rolls of Paper. A roll of brown paper and/or a roll of white paper come in very handy for group projects and for covering tables. A roll of paper in a color such as blue or yellow makes a great background for murals.

Tag Board. If you are interested in creating portfolios for the children's work, 18" x 24" (46 x 61 cm) folded sheets of tag board can be used for storing work.

Collage Materials. Interesting papers of different weights, textures, and colors, such as wallpaper and wrapping paper, can often be salvaged and are great for collage projects when cut down into manageable sizes of 4 x 6" (10 x 15 cm) or larger.

Other Useful Materials

Newspapers for protecting and padding surfaces and for wrapping fragile items are indispensable. Let parents know that you would appreciate donations of flat, clean newspapers.

A jointed manikin, and collections of animal and insect figurines are very helpful for researching characteristics, body parts and markings and as prompts for drawing and sculpting.

Observing animal models helps children learn to see proportions, markings, and points of view.

A manikin is useful for any lesson about people.

Printing Materials

Line printing tools. Line printing tools can be made out of cardboard or starter sets of plastic reusable tools can be ordered from Davis Publications.

Straight-line tools for line printing

Curved-line tools for line printing

Drawing Materials

- **Fine-line black markers.** At least two per child for the year
- **Fine line indelible black markers.** One per child and a few extras
- **6B soft drawing pencils**
- **Erasers.** One per child and extras
- **Colored markers**
- **Crayons**
- **Clipboards or Drawing boards.** These come in very handy for many projects. One per child and a few extras
- **It never hurts to have:**

 Colored pencils

 Oil pastels

 Chalk or pastels

Paints

Tempera cakes. It is easy to pass out one watercolor dish with a tempera cake and a brush to each child. Children can exchange colors with the accompanying brush. This has many benefits! The colors stay pure. Brush washing and water distribution is eliminated. Paintings made with tempera cakes dry much faster than those made with liquid tempera. All of these reasons also make it possible to paint in the classroom even if you are working from a cart.

Tempera cakes come in sets as well as in individual cakes. Spraying the cakes with water just before children use them softens the pigment and enables children to work up a deeper color more easily.

Liquid tempera. Although tempera cakes have decided advantages, there is nothing more glorious than painting with glowing colors of tempera paint when you get the chance. Prioritize buying the colors yellow, red, blue, white, brown, and black. Double up on yellow and white because they get used up first. When mixing primary colors you

When buying large tempera cakes like these, quality is important.

may have noticed that the green mixed from blue and yellow looks like an army green, rather than a grass green. A primary blue is not royal blue, but rather approaches the color turquoise. Often fire-engine red is considered a primary red, when really a primary red is closer to magenta. Invest in good quality tempera paints to ensure beautiful colors.

When it comes to amount it is often easier and more economical to purchase gallon-size containers. If possible, use squeeze bottles for paint distribution. They are easily refillable and make distributing paint in the classroom much easier, quicker and cleaner.

Watercolors. Watercolors usually come in sets of eight colors. Get full-size pans, as the half pans get used up quickly. It is easy to tape over colors you are not using at the time. During watercolor explorations you can save time on cleanup if you tape over black. Watercolor is a difficult medium for kindergarteners to control, and serves more of an exploratory purpose. It is also useful for painting over oil pastels and crayons, and for adding color to drawings made with indelible markers. Most sets come with a size 6 or 7 brush.

Brushes

Easel painting brushes. If you can only buy one type of brush, invest in 3/8" (1 cm) tempera brushes, at least one per child. It is helpful to have a smaller size for adding details.

Paste brushes. These can be used to spread glue.

Glue

Glue sticks. Two per child for the year. The large size seems to last a lot longer.

White glue. White glue can be distributed in many forms. Squeeze bottles come in many sizes, and can be refilled. An alternative to this would be pouring white glue into jars and using paste brushes to spread the glue. It is important to pour only a small amount of glue in containers, and to remind children to wipe brushes on the edge of the container before applying.

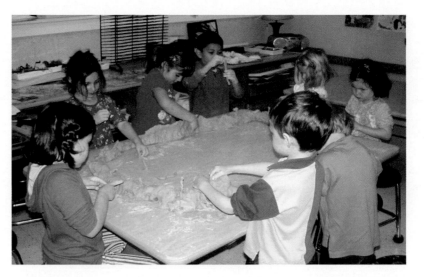

Clay experiences help develop muscles in children's shoulders and hands, and provide opportunities for group work.

Clay

If you have a kiln, low fire white or terracotta clay is the best choice for Kindergarten use.

If you do not have a kiln, you can also use low fire white or terracotta clay and let it dry. Or you can use air-dry clay. Be aware that air-dry clay often is very fragile when it dries. Have a plan on how children will transport projects home—it may mean supplying a base.

Glaze. It is always exciting to glaze a clay piece if that is possible.

Glossy polymer medium. To add color to clay pieces without firing in the kiln, use tempera paint or watercolors, then apply a coat of polymer medium to add finish and shine.

Clay boards. 1/8" (3 mm) thick tempered Masonite boards or rolls of canvas for covering tables are great for clay work. Canvas can also be cut into individual pieces. Masonite and canvas sizes depend on the size of working spaces.

Cutting Supplies

Scissors. Obtain good quality, blunt, small scissors, preferably in only one color to avoid squabbles.

Foam. Colorful sheets of foam come in a package of assorted colors and can be cut into smaller pieces and used to introduce cutting. Children can cut them into very small pieces. These pieces can be used for any of the collage projects.

Fiber Arts

Each year when I begin a unit on fiber arts—sewing and weaving—I am amazed at the involvement of the children and at all the learning that takes place through these new arts. It is always an unexpected child who seems to catch on to the processes right away and to find him or herself through the fiber arts. Sewing and weaving develop spatial awareness and eye/hand/and mind coordination. The skills involved in sewing and weaving are mathematical and repetitive. The children enjoy feeling and working with yarn and making something "real". One important aspect of exploring the fiber arts is that they take time. Children return to their work again and again, gaining more and more skill and control over time.

Stiffening burlap by edging it with masking tape makes it easier for small hands to manipulate.

Yarn. Purchase standard weight yarn, not too thick, in a variety of bright colors. Start with a few contrasting colors and add a color or two each year. Gradually you can build up a beautiful collection.

Needles. Metal or plastic tapestry needles, blunt size 18, or plastic blunt needles work well. Order enough for at least two needles for everyone in the class. Add a package or two each year. It is great to have many needles so that they can be threaded beforehand.

Burlap. Figure about a square foot of burlap per child. Order a few yards of a strong color such as red, blue, green or black. Think about contrasting colors of yarn so that it will stand out from the burlap.

Pony Beads. It is very exciting to learn to attach a bead to a stitchery. But it is important that the bead have a big enough hole for the tapestry needle to pass through. Bright-colored pony beads stand out on stitchery projects and have just the right-sized hole.

Styrofoam blocks are helpful to have around for collecting needles when they are not in use.

Teacher Supplies

These are just for the teacher to use.

- A box or two of yellow chalk
- Low heat glue guns and refills
- Utility knife
- Push pins
- Staplers
- Masking tape and clear tape dispenser
- CD or tape player
- Soft music that can set a working tone
- Digital Camera
 If you can afford it, a digital camera makes capturing moments in the art studio easier. It also promotes the program. If you cannot afford it, convince your school that it is a worthy investment, even if you have to share it with other teachers.

Organize

Take a little time at the beginning of the year to organize supplies. When supplies are organized it is so much easier to locate the supplies that you need, to transport them if necessary, and to put them away when class is over. Plan on straightening and rearranging at strategic times during the year.

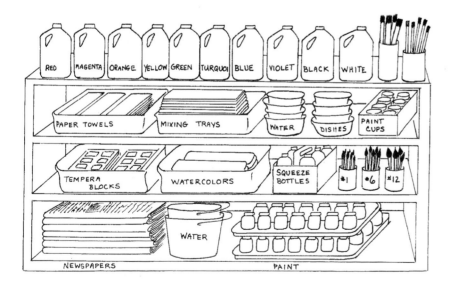

Organizing supplies is always time well spent, as it saves time in the long run.

Bibliography

Analyzing Children's Art by Rhoda Kellogg (Mayfield, 1970)

Beautiful Stuff: Learning with Found Materials by Cathy Weisman Topal and Lella Gandini (Davis Publications, 1999)

Children and Painting by Cathy Weisman Topal (Davis Publications, 1992)

Children, Clay and Sculpture by Cathy Weisman Topal (Davis Publications, 1984)

The Colors of Learning: Integrating the Visual Arts into the Early Childhood Curriculum by Rosemary Althouse, Margaret H. Johnson and Sharon T. Mitchell (Teacher's College Press, 2002)

Frames of Mind: The Theory of Multiple Intelligences, by Howard Gardner (Basic Books, 1993)

The Hundred Languages of Children, 2nd edition, by Carolyn Edwards, Lella Gandini and George Forman (Ablex Publishing, 1998)

In The Spirit of the Studio: Learning from the Atelier of Reggio Emilia by Lella Gandini, Lynn Hill, Louise Cadwell, Charles Schwall (Teacher's College Press, 2005)

It's Not a Bird Yet: The Drama of Drawing by Ursula Kolbe (Peppinot Press, 2005)

The Language of Art: Reggio-inspired Studio Practices in Early Childhood Settings by Ann Pelo (Redleaf Press, 2007)

Rapunzel's Supermarket: All About Young Children and Their Art, 2nd edition, by Ursula Kolbe (Peppinot Press, 2007)

Thinking with a Line (Teacher's guide and interactive CD-ROM) by Cathy Weisman Topal (Davis Publications, 2005)

Children's Trade Book Bibliography

Unit 1

Introductory Lesson

I Am an Artist by Pat Lowery Collins (Millbrook, 1994)

Stompin' at the Savoy by Bebe Moore Campbell, illustrated by Richard Yarde (Philomel, 2006)

Lesson 1

If You Find A Rock by Peggy Christian (Harcourt, 2000)

Everybody Needs a Rock by Byrd Baylor and Peter Parnall (Aladdin Books, 1974)

On My Beach There Are Many Pebbles by Leo Lionni
(HarperTrophy, 1995)

Georgia's Bones by Jen Bryant (Eerdman, 2005)

Lesson 2

How is a Crayon Made? by Charles Oz (Simon & Schuster, 1988)

The Hello, Goodbye Window by Norton Juster and
Christopher Raschka (Hyperion, 2005)

Harold and the Purple Crayon by Crockett Johnson (Bloomsbury, 1996)

Ish by Peter Reynolds (Candlewick, 2004)

My Crayons Talk by Patricia Hubbard and Brian Karas
(Henry Holt, 1996)

Lesson 3

A Picture for Harold's Room by Crockett Johnson (HarperTrophy, 1985)

The Squiggle by Carole Lexa Schaefer and Pierre Morgan (Crown, 1996)

The Line Up Book by Marisabina Russo (Greenwillow, 1986)

Lines by Philip Yenawine (Museum of Modern Art, 1991)

Spirals, Curves, Fanshapes & Lines by Tana Hoban (Greenwillow, 1992)

Going for a Walk with a Line by Douglas and Elizabeth MacAgy
(Doubleday, 1959)

Lesson 4

Frederick by Lio Lionni (Lectorum, 2005)

Little Blue and Little Yellow by Leo Lionni (Econoclad, 1999)

Lesson 5

I See a Song by Eric Carle (Scholastic, 1996)

Peter's Chair by Ezra Jack Keats (Viking, 1998)

Lesson 6

No One Saw by Bob Raczka (Millbrook, 2001)

Ma Lien and the Magic Brush by Hisako Kimishima (Macmillan, 2000)

Lesson 7

Shapes by Philip Yenawine (Museum of Modern Art, 2006)

Unit 2

Lesson 1

The Very Quiet Cricket by Eric Carle (Philomel, 1990)

Lesson 2

Brilliant Bees by Linda Glaser (Millbrook, 2003)

Lesson 3

The Very Clumsy Click Beetle by Eric Carle (Philomel, 1999)

The Grouchy Ladybug by Eric Carle (HarperTrophy, 1996)

Unit 3

Lesson 1

Go Away, Big Green Monster by Ed Emberley (L,B Kids, 1993)

Lesson 2

Fish is Fish by Leo Lionni (Dragonfly, 1974)

Pelle's New Suit by Elsa Beskow (Floris, 1989)

Peter's Chair by Ezra Jack Keats (Viking, 1998)

Lesson 3

Joseph Had a Little Overcoat by Simms Taback (Viking, 1999)

Where Does It Go? by Margaret Miller (Greenwillow, 1992)

Unit 4

Lesson 1

When Clay Sings by Byrd Baylor (Aladdin, 1987)

Lesson 2

Goodnight, Dear Monster by Terry Nell Morris (Random House, 1980)

Where the Wild Things Are by Maurice Sendak (Harper Collins, 1988)

Lesson 3

The Pot that Juan Built by Nancy Andrews-Goebel and David Diaz
(Lee & Low, 2002)

Helen Cordero and the Storytellers of Cochiti Pueblo,
by Nancy Shroyer Howard (Davis, 1995)

Lesson 4

From Head to Toe by Eric Carle (HarperCollins, 1997)

Unit 5

Lesson 1

The Dot and the Line by Norton Juster (Sea Star, 2000)

Lines by Philip Yenawine (MOMA, 2006)

Lesson 2

Kente Colors by Deborah M. Newton Chocolate and John Ward (Walker, 1997)

Echoes for the Eye: Poems to Celebrate Patterns in Nature by Barbara Juster Esbensen and Helen Davie (Harper Collins, 1996)

A Pair of Socks by Stuart Murphy and Lois Ehlert (Harper Trophy, 1996)

Lesson 3

Alphabet City by Stephen T. Johnson (Puffin, 1999)

The Graphic Alphabet by David Pelletier (Scholastic, 1996)

Albert Builds an Alphabet by Leslie Tryon (Aladdin, 1994)

Lesson 4

When a Line Bends, a Shape Begins by Rhonda Gowler Greene and James Kaczman (Houghton Mifflin, 2001)

The Greedy Triangle by Marilyn Burns and Gordon Silveria (Scholastic, 1995)

So Many Circles, So Many Squares by Tana Hoban (Greenwillow, 1998)

Unit 6

Lesson 1

Shape Patterns (Let's Investigate) by Marion Smoothey (Benchmark, 1993)

All About Pattern by Irene Yates (Chrysalis, 2002)

Lesson 2

Snowflake Bentley by Jacqueline Briggs Martin (Houghton Mifflin, 1998)

A Drop of Water by Walter Wick (Scholastic, 1997)

Lesson 3

Meet Matisse by Nelly Munthe (Little Brown, 1983)

Henri Matisse by Mike Venezia (Children's Press, 1997)

Unit 7

Lesson 2

Corduroy by Don Freeman (Puffin, 2007)

The Keeping Quilt by Patricia Polacco (Aladdin, 2001)

Unit 8

Lesson 1

Maria's Cave by William Hooks (Coward, McCann, 1977)

How Artists See Animals by Colleen Carroll (Abbeville, 1996)*Animals: Through the Eyes of Artists* by Wendy and Jack Richardson (Children's Press, 1991)

Lesson 2

Bringing the Rain to Kapiti Plain by Verna Aardema, illustrated by Beatriz Vidal (Puffin Books, 1992)

The Water Hole by Graeme Base (Puffin Books, 2004)

Unit 9

Lesson 1

Color Dance by Ann Jones (Trumpet, 1989)

Lesson 2

Georgia's Bones by Jen Bryant (Eerdman, 2005)

Through Georgia's Eyes by Rachel Rodriguez and Julie Paschkis (Henry Holt, 2006)

My Name is Georgia by Jeanette Winter (Harcourt Brace, 1998)

Unit 10

Lesson 1

The Big Orange Splot by Daniel Pinkwater (Scholastic, 1977)

My Painted House by Maya Angelou and Margaret Courtney-Clarke (Clarkson Potter, 1994)

Lesson 2

Architecture SHAPES by Michael J. Crosbie and Steve Rosenthal (Tien Wah, 1993)

Lesson 3

Castle by David Macaulay (Houghton Mifflin, 1977)

Scope and Sequence— National Standards Kindergarten

	Introduction	Unit 1 Lesson 1	Lesson 2	Lesson 3	Lesson 4	Lesson 5	Lesson 6	Lesson 7	Lesson 8	Unit 2 Lesson 1	Lesson 2	Lesson 3
Standards	1a 2a 2b 4b 5a 5b	1a 1b 2a 3a 4a 4b 5a 5c 6b	1a 1b 1c 2a 3b	1a 1b 1d 2c 6b	1a 1b 2b 2c 3a	1a 1c 1d 3a 3b 4a 4b 5a	1a 1b 1c 1d 2c 3a 3b 4c 6a	1c 1d 2a 3a 3b 4c 4b 6b	1a 1b 1c 1d 2b 4a 4c	1a 1c,1d 2a 3a 3b 5b 6a 6b	1a,1b 1c,1d 2b 3a 3b 5a 5c 6b	1a,1b 1c,1d 2b 3a 3b 5a 5b

Student Abilities in Art

Perception

Using knowledge of structures and functions

	Intro	L1	L2	L3	L4	L5	L6	L7	L8	U2L1	U2L2	U2L3
Observing visual, tactile, spatial, and temporal elements in the natural and built environments	•			•						•	•	•
Observing visual, tactile, spatial, and temporal elements in artworks		•	•	•		•	•	•	•		•	•
Considering use of elements and principles of design		•	•	•	•	•	•	•	•		•	•

Art Production

Understanding and applying, media, techniques, and processes

	Intro	L1	L2	L3	L4	L5	L6	L7	L8	U2L1	U2L2	U2L3
Generating ideas for artistic expression		•	•	•	•	•	•	•	•	•		•

Choosing and evaluating a range of subject matter, symbols and ideas

	Intro	L1	L2	L3	L4	L5	L6	L7	L8	U2L1	U2L2	U2L3
Developing approaches for expressing ideas		•	•	•	•	•	•	•	•	•	•	•
Exploring expressive potential of art forms, media, and techniques		•	•	•	•	•	•	•	•	•	•	•
Reflecting on artistic process, meaning, and quality of work		•	•	•	•	•	•	•	•	•	•	•
Safety in art making							•					

Art History

Understanding the visual arts in relation to history and cultures

	Intro	L1	L2	L3	L4	L5	L6	L7	L8	U2L1	U2L2	U2L3
Investigating historical/cultural meanings of artworks		•									•	•
Understanding historical/cultural context			•			•		•		•		
Developing global and multicultural perspectives												
Considering styles, influences, and themes in art		•	•	•		•	•	•		•		

Art Criticism

Reflecting upon and assessing the characteristics and merits of their work and the work of others

	Intro	L1	L2	L3	L4	L5	L6	L7	L8	U2L1	U2L2	U2L3
Describing and analyzing details in artworks		•	•	•		•	•	•	•		•	•
Interpreting meanings in artworks		•				•		•			•	•
Judging merit and significance in artworks		•				•		•			•	•

Aesthetics

Reflecting upon and assessing the characteristics and merits of their work and the work of others

	Intro	L1	L2	L3	L4	L5	L6	L7	L8	U2L1	U2L2	U2L3
Understanding reasons for valuing art		•	•	•		•	•	•	•	•	•	
Raising and addressing philosophical questions about art and human experience		•	•			•	•	•	•	•	•	
Forming opinions about art		•	•	•		•	•	•	•		•	•

Presentation, Exhibition, and Critique

Reflecting upon and assessing the characteristics and merits of their work and the work of others

	Intro	L1	L2	L3	L4	L5	L6	L7	L8	U2L1	U2L2	U2L3
Keeping a portfolio and sketchbook												
Making work public												
Evaluating progress and accomplishments												

Learning for Life

Making connections between visual arts and other disciplines

	Intro	L1	L2	L3	L4	L5	L6	L7	L8	U2L1	U2L2	U2L3
Performing arts connections												
Daily life and visual culture connections		•	•	•	•	•	•	•	•	•	•	•
Interdisciplinary connections		•			•		•	•		•	•	•
Careers											•	
Computer connection												

National Standard

1a Students know the differences between materials, techniques, and processes

1b Students describe how different materials, techniques, and processes cause different responses

1c Students use different media, techniques, and processes to communicate ideas, experiences, and stories

1d Students use art materials and tools in a safe and responsible manner

2a Students know the differences among visual characteristics and purposes of art in order to convey ideas

2b Students describe how different expressive features and organizational principles cause different responses

2c Students use visual structures and functions of art to communicate ideas

3a Students explore and understand prospective content for works of art

	Unit 3				Unit 4				Unit 5				Unit 6				Unit 7		Unit 8			Unit 9			Unit 10		
	Lesson 1	Lesson 2	Lesson 3	Lesson 4	Lesson 1	Lesson 2	Lesson 3	Lesson 4	Lesson 1	Lesson 2	Lesson 3	Lesson 4	Lesson 1	Lesson 2	Lesson 3	Lesson 4	Lesson 1	Lesson 2	Lesson 1	Lesson 2	Lesson 3	Lesson 1	Lesson 2	Lesson 3	Lesson 1	Lesson 2	Lesson 3
	1a,1b 1c 2a 2b 2c 3a 3b 5b 5c	1a,1b 1c 2c	1a,1b 1c 1d 2a 2b 2c 3a 3b 5c	1a,1b 1c 2a 2b 3a 3b 5c 6b	1a,1b 1d 2a 2b,2c 3a,3b 4a,4b 4c, 5a,5c 6b	1a,1b 1c 2b 2c 3a 3b	1a 1c 2a 2c 3a 3b 5a	1a,1c 2b 2c 3a,3b 4a 4b 4c 5a 6b	1a,1c 1d 2a 2b 2c 3a 3b 5a 5c	1a,1b 1c 2a 2b 3a 3b 5a 6b	1c 2a 2c 3a 3b 4b 5a 6b	1a,1c 2a 2b,2c 3a 3b 4a 4b 5a,5c 6b	1a 2a 2b 2c 3a 3b 5c	1a,1b 2a 2b 2c 3a 3b 6b	1a,1b 1c,1d 2a 2b,2c 3a,3b 4a 4b 6b	1a,1c 2a 2b 2c 3a 3b 4a 5b	1a,1c 1d 2c 3a 3b 5a	1a 1b 1c 1d 2b 2c 3a 3b	1b 2b 4a 4b 5a 5b 5c 6b	1a 1b 1c 2a 2b 2c 3a 3b 6b	1b 1c 2c 3a 3b	1a 1b 1c 1d 2a 2b 2c	1a 1c 2a 3a 3b 5c	1a 1c 1d 2b 3a 3b 5b	1b 1c 2a 3a 3b 5b 5c	1a,1b 1c 2a,2b 2c 3a 3b 5a,5b	1c 2a 2b 2c 3a 3b 5c

3b
Students select and use subject matter, symbols, and ideas to communicate meaning

4a
Students know that the visual arts have both a history and specific relationships to various cultures

4b
Students identify specific works of art as belonging to particular cultures, times, and places

4c
Students demonstrate how history, culture, and the visual arts can influence each other in making and studying works of art

5a
Students understand there are various purposes for creating works of visual art

5b
Students describe how people's experiences influence the development of specific artworks

5c
Students understand there are different responses to specific artworks

6a
Students understand and use similarities and differences between characteristics of the visual arts and other arts disciplines

6b
Students identify connections between the visual arts and other disciplines in the curriculum

Glossary

abstract An abstract artwork is usually based on an identifiable subject, but the artist leaves out details, simplifies or rearranges visual elements. Abstract works that have no identifiable subject are called nonobjective art.

architect An artist who plans and makes buildings.

background Parts of artwork that appear to be in the distance or behind the objects in the foreground.

balance A principle of design that describes the arrangement of parts of an artwork to create a sense of equality in visual weight, interest, or stability. Major types of balance are symmetrical, asymmetrical, and radial.

brushstrokes The paint left on a surface by a paintbrush.

building A usually roofed and walled structure built for permanent use (as for a dwelling).

clay A natural material from the earth composed of mostly fine minerals. When moist it is easily shaped; when fired at a high temperature, it becomes permanently hard.

close-up A view that looks very near or close.

coil method Pottery made by joining rope like pieces of clay. Used to make pots, bowls and sculptures.

collage An artwork created by gluing bits of paper, fabric, scraps, photographs, or other materials to a flat surface.

compose To plan or design an artwork by arranging the parts to create a unified whole.

contour drawing A drawing in which the lines represent or describe the edges, ridges or outline of a shape or form.

cool colors Colors often associated with cool places, things, or sensations. The family of colors ranging from the greens through the blues and violets.

crayon resist A process in which wax crayons are used because they will not mix with water. The crayons are used to block out certain areas of a surface that the artist does not want to be affected by dye, paint, or ink that is applied over the wax.

dab Applying paint or other medium to a surface by gently tapping it with a brush or sponge.

decoration Something that adorns, enriches, or beautifies the surface of an object.

design The plan, organization, or arrangement of elements in a work of art.

emphasis Areas in a work of art which dominate the viewer's attention. These areas usually have contrasting sizes, shapes, colors, or other distinctive features.

expression 1. The way a person's face shows feelings such as happiness, sadness, surprise, or excitement. 2. Artwork in which the main idea is to convey a definite or strong mood or feeling.

exterior The outside surface of an object; for example, the outside walls of a building.

fabric Cloth used to create artworks.

fiber Any thin, threadlike linear material that can be shaped or joined to create art. Usually associated with yarn and woven fabrics.

fiber artist Artists who use long, thin, threadlike materials to create artwork.

figure proportions The size and distance relationships of the major anatomical parts of the human body to each other.

firing In ceramics, the process of exposing a clay object to high heat, usually in a furnacelike oven called a kiln, in order to harden it permanently.

foreground In a scene or artwork, the part that seems near or close to you.

form Any three-dimensional object. A form can be measured from top to bottom (height), side to side (width), and front to back (depth). Also a general term that refers to the structure or design of a work.

found materials Natural or manufactured objects that artists find and repurpose for use in their artworks.

frame One part of an artwork that tells a story in several parts.

free-form A term for irregular and uneven shapes or forms, not easily described by reference to simple shapes or measurements.

geometric Refers to mechanical-looking shapes or forms as well as those described through mathematical formulas in geometry: shapes, such as circles, squares, rectangles, triangles, and ellipses; forms such as cones, cubes, cylinders, slabs, pyramids, and spheres.

horizon line The line where the sky meets the ground.

hue The common name of a color in, or related to, the spectrum, such as yellow, yellow-orange, blue-violet, green. Hue is another word for color.

human-made environment The buildings and structures in the world that are created by man. These structures often have geometric lines and shapes.

illustrator An artist who creates pictures to explain a point, to show an important part of a story, or to add decoration to a book, magazine, or other printed work.

imagination Creating a mental picture of something that is unlike things one has seen. Describes a mental picture of something that is creative and unlike anything one has seen before.

kiln The furnace-like oven used for firing ceramic objects or for fusing glass or enamels to metal.

lettering The use of letters on common objects. Frequently used on posters, billboards and cereal boxes.

line A continuous mark with length and direction, created by a point that moves across a surface. A line can vary in length, width, direction, curvature, and color. Lines can be two-dimensional (a pencil line on paper), three-dimensional (wire), or implied.

line quality The way a line looks: skinny, thick, dark or light.

loom A frame or related support for weaving cloth. Lengthwise threads (the warp) are held taut by the loom while other threads (the weft) are woven through them.

media The materials and techniques used by an artist to produce a work of art. Plural of medium.

middle ground Parts of an artwork that appear to be between objects in the foreground and objects in the background.

model 1. A usually miniature representation of a building or project. 2. A person who poses for an artist.

movement A way of combining visual elements to produce the illusion of action or to cause the viewer's eye to sweep over the work in a definite manner.

natural environment All the rivers, hills, trees, and other elements of the earth.

negative shape or space The space surrounding shapes or solid forms in a work of art.

nonobjective An artwork where none of the objects can be recognized. The viewer only sees lines, shapes and other design elements. This art style uses lines and shapes to convey a message or feelings to the viewer.

organic Having a quality that resembles living things or objects in the natural environment.

ornament A decoration that is applied to a building or other object.

overlap One part that covers up all or some of other parts in an artwork.

paintbrush A brush used to apply paint.

pattern A choice of lines, colors, or shapes repeated over and over in a planned way. Also, a model or guide for making something.

photograph A picture or likeness obtained by the action of radiant energy and especially light on a sensitive surface such as film.

pinch To squeeze between the finger and thumb.

portrait Any form of art expression which resembles a specific person or animal.

pose To assume a posture for artistic purposes.

positive shape or space The main shape or space in a work of art, not the background or the space around the positive shape.

pottery Pots, dishes, vases, and other objects modeled from wet clay. Also, a potter's workshop.

primary colors One of three basic colors (red, yellow, and blue) that cannot be produced by mixing colors and that serve as the basis for mixing other colors. In light, the primary colors are red, green, and blue.

print A shape or mark made from a printing block or other object that is covered with ink and then pressed on a flat surface, such as paper or cloth. Most prints can be repeated over and over again by re-inking the printing block.

printmaking Any of several techniques for making multiple copies of a single image. Some examples are woodcuts, etchings, collagraphs, and silkscreen prints

profile A representation of something as seen from a side view.

proportion The relation of one object to another with respect to size, amount, number, or degree.

puppet A small-scale figure of a person or animal, usually with a cloth body and hollow head that fits over and is moved by the hand.

quilt Fabric artwork made of two layers of cloth filled with padding (as down or batting) held in place by ties or stitched designs.

radial balance A kind of balance in which lines or shapes radiate from a center point.

realistic Realistic art protrays a recognizable subject with lifelike colors, textures, shadows, proportions, and the like.

recycled materials Products made of paper, plastic, glass, or metal that can be made into other products and reused rather than being thrown away.

relief sculpture A three-dimensional form, designed to be viewed from one side, in which surfaces project from a background.

resist painting A process in which materials such as oil or wax are used because they will not mix with water. The resist material is used to block out certain areas of a surface that the artist does not want to be affected by dye, paint, varnish, acid, or another substance.

rhythm A principle of design that refers to a type of visual or actual movement in an artwork. A rhythm is usually created by repeating visual elements. Rhythms are often described as regular, alternating, flowing, progressive, or jazzy.

rubbing A technique for transferring the textural quality of a surface to paper. Paper is placed over the surface. The top of the paper is rubbed with crayon, chalk, or pencil.

scene The setting or view shown in an artwork.

sculpture A work of art with three dimensions: height, width, and depth. Such a work may be carved, modeled, constructed, or cast.

secondary colors A color made by mixing equal amounts of two primary colors. Green, orange, and violet are the secondary colors. Green is made by mixing blue and yellow. Orange is made by mixing red and yellow. Violet is made by mixing red and blue.

self-portrait Any work of art in which an artist portrays himself or herself.

shade Any dark value of a color, usually achieved by adding black.

shape A flat figure created when actual or implied lines meet to enclose a space. A change in color or shading can define a shape. Shapes can be divided into several types: geometric (square, triangle, circle) and organic (irregular in outline).

sketch A drawing done quickly to catch the important features of a subject. Also, a drawing that may be used to try out an idea or to plan another work.

slab A form that is solid, flat, and thick. A thick, even slice of clay, stone, wood, or similar material.

space Element of art referring to the empty or open area between, around, above, below, or within objects. Shapes and forms are defined by space around and within them. Space is often described as three-dimensional or two-dimensional, as positive (occupied by a shape or form) or negative (surrounding a shape or form).

stitchery A general term for artwork created with needles, thread or yarn, and cloth. A stitch is one in-and-out movement of a threaded needle.

structure Something that is constructed.

style A style is the result of an artist's means of expression—the use of materials, design qualities, methods of work, choice of subject matter, and the like. In most cases, these choices reveal the unique qualities of an individual, culture, or time period. The style of an artwork helps you to know how it is different from other artworks.

subject matter A topic or idea represented in an artwork, especially anything recognizable, such as a landscape or animals.

symmetrical balance A type of balance in which the contents on either side of a center line are exactly or nearly the same, like a mirror image in which things on each side of a center line are identical. For example, the wings of a butterfly are symmetrical. Also known as "formal balance."

symmetry A type of balance in which the contents on either side of a center line are exactly or nearly the same, like a mirror image in which things on each side of a center line are identical. For example, the wings of a butterfly are symmetrical. Also known as "formal balance."

technique An artist's ways of using art materials to achieve a desired result. A technique can be an artist's unique way to create artwork (a special kind of brushstroke) or a fairly standard step-by-step procedure (the technique of creating a crayon-resist).

texture Texture is perceived by touch and sight. Texture refers to the way a surface feels to the sense of touch (actual texture) or how it may appear to the sense of sight (simulated texture). Textures are described by words such as rough, silky, or pebbly.

three-dimensional Artwork that can be measured three ways: height, width, and depth or thickness. Artwork that is not flat. Any object which has depth, height, and width.

tint A light value or variation of a pure color, usually achieved by adding white to the pure color. For example, pink is a tint of red.

unity A feeling that all parts of a composition are working together.

value Element of art that refers to the darkness or lightness of a surface. Value depends on how much light a surface reflects. Tints are light values of pure colors. Shades are dark values of pure colors. Value can also be an important element in works of art in which color is absent or very subtle, such as drawings, prints, and photographs.

view The position of something as an artist looks at it. Artists choose from above, below, or straight ahead.

warm colors Warm colors are so called because they are often associated with fire and the sun, and remind people of warm places, things, and sensations. Warm colors are related and range from the reds through the oranges and yellows.

weaving 1. The process of interlocking two sets of parallel threads or fiber-like materials, usually held at right angles to one another on a loom, to create a fabric. 2. The cloth or fabric created by weaving.

Spanish Glossary

abstracto Una obra de arte abstracta usualmente se basa en un tema identificable, pero el artista omite detalles, o simplifica o reorganiza elementos visuales. Trabajos abstractos que no tienen un tema identificable se conocen como arte sin objeto. (*abstract*)

adorno 1. Algo que adorna, enriquece o embellece la superficie de un objeto. (*decoration*) 2. La decoración que se le aplica a un edificio u otro objeto. (*ornament*)

ambiente artificial Los edificios y las estructuras creadas por el ser humano. Estas estructuras a menudo tienen formas geométricas. (*human-made environment*)

ambiente natural Todos los ríos, árboles, colinas y otros elementos de la tierra. (*natural environment*)

arcilla Un material natural de la tierra compuesto mayormente de minerales finos. Fácil de moldear cuando húmedo; se endurece de manera permanente cuando es expuesto a altas temperaturas. (*clay*)

arquitecto Un artista que diseña y construye edificios. (*architect*)

arte de resistencia con lápices de colores Un dibujo hecho con crayón de cera y cubierto con una aguada. Debido a que la cera repele el agua, la pintura no llega a cubrir el área dibujada con el crayón. (*crayon resist*)

autorretrato Cualquier obra de arte en la que un artista se representa a sí mismo. (*self portrait*)

balance Un principio de diseño que describe el arreglo de partes de una pieza de arte para crear una sensación de equilibrio en peso, interés y estabilidad visual. Simétrico, asimétrico y radial son los principales tipos de equilibrio. (*balance*)

bosquejo Un dibujo hecho rápidamente para captar las características de un sujeto. También se refiere a un dibujo que puede ser usado para probar una idea o planear otra obra. (*sketch*)

calco Una técnica usada para trasladar la calidad de la textura de una superficie al papel. El papel se coloca sobre una superficie y la parte superior de un papel se frota con un crayón, tiza, o lápiz. (*rubbing*)

calidad de la línea La manera en que se ve una línea: angosta, ancha, oscura o clara. (*line quality*)

cerámica Objetos tales como vasijas, platos, floreros hechos de arcilla mojada. También se refiere al taller del ceramista. (*pottery*)

collage Una obra de arte que se crea pegando trozos de papel, tela, retratos, fotografías u otros materiales sobre una superficie plana. (*collage*)

color primario Uno de los tres colores básicos (rojo, amarillo y azul) que no pueden ser creados mezclando colores y que sirven como base para mezclar otros colores. Con referencia a la luz, los colores primarios son el rojo, el verde y el azul. (*primary color*)

colores cálidos A los colores cálidos se les da este nombre porque a menudo se les asocia con el fuego y el sol, y le recuerdan a la gente lugares, cosas y sentimientos cálidos. Los colores cálidos están relacionados y van desde el rojo hasta los naranjas y los amarillos. (*warm colors*)

colores fresca Colores que a menudo se asocian con lugares, cosas o sensaciones frías. Es aquella familia de colores que comprende desde el verde hasta los azules y violetas. (*cool colors*)

colores secundarios Colores que se logran al mezclar partes iguales de dos colores primarios. Verde, naranja y violeta son los colores secundarios. El verde se hace mezclando azul y amarillo. El naranja se hace mezclando rojo y amarillo. El violeta se hace mezclando rojo y azul. (*secondary color*)

componer Planificar o diseñar una pieza de arte al disponer las partes para crear un todo unificado. (*compose*)

cuadro de resistencia Un proceso por el cual se utilizan materiales tales como aceite o cera porque no se mezclarán con el agua. El material resistente se usa para bloquear ciertas áreas de una superficie que el artista no quiere que se vean afectadas por tinte, pintura, barniz, ácido, u otra sustancia. (*resist painting*)

dibujo de contorno Un dibujo en el cual las líneas representan o describen los bordes, las crestas, o el perfil de una forma o figura.(*contour drawing*)

diseño El plan, la organización, o el arreglo de elementos en una obra de arte. (*design*)

edificio Una estructura de paredes y techo construida para uso permanente (como para una vivienda). (*building*)

edredón Trabajo artístico hecho de dos capas de tela con relleno (como con plumas o entretela) sujetadas por lazos o diseños de bordado. (*quilt*)

encender En cerámica, el proceso de exponer un objeto de arcilla a temperaturas altas, a menudo en un horno de cerámica para que endurezca de manera permanente. (*firing*)

énfasis Áreas en una obra de arte que dominan la atención del observador. Estas áreas por lo general tienen tamaños, formas, colores u otros rasgos distintivos que contrastan. (*emphasis*)

equilibrio simétrico Una clase de equilibrio en el cual el contenido a ambos lados de una línea central es exactamente o casi el mismo, como una imagen reflejada en un espejo en la que las cosas a ambos lados de una línea central son idénticas. Por ejemplo, las alas de una mariposa son simétricas. Se le conoce también como "equilibrio formal." (*symmetrical balance*)

escultura Una obra de arte con tres dimensiones: alto, ancho y profundidad. Esta clase de obra puede ser tallada, modelada, construida o fundida. (sculpture)

escultura en relieve Una forma tridimensional, diseñada para ser vista de un lado, donde las superficies se proyectan desde un fondo. (relief sculpture)

espacio Un elemento de arte que se refiere al área vacía o abierta en medio, alrededor, arriba, abajo o adentro de los objetos. Las figuras y las formas están definidas por el espacio alrededor y dentro de ellas. El espacio a menudo se describe como tridimensional o bidimensional, como positivo (ocupado por una figura o forma) o negativo (que rodea una figura o forma). (space)

espacio o forma negativa El espacio que circunda figuras o formas sólidas en una obra de arte. (negative shape/space)

espacio o forma positiva Las figuras o espacios principales en una obra de arte, no el fondo ni el espacio circundante. (positive space/shape)

estilo Un estilo es el resultado de los medios de expresión de un artista—el uso de materiales, cualidades del diseño, métodos de trabajo, el tema escogido y otros similares. En la mayoría de los casos, estas selecciones revelan las cualidades únicas de un individuo, una cultura o una época. El estilo de una obra de arte ayuda a reconocer en qué difiere de otras obras de arte. (style)

estructura Algo que se construye. (structure)

expresión 1. El modo en el que la cara de una persona demuestra sentimientos tales como felicidad, tristeza, sorpresa, o emoción. 2. Una pieza de arte cuya idea principal es comunicar un sentimiento o estado de ánimo fuerte o específico. (expression)

exterior La superficie externa de un objeto; por ejemplo, las paredes externas de un edificio. (exterior)

fibra Cualquier material delgado similar a una hebra al que se le puede dar forma o unir para crear arte. Generalmente se le asocia con el hilo y las telas tejidas. (fiber)

fondo Partes de una obra de arte que parecen estar lejos o detrás de objetos que se encuentran en primer plano. (background)

forma 1. Cualquier objeto tridimensional. Una forma puede ser medida de arriba hacia abajo (alto), de lado a lado (ancho), y del frente hacia atrás (profundidad). También es un término general que se refiere a la estructura o diseño de un trabajo. (form) 2. Una figura plana que se crea al unirse las líneas reales o implícitas para delimitar cierto espacio. Las formas pueden estar definidas por un cambio de color o sombreado. Se puede clasificar las formas en diversas categorías: geométricas (cuadrado, triángulo, círculo) y orgánicas (de contorno irregular). (shape)

forma libre Un término usado para designar figuras o formas que no se pueden describir fácilmente en referencia a simples figuras o medidas. (free-form)

fotografía Un retrato o parecido obtenido por la acción de energía radiante y especialmente luz sobre una superficie sensible como película fotográfica. (photograph)

geométrico Término que se refiere a objetos de apariencia o forma mecánica, y a aquellos descritos por medio de fórmulas matemáticas en la geometría: figuras tales como círculos, cuadrados, rectángulos, triángulos y elipses; formas tales como conos, cubos, cilindros, bloques, pirámides y esferas. (geometric)

horno Aparato que sirve para trabajar y transformar con la ayuda del calor las sustancias minerales. Usado para cocer objetos de cerámica o para fusionar metales a vidrio o a esmaltes. (kiln)

ilustrador Un artista que crea dibujos para explicar algo, para ilustrar una parte importante de un cuento, o para añadirle un elemento decorativo a un libro, una revista u otro trabajo impreso. (illustrator)

imaginación La creación de una imagen mental de algo que no se parece a nada que uno haya visto. Describe la imagen mental de algo que ese creativo y en nada parecido a lo que uno ya haya visto. (imagination)

imprenta Una de varias técnicas utilizadas para hacer múltiples copias de una sola imagen. Algunos ejemplos son el tallado, grabados, ecolágrafos y serigrafía. (printmaking)

impresión Cualquier marca o huella hecha por presión. En grabado, una estampa que resulta del contacto de una superficie entintada con la superficie de un papel. Forma o marca hecha con un molde de imprenta u otro objeto cubierto con tinta y luego presionado sobre una superficie plana, tal como papel o tela. La mayoría de las impresiones pueden repetirse si se vuelve a colocar tinta en el molde.(print)

leyenda El uso de letras en objetos comunes. Frecuentemente usado en cartulinas, carteleras y cajas de cereal. (lettering)

línea Una marca continua con longitud y dirección, creada por un punto que se mueve a lo largo de una superficie. Una línea puede variar en longitud, ancho, dirección, curvatura y color. Una línea puede ser bidimensional (una línea a lápiz sobre papel), tridimensional (alambre), o implícita. (line)

línea del horizonte Línea en la que se encuentran el cielo y la tierra. (horizon line)

losa Una forma que es sólida, plana y gruesa. Un trozo grueso y uniforme de arcilla, piedra, madera, o material similar. (slab)

marco Parte de un trabajo de arte que relata una historia en varias partes. (frame)

materiales encontrados Objeto naturales u objetos manufacturados que los artistas encuentran y usan con un propósito nuevo en arte. (*found materials*)

materiales reciclados Productos hecho de papel, plástico, vidrio, o metal que se pueden convertir en otros productos y reutilizar en vez de desechar. (*recycled materials*)

medios Los materiales y técnicas que el artista usa para producir una obra de arte. Se puede referir también al líquido en el cual los pigmentos en polvo se mezclan para hacer una pintura. (*media*)

método espiral Pieza de cerámica elaborada con piezas de arcilla que se unen como si fueran una soga. Se usa para hacer vasijas, tazones y esculturas. (*coil method*)

modelo 1. Una representación usualmente en miniatura de un edificio o proyecto. 2. Una persona que posa para un artista. (*model*)

movimiento 1. Sensación de movimiento en una pieza de arte creada por el arreglo de elementos de arte. 2. Ir de un sitio para otro, o la sensación de acción en una picza de arte. (*motion*) 3. Una forma de combinar elementos visuales para producir la ilusión de acción, o causar que la mirada del observador recorra la obra de una manera determinada. (*movement*)

orgánico Que tiene una cualidad que se asemeja a las cosas vivas. (*organic*)

patrón Las líneas, colores o figuras que se han escogido y que se repiten una y otra vez de acuerdo con un plan. Puede ser también un modelo o guía para hacer algo. (*pattern*)

pellizcar Apretar entre un dedo y el pulgar. (*pinch*)

perfil Representación de algo cuando se le ve de lado. (*profile*)

pespunteado Término general que describe el trabajo con agujas, hilo o lana y tela. El pespunteado se realiza con un movimiento de la aguja enhebrada. (*stitchery*)

pincel Una brocha usada principalmente para pintar. (*paintbrush*)

pinceladas La pintura que deja un pincel en la superficie. (*brushstrokes*)

posar Asumir una postura para propósitos artísticos. (*pose*)

primer plano 1. En una escena u obra de arte, la parte que parece estar más cercana al observador. (*foreground*) 2. Punto de vista en una escena donde los objetos parecen estar muy cerca del observador. (*close-up*)

proporción La relación entre objetos respecto al tamaño, la cantidad, el número o el grado. (*proportion*)

proporciones de figuras Las relaciones de tamaño y distancia entre las principales partes anatómicas del cuerpo humano. (*figure proportions*)

radial Una clase de equilibrio en el que líneas o figuras irradian desde un punto central. (*radial balance*)

realista El arte realista representa un tema reconocible en colores, texturas, sombras, proporciones y otros elementos similares que parecen vivos. (*realistic*)

retrato Cualquier forma de expresión artística que se asemeja a una determinada persona o animal. (*portrait*)

ritmo Principio de diseño que se refiere a un tipo de movimiento visual o real en una obra de arte. Un ritmo se crea usualmente con la repetición de elementos visuales. El ritmo se describe a menudo como regular, repetitivo, fluido, progresivo o de jazz. (*rhythm*)

simetría Una clase de equilibrio en el cual el contenido a ambos lados de una línea central es exactamente o casi el mismo, como una imagen reflejada en un espejo en la que las cosas a ambos lados de una línea central son idénticas. Por ejemplo, las alas de una mariposa son simétricas. Se le conoce también como "equilibrio formal." (*symmetry*)

sin objeto Una pieza de arte donde ninguno de los objetos pueden ser reconocidos. El observador sólo ve líneas, formas y otros elementos de diseño. Este estilo artístico usa líneas y formas para comunicar un mensaje o sentimientos al observador. (*nonobjective*)

sombra Cualquier valor oscuro de un color que se logra generalmente añadiendo negro. (*shade*)

superposición Una parte que cubre todas o algunas partes en una pieza de arte. (*overlap*)

técnica La forma en que un artista usa los materiales de arte para lograr el efecto deseado. Una técnica puede ser la manera particular mediante la que un artista crea su obra de arte (un tipo especial de pincelada) o un procedimiento estándar (la técnica para crear un crayón indeleble). (*technique*)

tejido 1. El proceso de entrelazar dos pares de hilos o materiales de fibras paralelos, usualmente emparejados en ángulos rectos en un telar, para crear una tela. 2. La tela creada mediante este proceso. (*weaving*)

tela La tela usada para crear piezas de arte. (*fabric*)

telar Un bastidor o soportes relacionados para tejer telas. El telar sostiene algunos hilos (la urdimbre) mientras otros hilos (la trama) se tejen a través de ellos. (*loom*)

tema Un tópico o idea representado en una pieza de arte, especialmente algo reconocible, como un paisaje o animales. (*subject matter*)

término medio Partes de una pieza de arte que parecen estar entre objetos en el primer plano y objetos en el fondo. (*middle ground*)

textura La textura se percibe por medio del tacto y la vista. La textura se refiere a la manera como una superficie se siente al tacto (textura real) o a la vista (textura simulada). Las texturas se describen con palabras como áspero, sedoso, granoso. (*texture*)

tinte Un valor suave o una variación de un color puro que usualmente se logra agregando blanco. Por ejemplo, el rosado es un tinte del rojo. (*tint*)

títere Una figura en pequeña escala de una persona o animal, usualmente con cuerpo de tela y cabeza hueca que se mueve con las manos. (*puppet*)

tono El nombre común de un color en, o relacionado a, el espectro, como amarillo, amarillo-naranja, azul-violeta, verde. Tono es otra palabra para color. (*hue*)

toque Aplicar pintura u otro medio a la superficie con toques leves de una brocha o esponja. (*dab*)

tridimensional Obra de arte que se puede medir en tres sentidos: alto, ancho y profundidad o espesor. Obra de arte que no es plana. Cualquier objeto que tiene alto, ancho y profundidad. (*three-dimensional*)

unidad Sensación de que todas las partes de un diseño funcionan como un conjunto. (*unity*)

valor Elemento de arte que se refiere a la oscuridad o luminosidad de una superficie. El valor depende de la cantidad de luz que refleja una superficie. Los tintes son los valores luminosos de un color puro. Las sombras son los valores oscuros de un color puro. El valor puede ser también un elemento importante en las obras de arte en las que el color está ausente o es muy sutil, tales como dibujos, grabados y fotografías. (*value*)

vista La posición de algo según lo ve el artista. Los artistas escogen encima, debajo o enfrente. (*view*)